FOR MAURIZIO, MY TWIN BROTHER

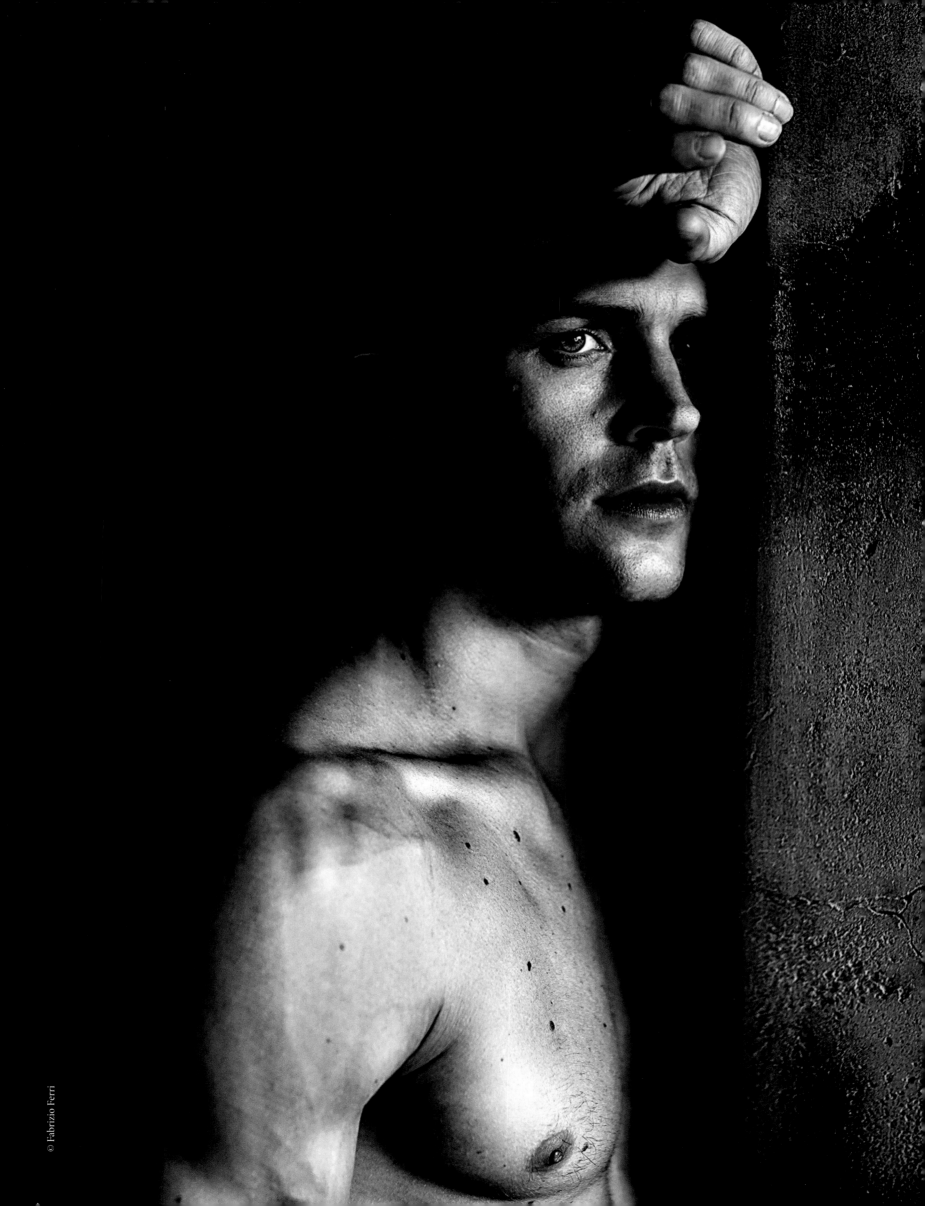

ROBERTO
BOLLE

Voyage into Beauty

Introduction by ROBERT WILSON

Pompeii
Photos by FABRIZIO FERRI

———

Italian Journey
Photos by LUCIANO ROMANO

Text by VALERIA CRIPPA

RIZZOLI
NEW YORK

New York · Paris · London · Milan

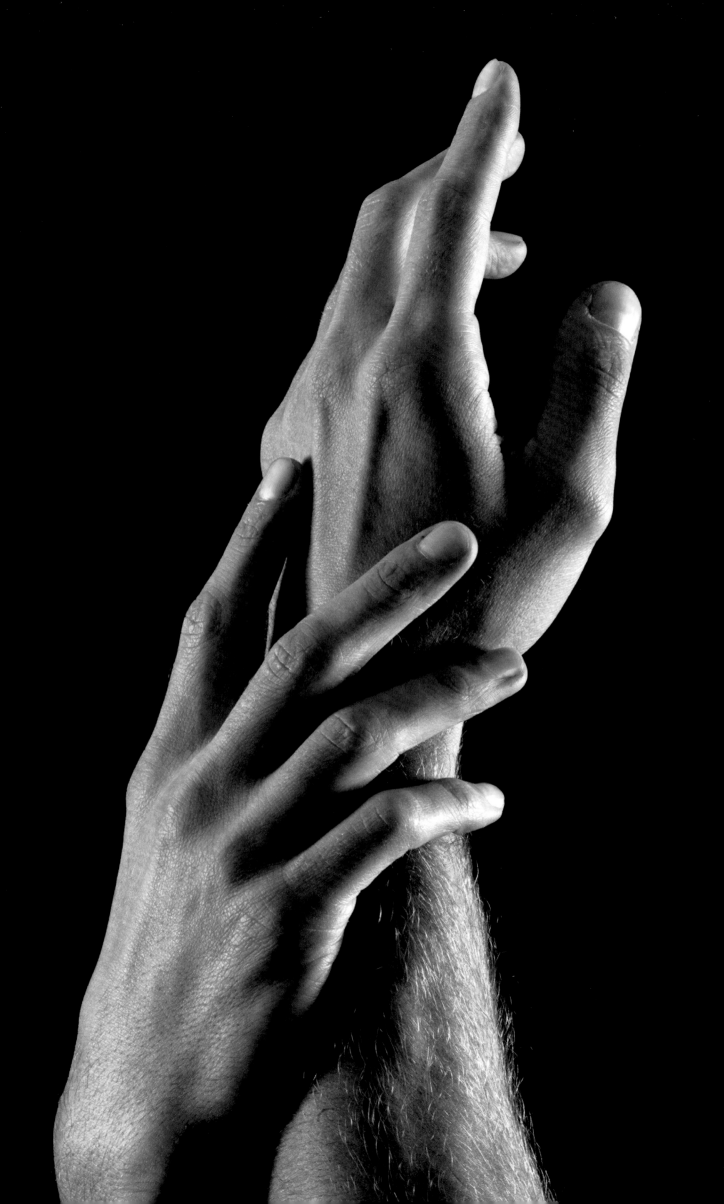

CONTENTS

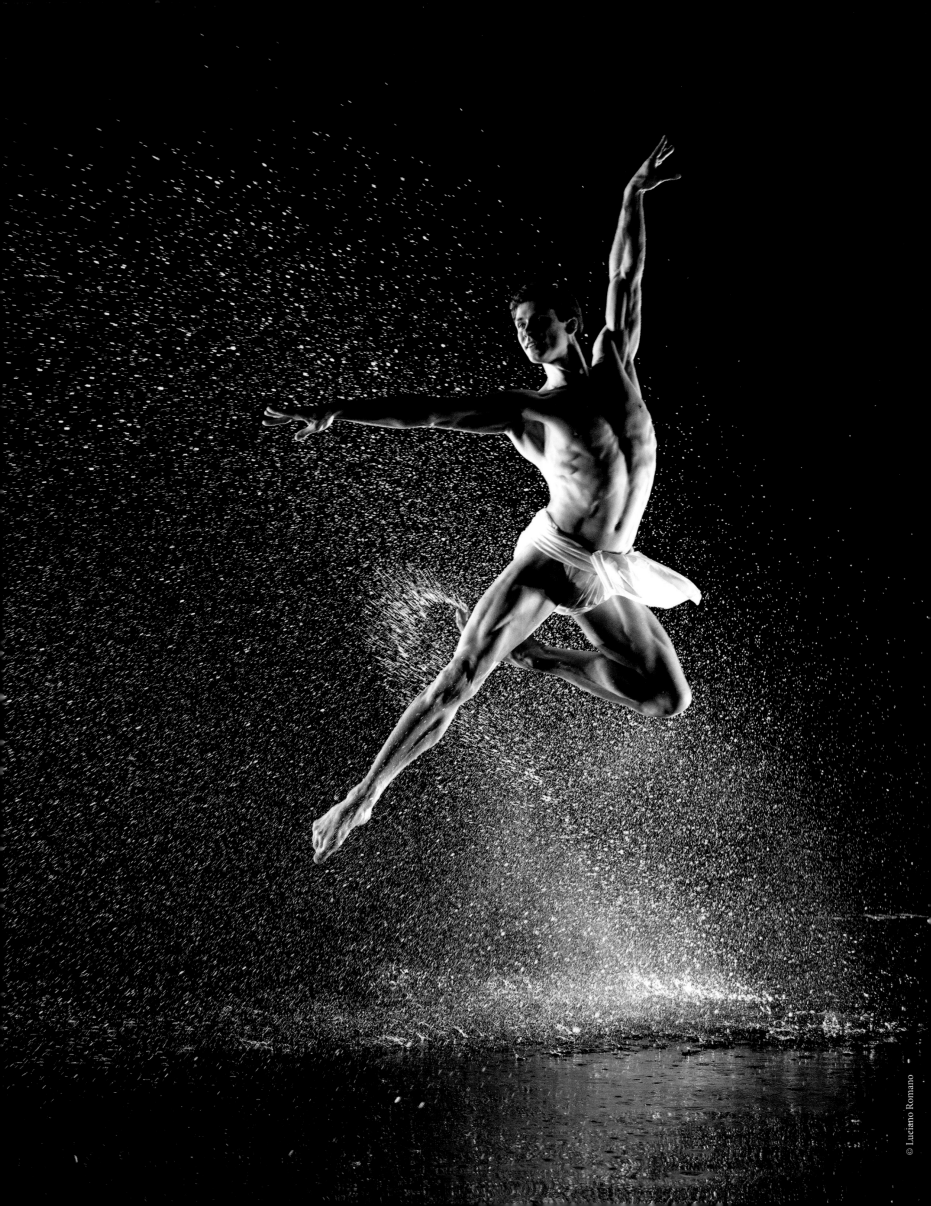

The words of the poet hailing from Lesbos constitute, if not the first, then certainly one of the most famous and explicit associations between the concept of beauty and goodness in the history of Western thought. In actuality, beauty did not seem to possess its own autonomy in ancient Greece. It gained value only when it was associated with other qualities such as goodness. However, unlike the vision of these concepts on the part of the Church and its development over the centuries, the association between beauty and moral virtue would never be in opposition. The words sung by Sappho convey a sense of a lasting, metaphysical union between beauty and goodness, which over time would form the ideal of human virtue.

Indeed, whatever the notion of beauty may have been thereafter—from the Pythagorean theories of proportion and harmony, to the concept of Platonic "splendor" (which would also be reflected in the medieval idea of *claritas*, considered to be a form of beauty), from the Augustinian principle of "measure," to the Thomistic concept of "adherence to purpose"—throughout the history of Western civilization beauty has usually been related to a broader, positive connotation.

Beauty is therefore goodness, but we might also add that beauty is good because it is useful (and vice versa, ugliness is evil because it is useless). This correlation was so evident in our ancestors' thoughts that it spawned poetic metaphors which still amuse and delight: for example, the salvific powers of the *donna angelicata* (angelic woman) by the Dolce Stil Novo poets—that angelic figure who—in the words of Lapo Gianni—*from the sky descended to spread her beauty.*

I would like to stop and discuss the Italian verb "spander" used by the poet Lapo Gianni, meaning to spread, scatter, or disseminate freely. This verb helps us to shed light on an essential feature of the beauty of the woman sung by

the poets who founded Italy's lyrical and—with Dante—literary tradition. This beauty is not only intended for the beloved, the lover, or the poet, but, rather for all of humanity. While it is implicit in Lapo's use of the verb *spander*, the role played by female beauty in the salvation of humanity (beauty, as mentioned earlier, accompanied by moral values) becomes especially evident in Dante's Beatrice, who in life *doth go benignly dressed vested with humility [and] pleaseth she whoever cometh nigh*. In death, Beatrice would instead serve as the go-between for the path of purification undertaken by Dante in the *Divine Comedy* on behalf of every human being.

In short, beauty is never represented on its own, nor as an end in itself, nor as something that is exclusive to he or she who possesses it. Rather, it is always accompanied by other virtues, primarily goodness, which is functional to the achievement of a positive state, and generously—we might say democratically—accessible to anyone who comes into contact with it.

If we momentarily set female beauty aside, the same can be said for every other type of beauty—be it of a landscape, a flower, a city, a building, a painting, a poem and—why not—a judicial system, a mathematical formula, a government system, a scientific study, but also of a dance troupe, and even the statuary performances of a great dancer: their beauty has a moral, social, educational and civic function as well.

This is the reason why the most beautiful manifestations of nature and culture on the planet are declared "heritage"—because it is believed that through the moral and civil values they express, humanity will be able to build a better, more just world—one that is finally at peace. (Unfortunately, we are afforded proof of the moral and not merely celebratory nature of UNESCO's efforts when they are attacked by the forces of hatred and opposition, such as the voluntary destruction of the monumental Buddha statues of Bamiyan by the Taliban militia in March 2001).

Roberto Bolle's performances, set in Italy's most beautiful and evocative locations, are a way of combining two complementary beauties—the harmonious gestures by the sculpted body of this *étoile* from La Scala Theatre Ballet, and the ecstatic vision of some of the most beautiful places in the country.

But, one might object, why then is Italy—the most beautiful country in the world, at least based on the record it holds, with 50 sites included on UNESCO's World Heritage List—in a situation of such great difficulty and social injustice

today? How is it possible that this veritable "immersion" in beauty which distinguishes the life of most Italians from the day they were born—not just from Venice to Palermo, or other cities on the Grand Tour such as Florence, Rome, and Naples, but also from the Valley of the Temples in Agrigento to the Boboli Gardens in Florence), cannot be automatically translated into opportunities, well-being, and social harmony?

The answer is quite simple and also rather bitter: because Italy has stopped safeguarding its own beauty—and perhaps even worse—it has stopped creating new beauty. The ravaging of the landscape and structure of our cities, constant cuts in conservation spending, and a lack of incentives for cultural and creative industries, have had a much more devastating effect than the "mere" economic and employment crisis that the country is facing. It has made us question our identity, our capacity—to paraphrase Dostoevsky in *Notes from Underground*—to be saved.

By combining the theme of beauty with the equally important theme of education, this collection of images of Roberto Bolle performing in beautiful Italian sites, consecrated by both UNESCO and by universal admiration, is included among the initiatives aimed at safeguarding and promoting the beauty of Italy. The images in this book exude an awe-inspiring harmony that is "pre-established" amid the fantastic musical leaps by the famous Piedmontese dancer and the aesthetics of the locations in which he performs. It is almost as if we can hear the notes of the symphonies that have accompanied his great artistry in the places portrayed in this album of exceptional beauty.

This is how beauty becomes didactically good, that is, its worth goes well beyond fleeting or momentary enchantment, as was so greatly desired by the Ancient Greeks.

GIOVANNI PUGLISI
President of the Italian National Commission for UNESCO

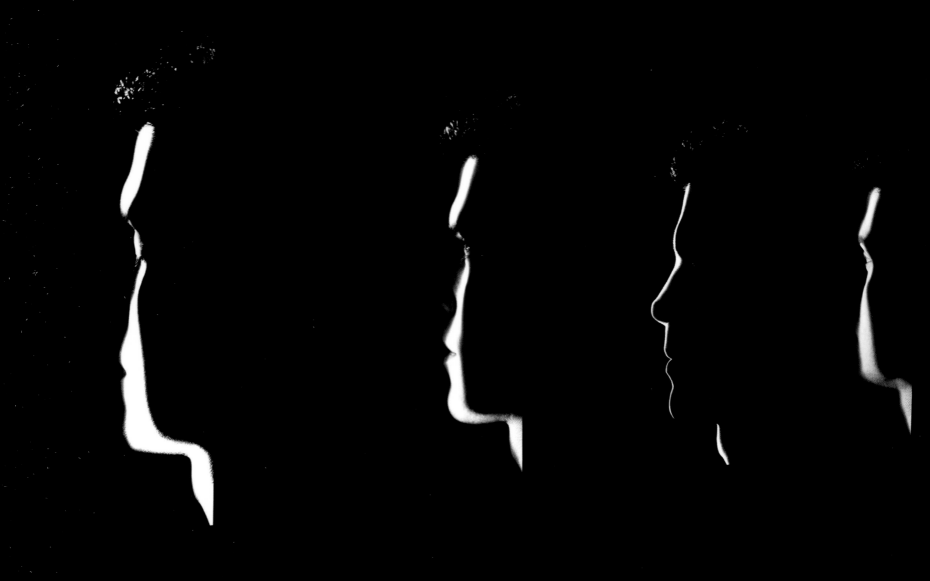

"THERE IS NO SUCH THING AS NO MOVEMENT SOMETIMES WHEN WE ARE VERY STILL WE BECOME MORE AWARE OF MOVEMENT THAN WHEN WE MOVE OUTWARDLY" MARTHA GRAHAM

THE SIMPLEST THING IS ALWAYS THE MOST DIFFICULT TO DO. ROBERTO BOLLE IS UNIQUE IN THAT HE UNDERSTANDS STILLNESS, WHICH IS REMARKABLE FOR A CLASSICAL BALLET DANCER. THERE IS ALWAYS AN INTERIOR MOVEMENT. THE INNER SENSE OF MOVEMENT CONTINUES THE LINE. IN 2010 I MADE 36 VIDEO PORTRAITS OF ROBERTO ON HIGH DEFINITION LIFE-SIZE FLAT SCREENS. IN ALMOST ALL OF THE PORTRAITS THERE IS MINIMAL MOVEMENT; A VERY DIFFICULT TASK FOR ANY ARTIST TO PERFORM. YET ROBERTO IS NEVER A STATUE. THERE IS ALWAYS A MYSTERY. A SPECIAL LIGHT IN WHICH WE SEE AN ELEGANT DANCER'S VULNERABILITY. WHEN ROBERTO PERFORMS, HIS MOVEMENTS LOOK EFFORTLESS HE NEVER PUSHES TOO HARD. IN HIS STILLNESS, ONE FEELS ALL KINDS OF EMOTION: LOVE PASSION, DESPERATION AND JOY. HE IS BLESSED WITH AN INHERENT NOBLE BEARING. HAVING WATCHED ROBERTO PERFORM, ONE IS DRAWN TO HIS MODEST DEMEANOR AS WELL AS HIS VIRTUOSO ABILITIES AS A DANCER, WITH AN ELEGANT, REFINED TECHNIQUE. THROUGH THE YEARS I HAVE GOTTEN TO KNOW ROBERTO AND RESPECT HIM NOT ONLY AS A GREAT DANCER, BUT AS A COMPASSIONATE MAN WHO SPEAKS FOR HUMAN RIGHTS AND SOCIAL CAUSES IN SUPPORT OF PEOPLE LESS FORTUNATE THAN HIMSELF, HE HAS BEEN A UNICEF GOODWILL AMBASSADOR RAISING AWARENESS AND FUNDS FOR SUDAN IN PARTICULAR. HE IS A NATIONAL HERO! A GATEKEEPER OF ITALIAN CULTURE.

Robert Wilson

Dance is both form and content, living sculpture,
and corporeal matter that translates a universal aesthetic ideal into gesture.

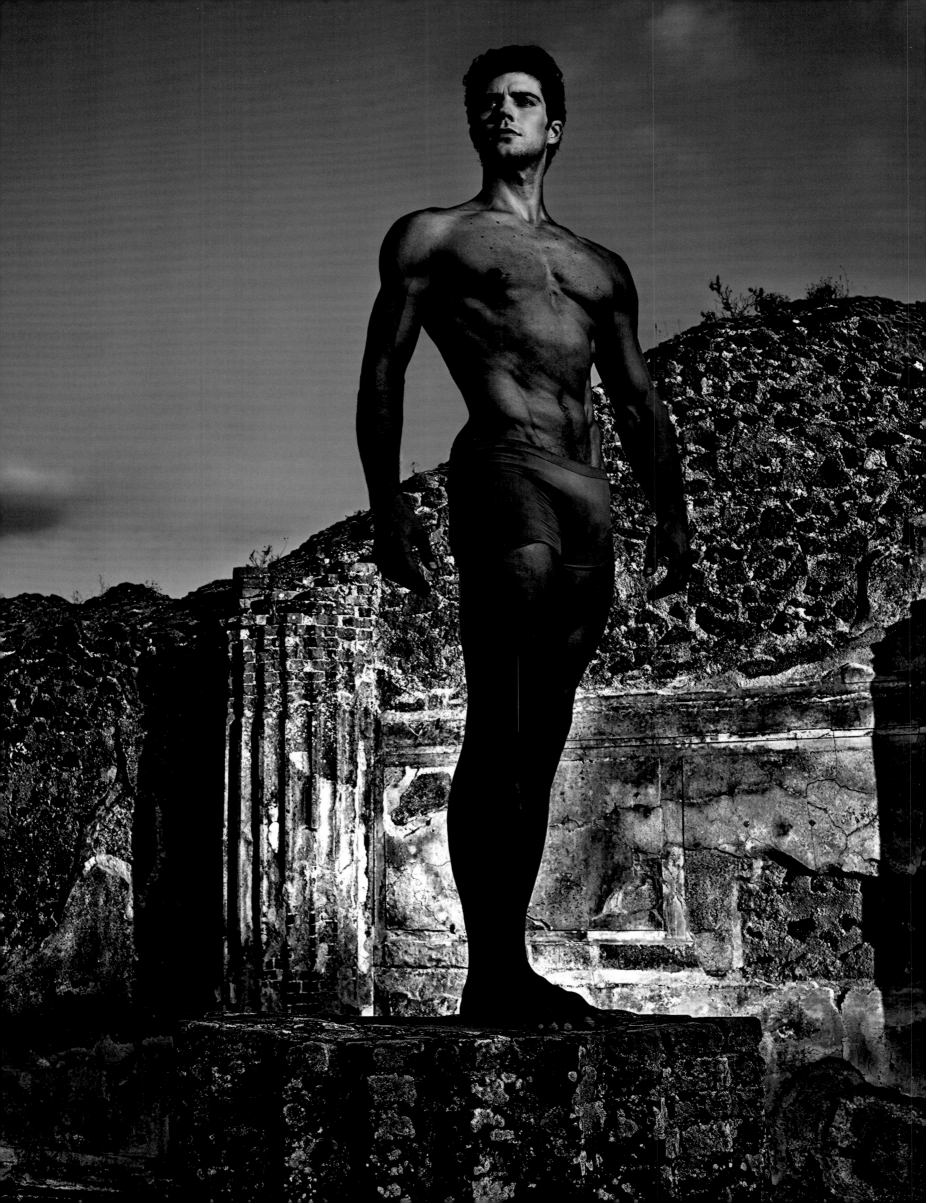

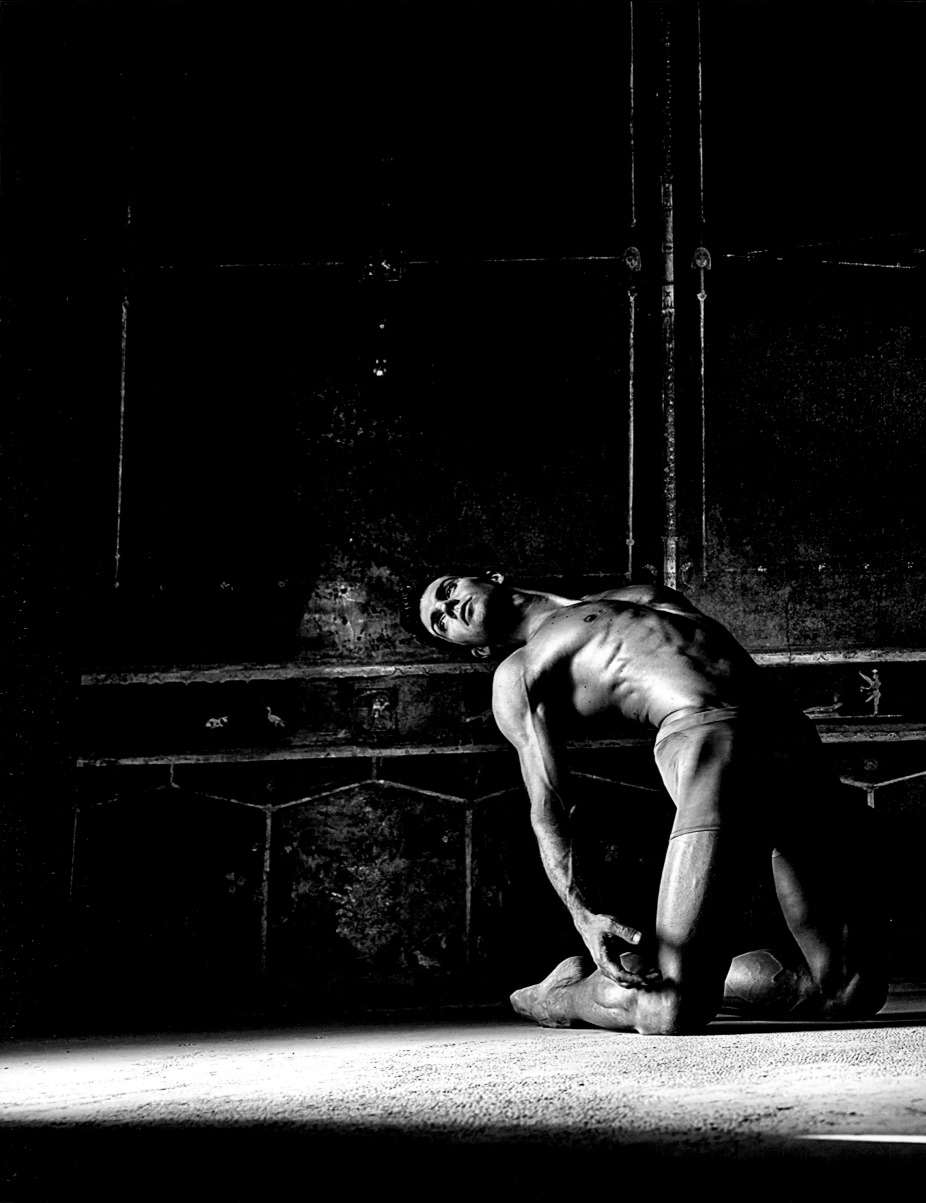

Past, present, future. Historical ebbs and flows.
The cycle of time flows in a single theater.
We are the characters of the same performance,
a human comedy that, if unheeded, can turn into tragedy.

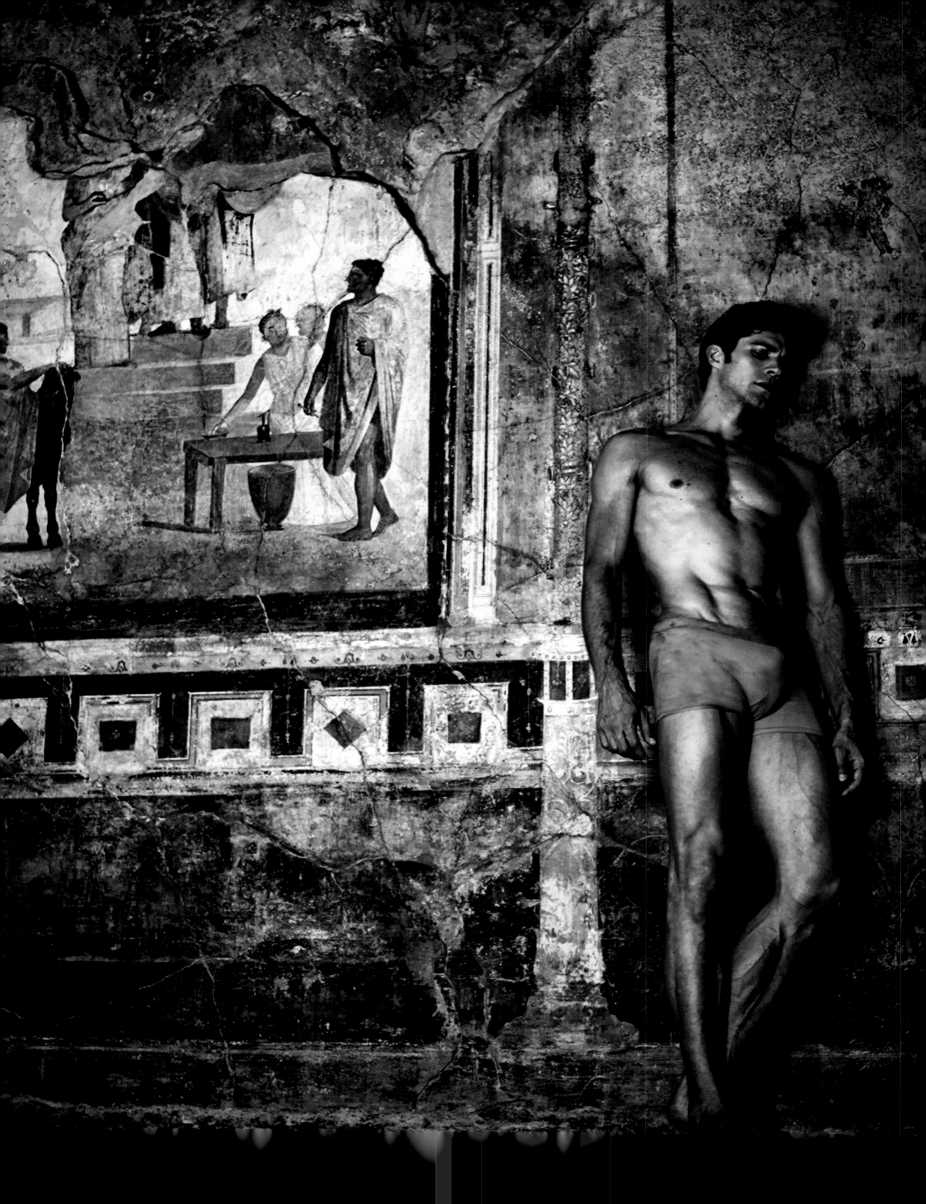

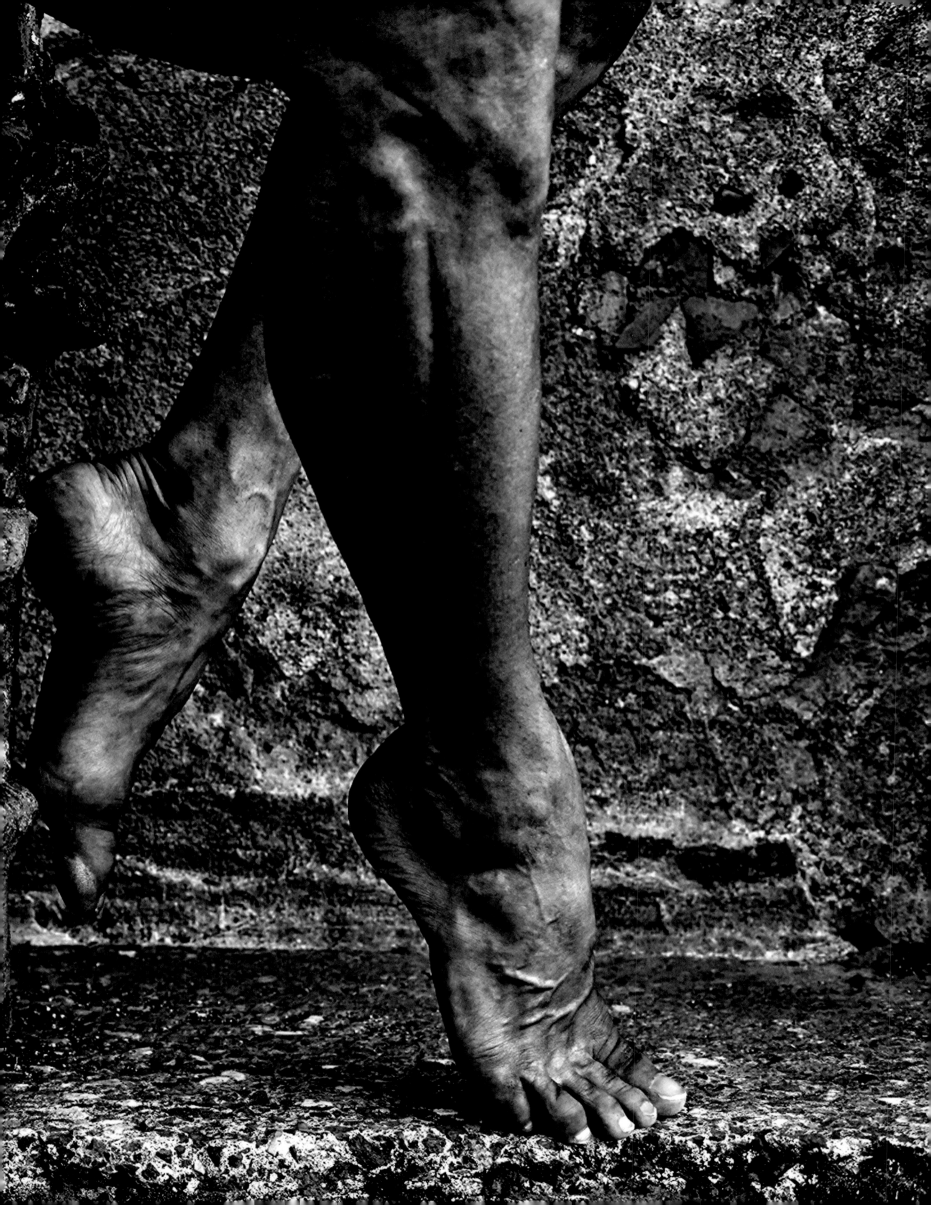

In Pompeii, buried by the ash and stones of Mount Vesuvius, nature reminds us that not even a great civilization can dominate it. It is a lesson in humility that stirs the chords of our deepest feelings.

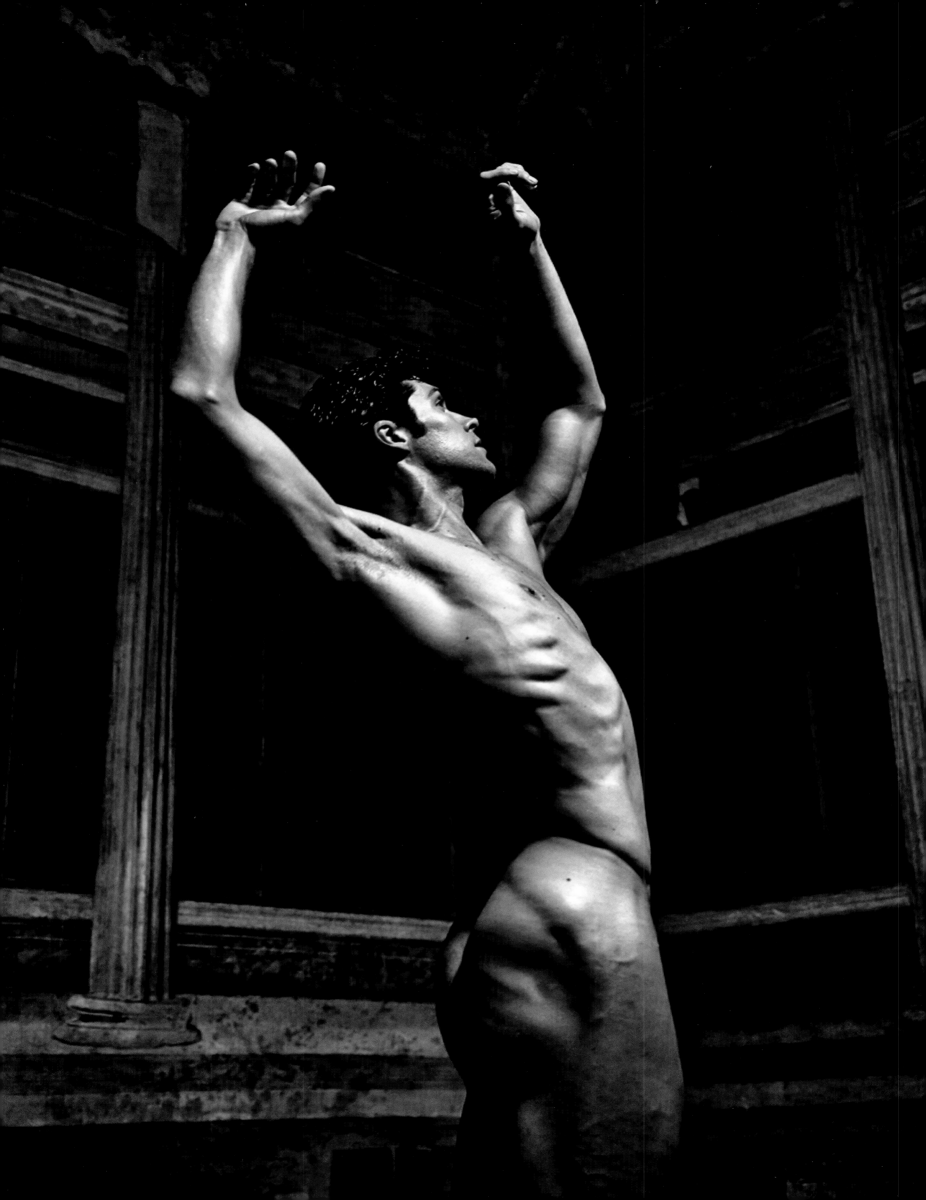

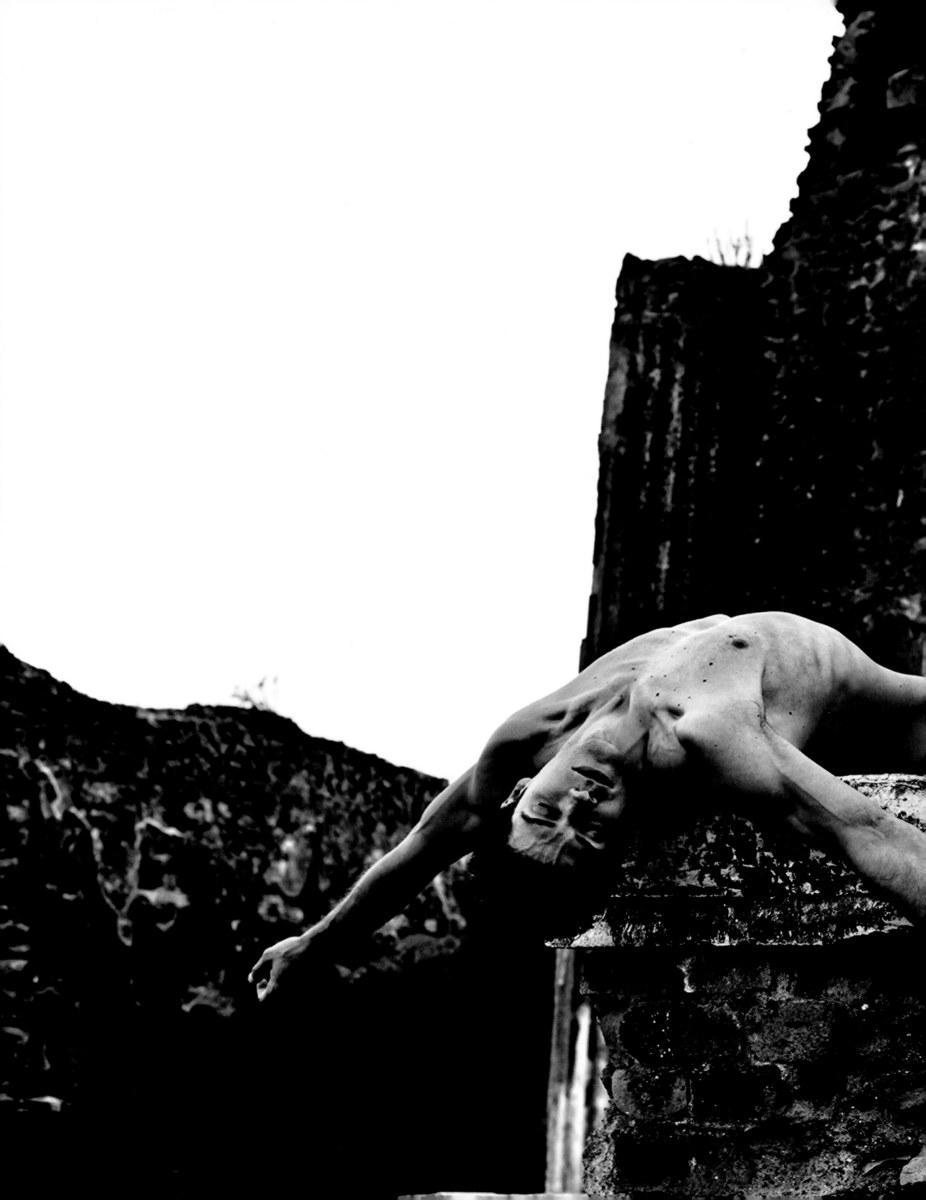

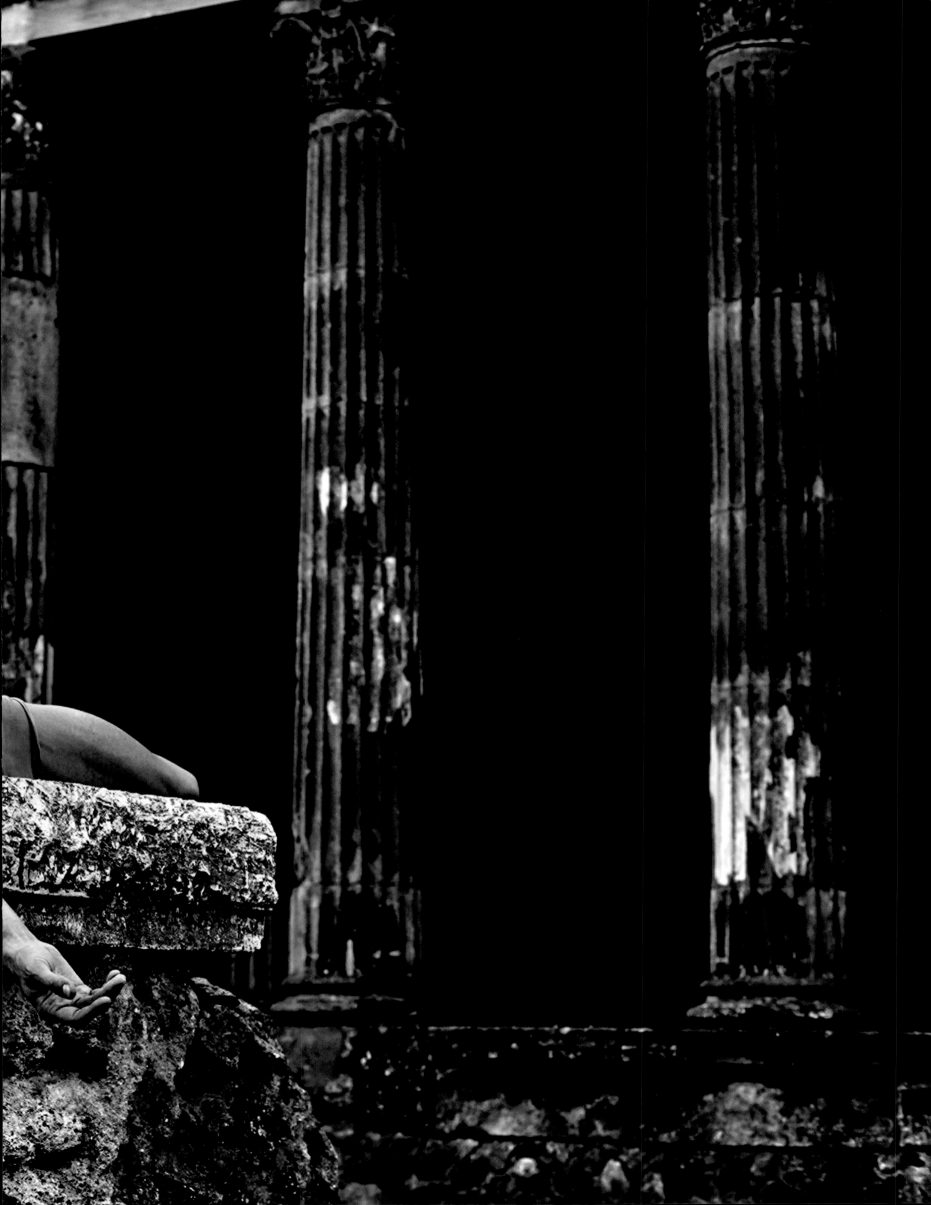

Amidst these chipped walls,
surrounded by the frescoes of our ancestors, history
is stratified and speaks to us of our glorious past.

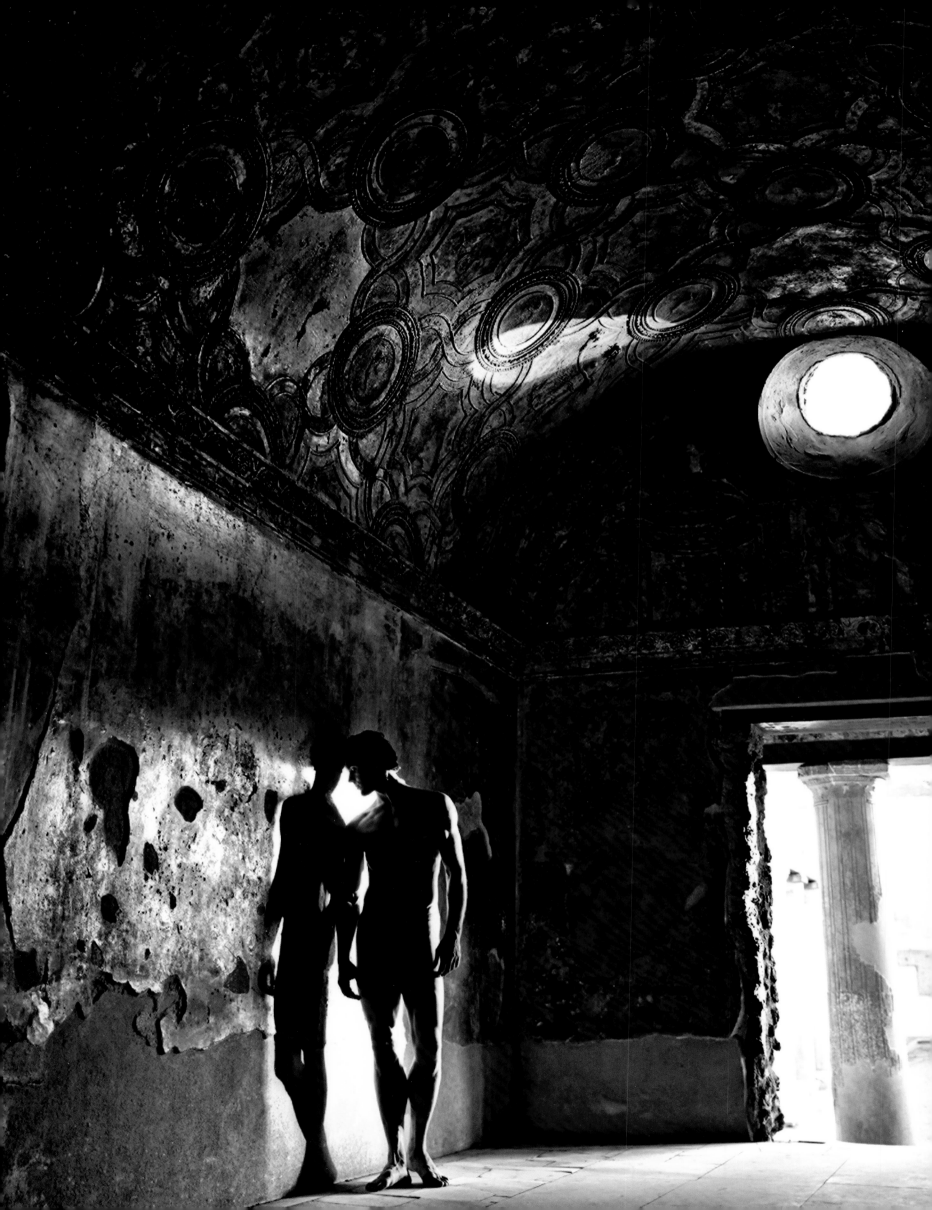

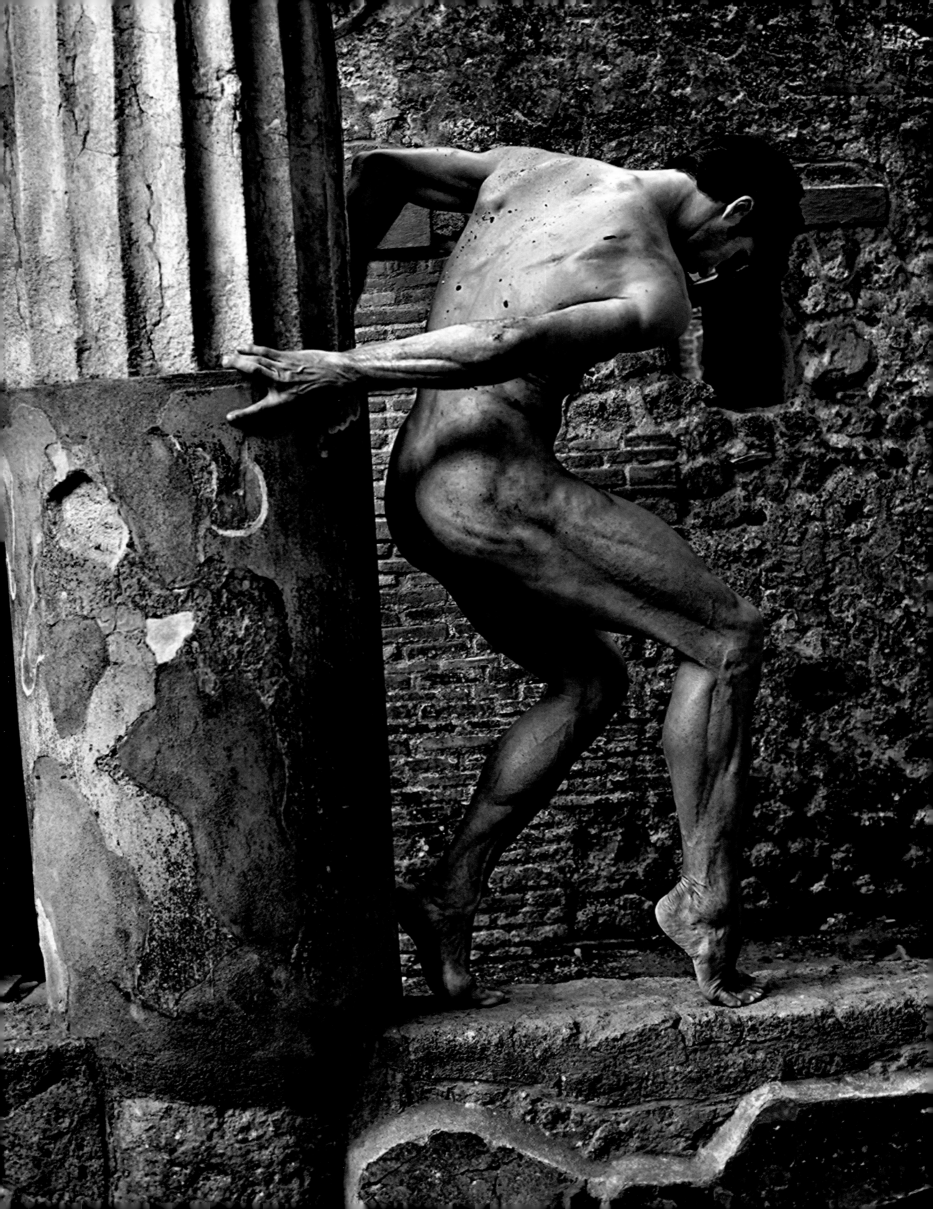

Art nurtures history.
We are heirs to the greatness of those who came before us,
a challenge that encourages us to rise again from our ruins.
A sign of pride is all we need.

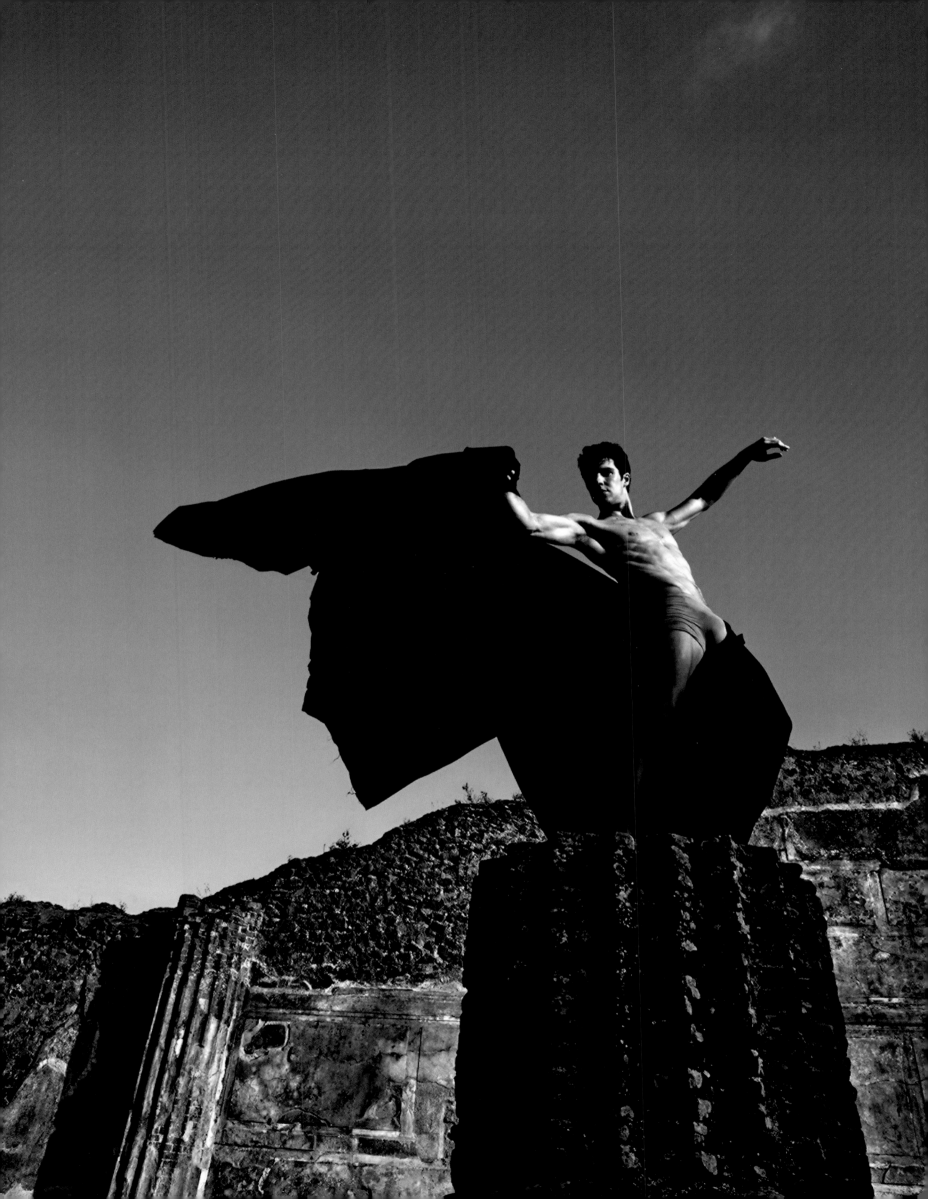

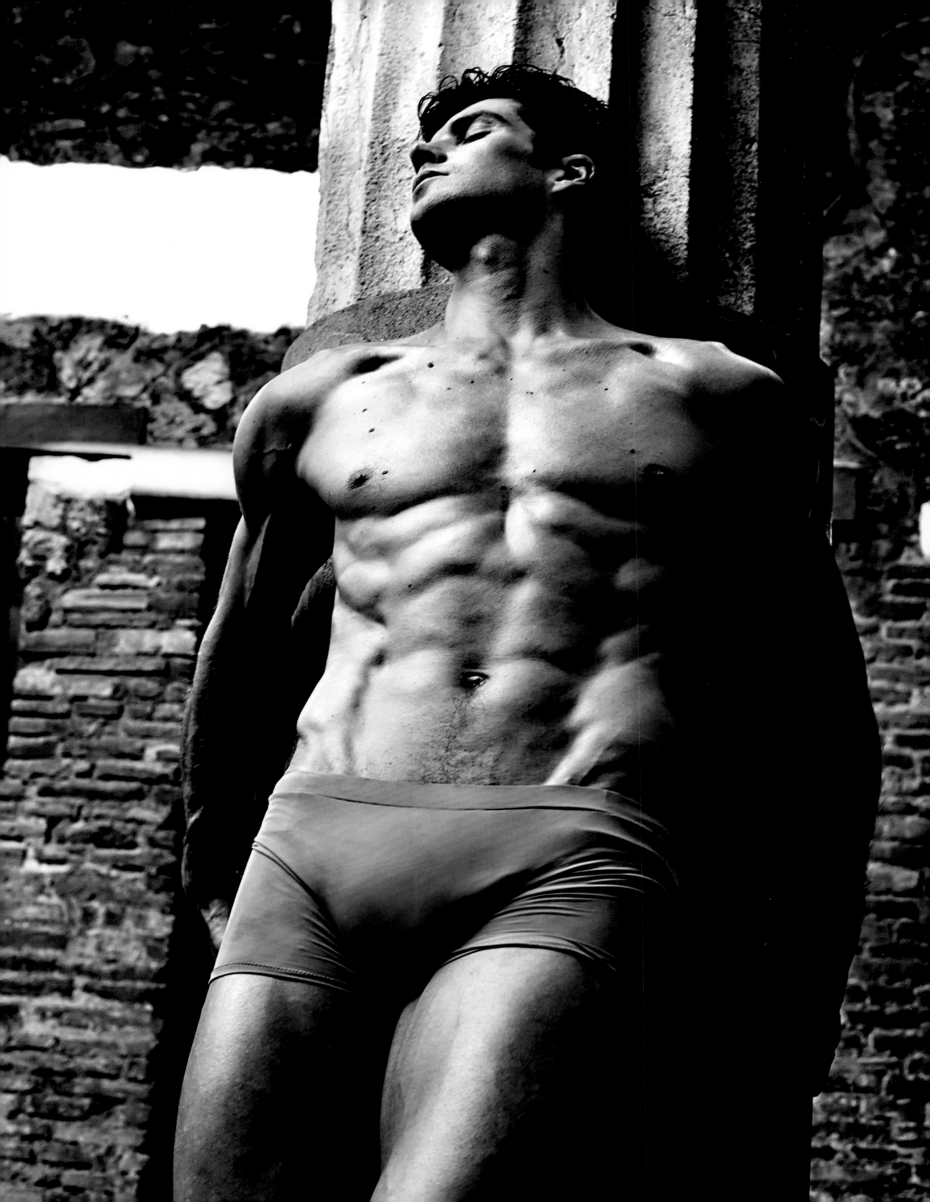

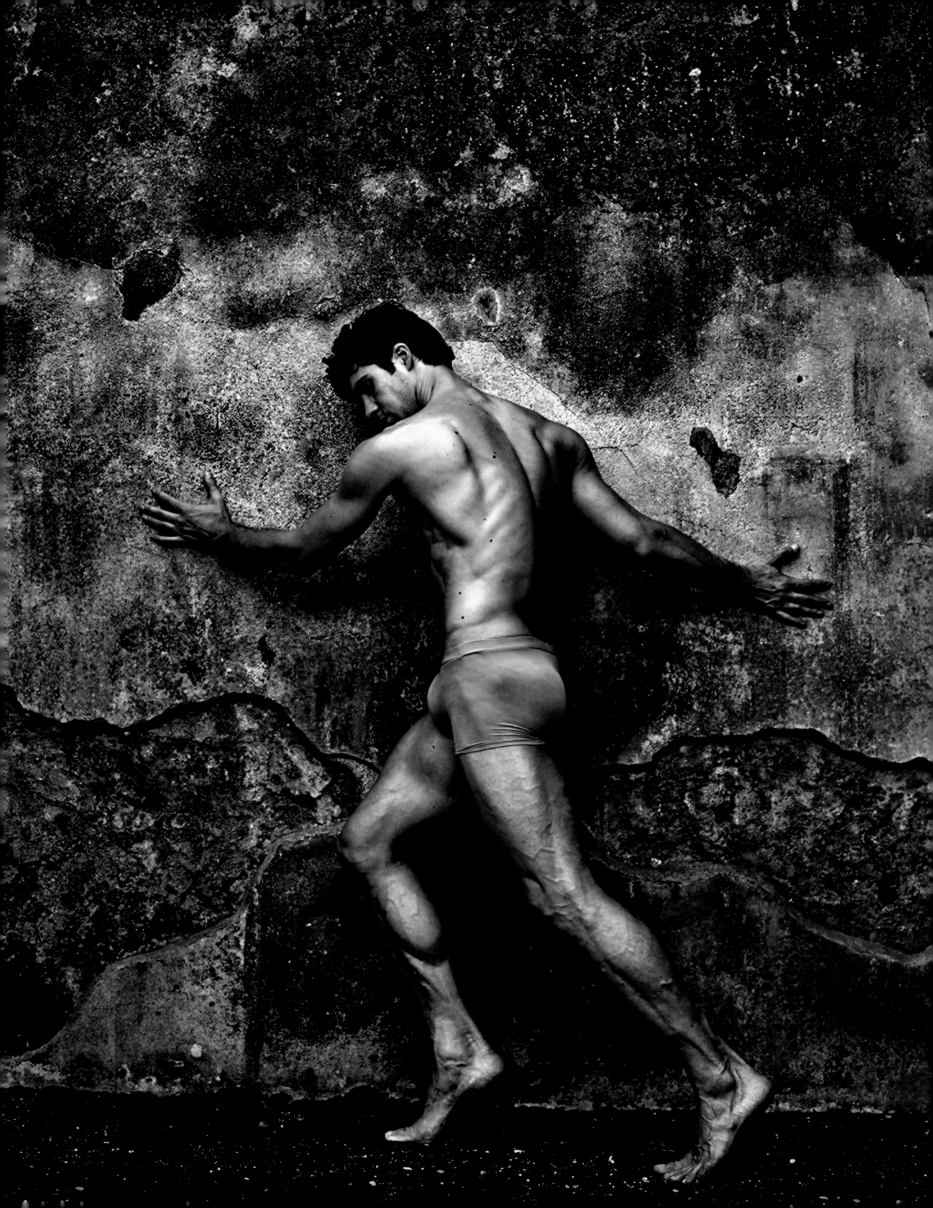

Pompeii is an open wound in the midst of beauty.
It is up to us to treat and care for it.

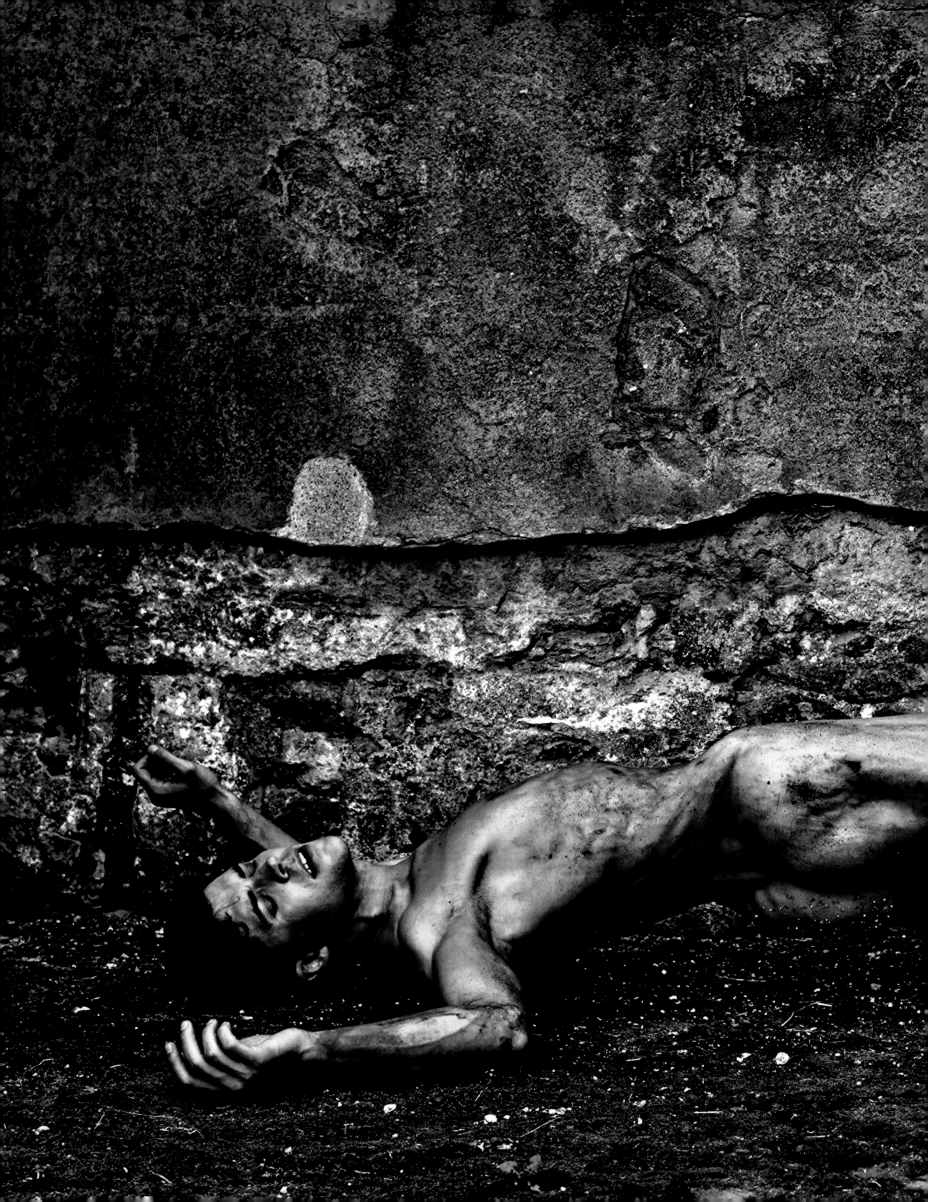

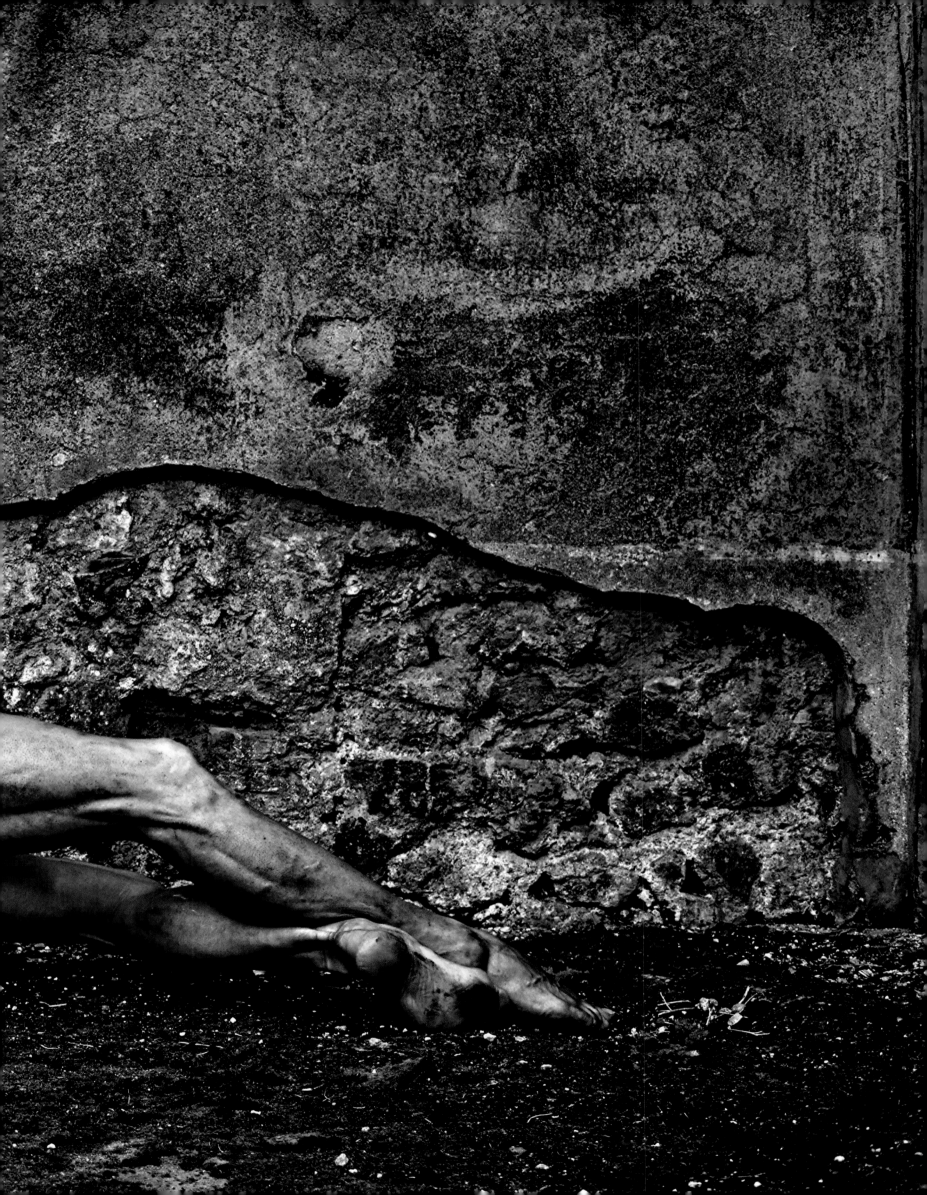

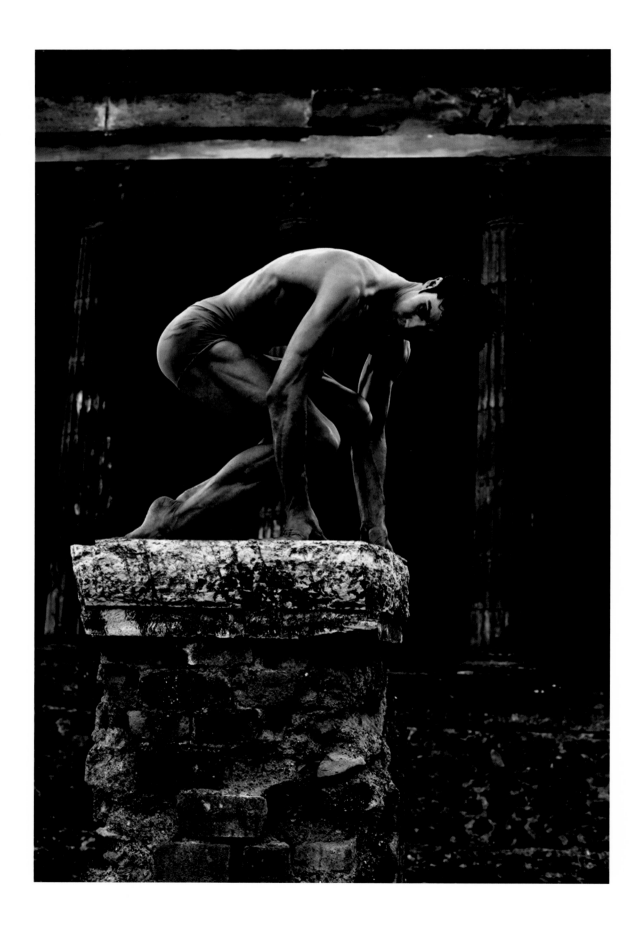

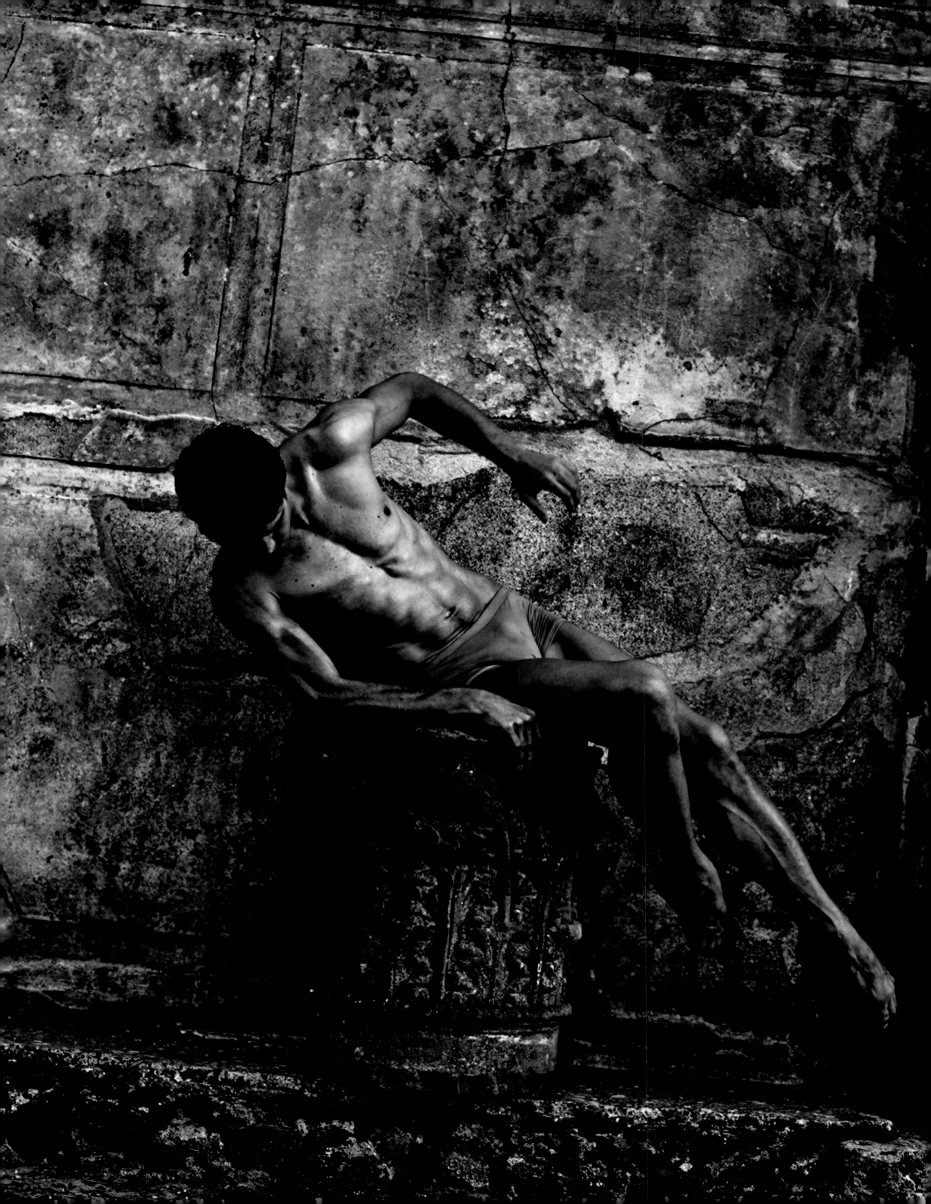

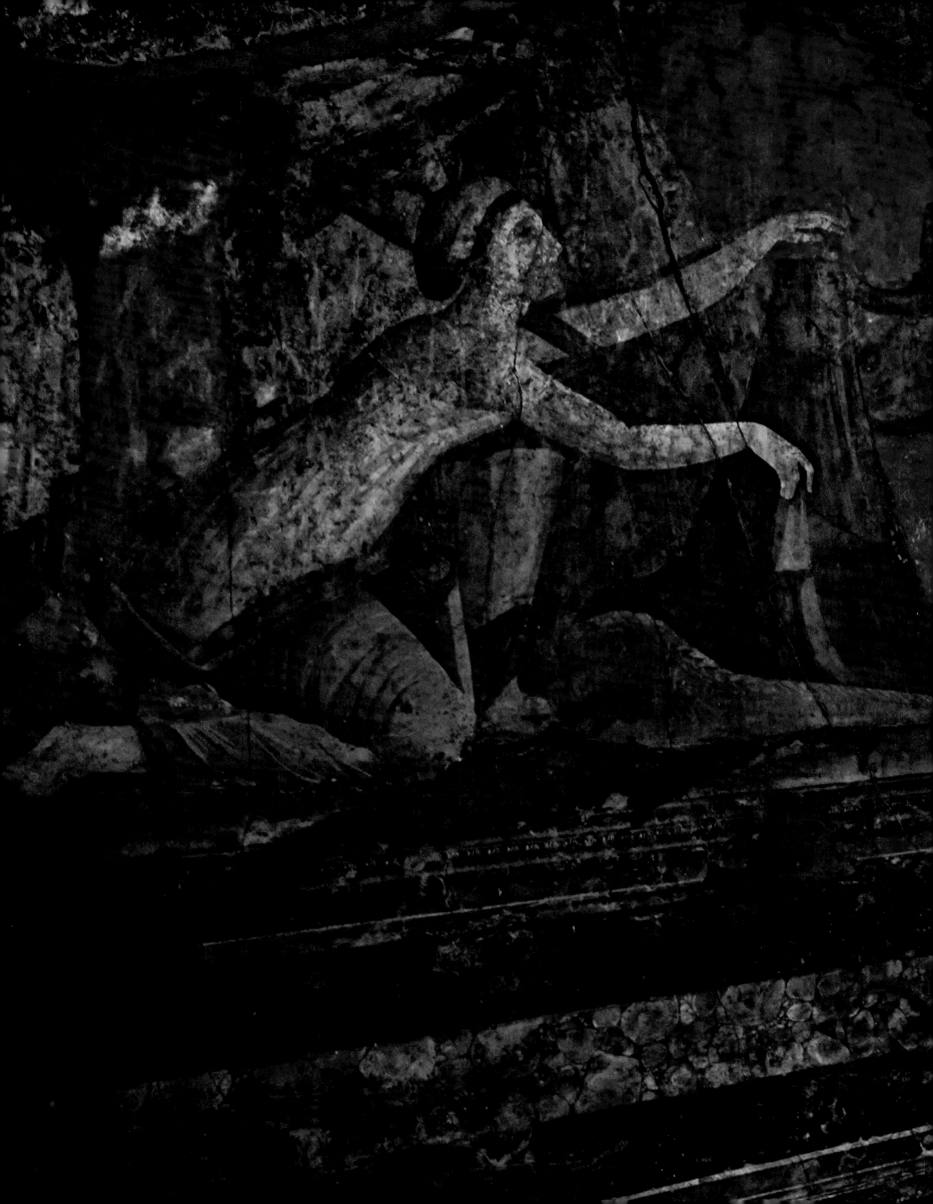

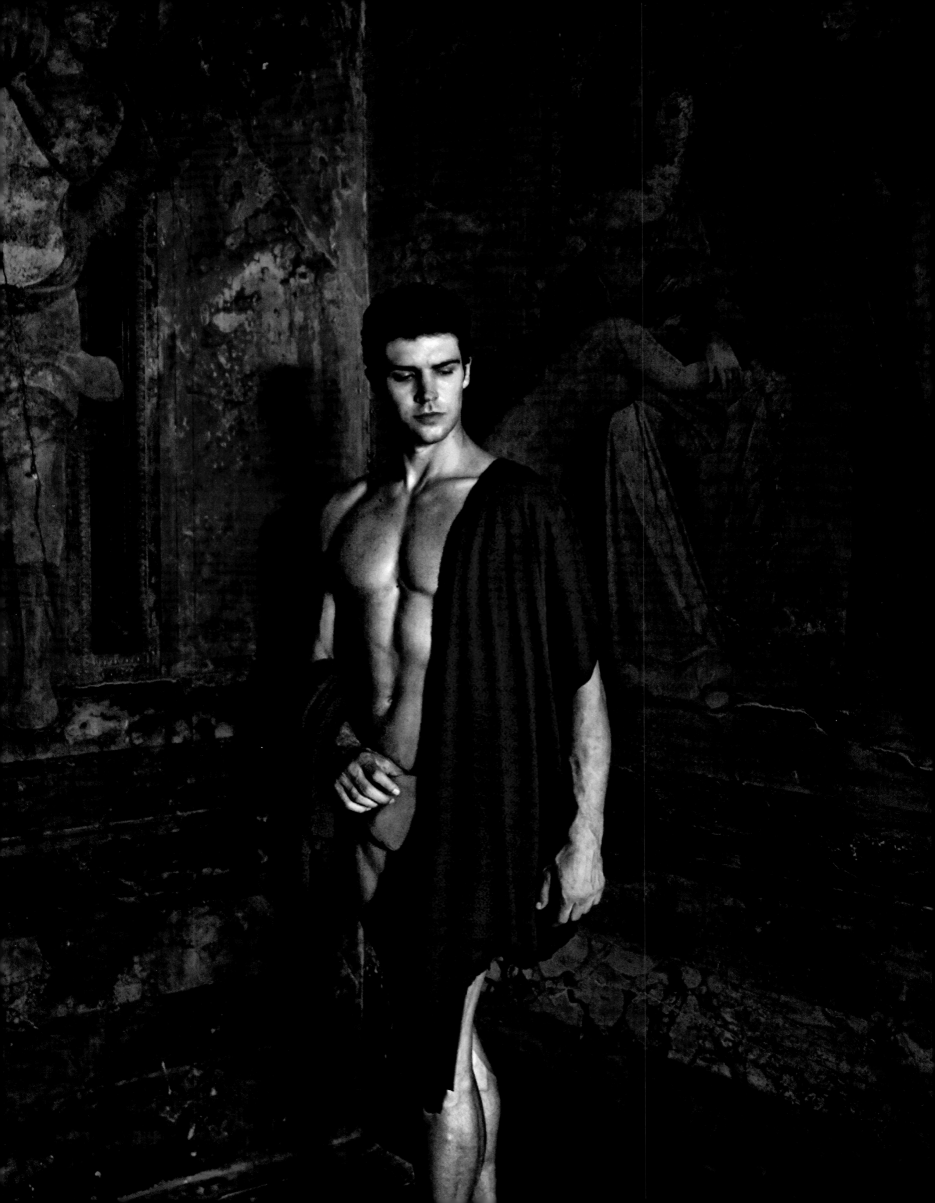

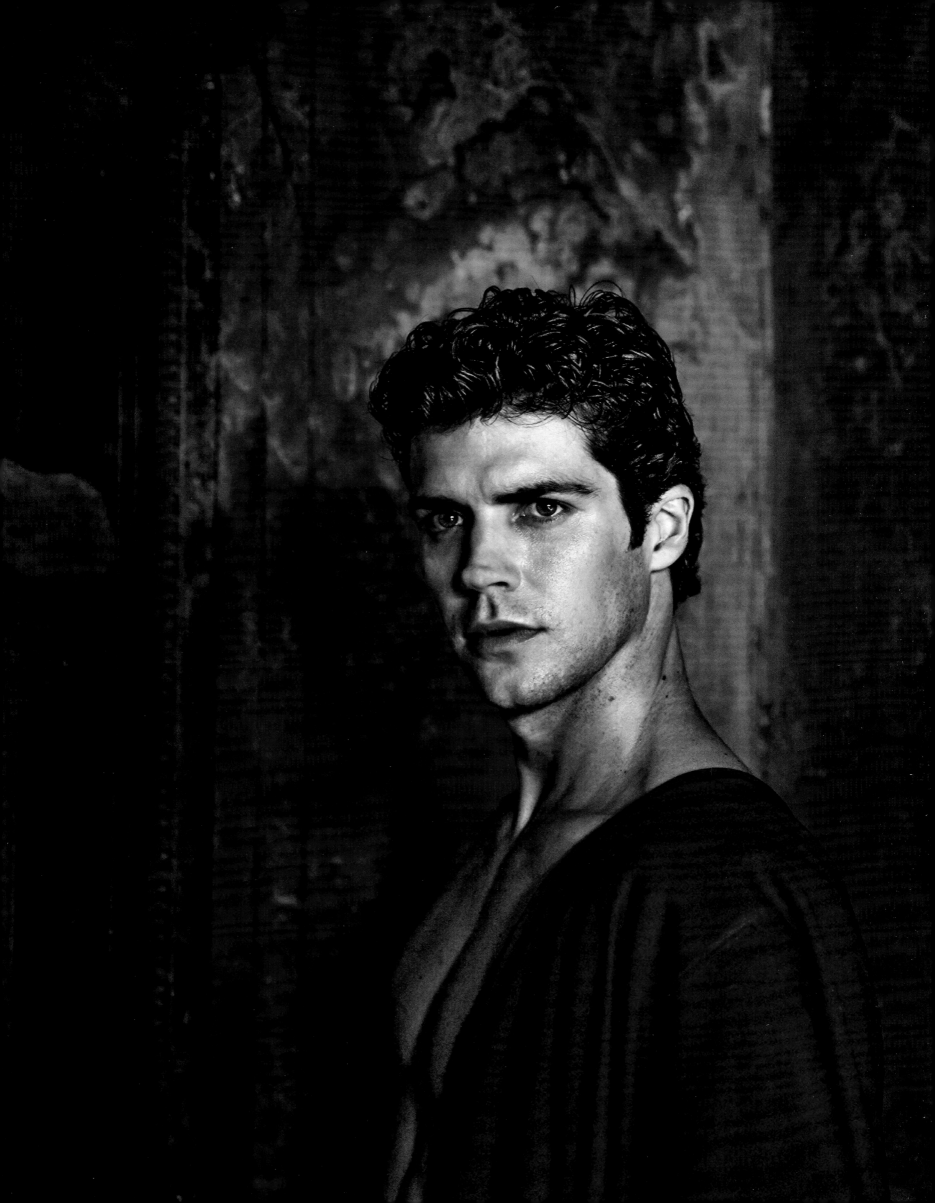

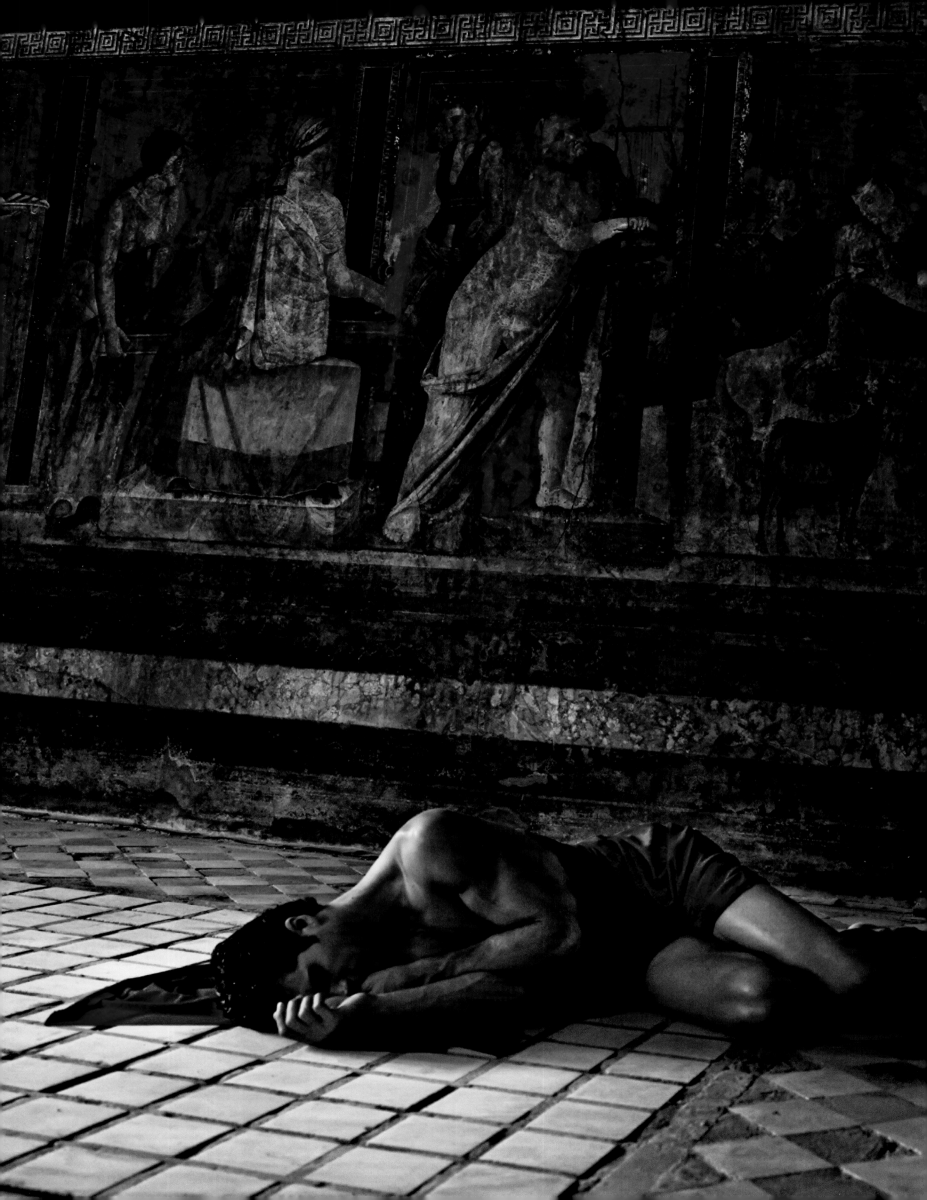

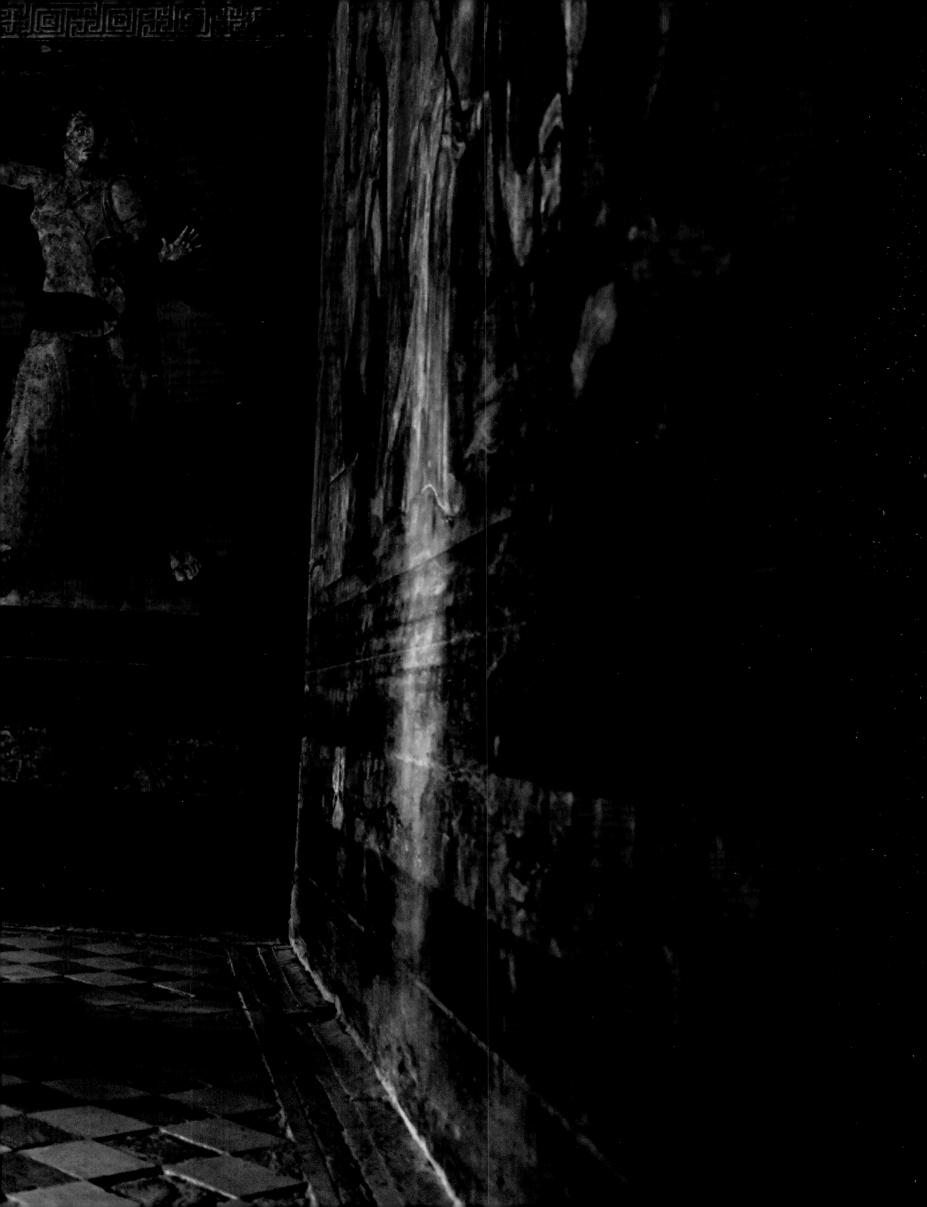

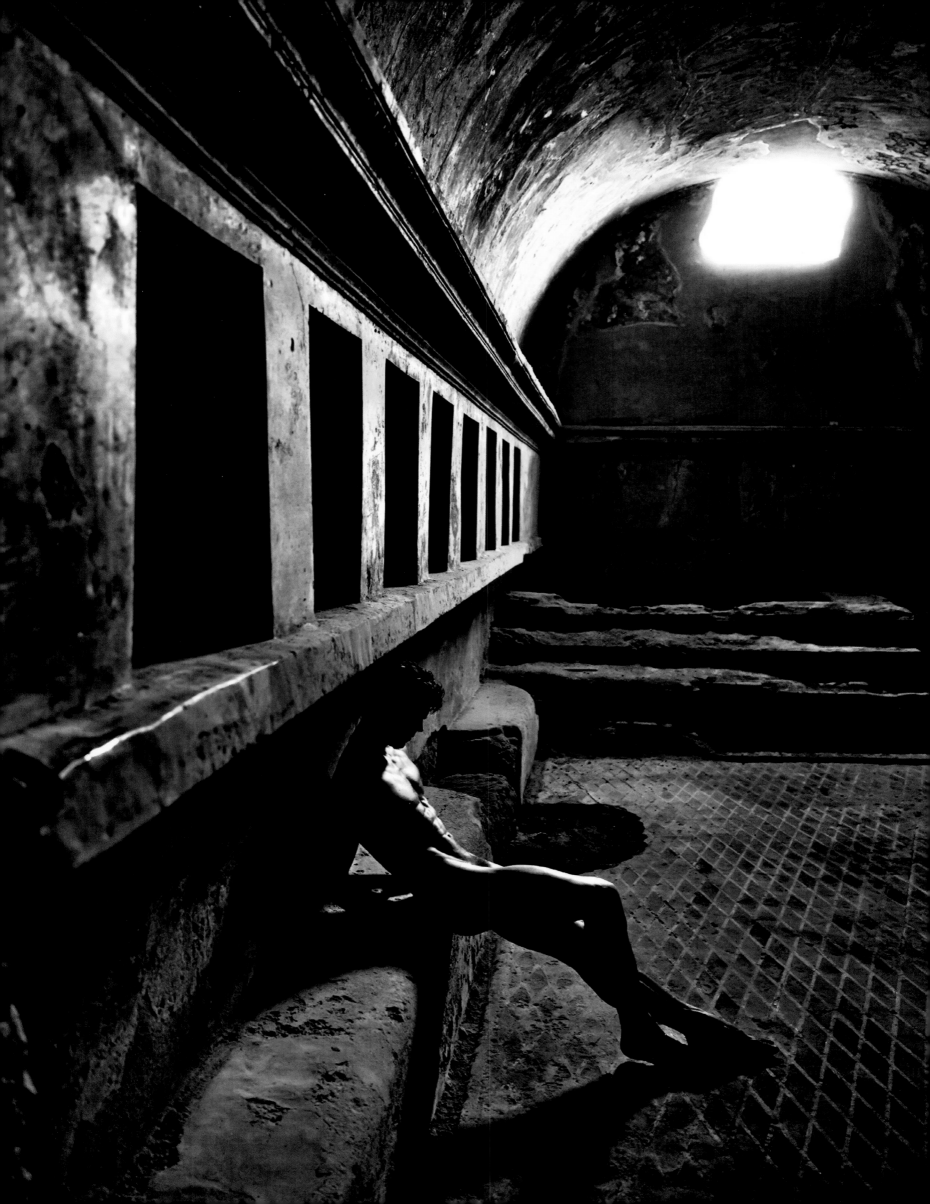

Dance is introspective, it goes deep into the soul.
Beauty inhabits the body, giving it invisible wings.

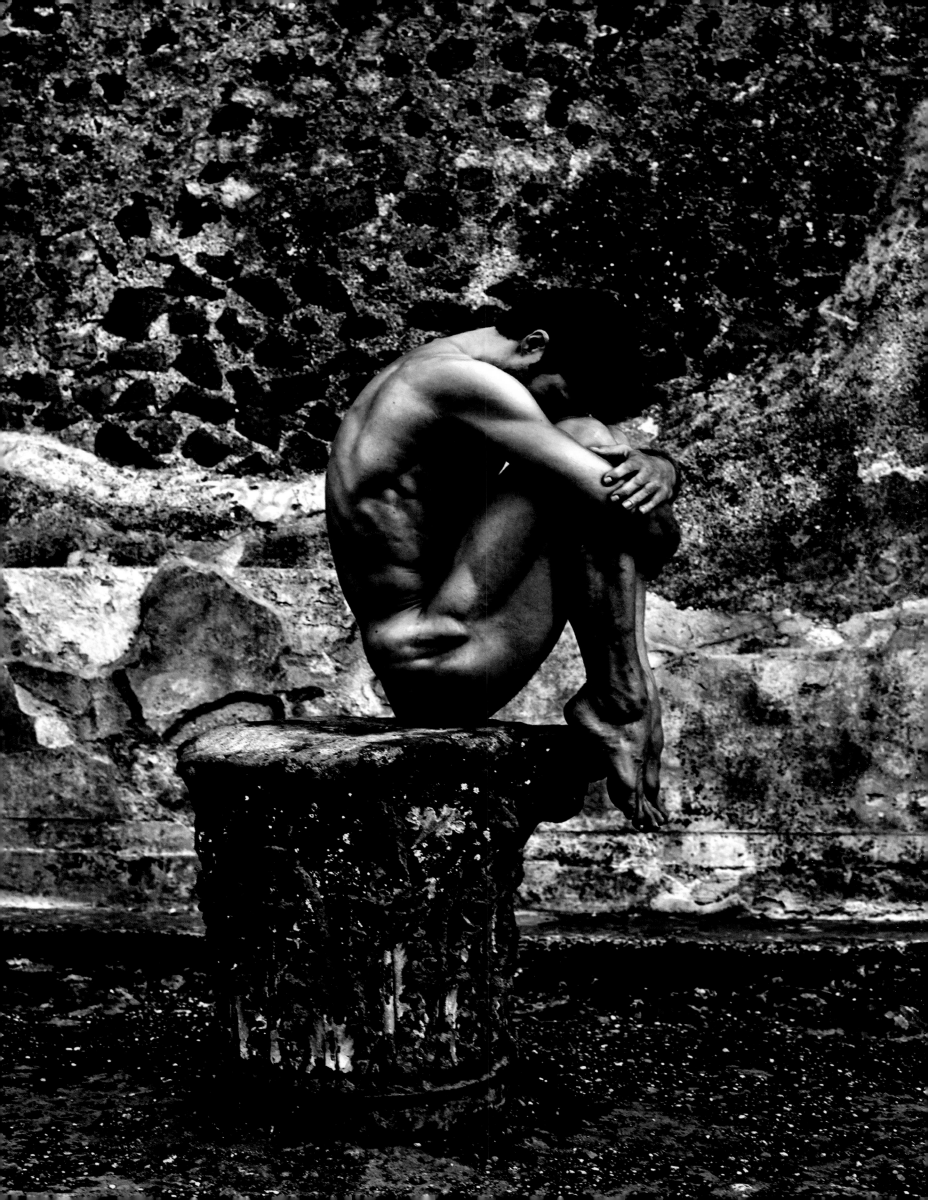

Why Pompeii? It was the first affront to the art of the Bel Paese (inflicted by the lava that flowed from Mount Vesuvius in 79 AD, and further aggravated by human negligence), the violated face of Italian beauty, an irreparable disgrace exposed to the eyes of tourists, the disheartened pride of the greatness that once was. Fabrizio Ferri's photographic lens has dwelled upon the essence of this original sin in the folds of a material duet between Roberto Bolle's sculpted body and the crumbling surfaces of Roman frescoes. In this exchange of substances, art becomes body, the body is transformed into sculpture, and stone melts into flesh—an alchemical ritual celebrated by Ferri's aesthetic sensibility. It is a metaphysical journey that wedges its way into the mystery of creativity, amidst mutilated Corinthian capitals and underground dew.

The real physical journey begins with Luciano Romano's images and with the artistic adventure of Bolle out to conquer sacred sites across Italy, masterpieces admired by the world which UNESCO has chosen to safeguard, taking them under its protective wing. It is a unique testimony, developed by Romano over years of impassioned research, which captures, in the ideal synthesis between movement, space, and time, Bolle's expressive potential in that fleeting moment when a step, a gesture, or an explosive leap reach a climax and pierce the spectator's gaze, remaining indelibly etched in their memory. The instant when the dance is crystallized evokes the movement that precedes each single frame and suggests what follows, for an incessant, virtually endless flow, in which the echo of the music and the design of the choreography vibrate in unison. Lastly, these "travel notes" which accompany the images unveil the emotional resonance of Bolle's solitary course, a pioneer in the art of taking on places where dance is not usually seen, while mesmerizing audiences, enraptured by beauty, classical art, and ballet all at once. The harmonious power of the star, on stage with his friends, is steeped in the courtly context that surrounds this power, the mastery of the great choreographies exalted by the spirit of wonderful, unique and irreplaceable architecture, the entangled impressions of our sublime past.

Valeria Crippa

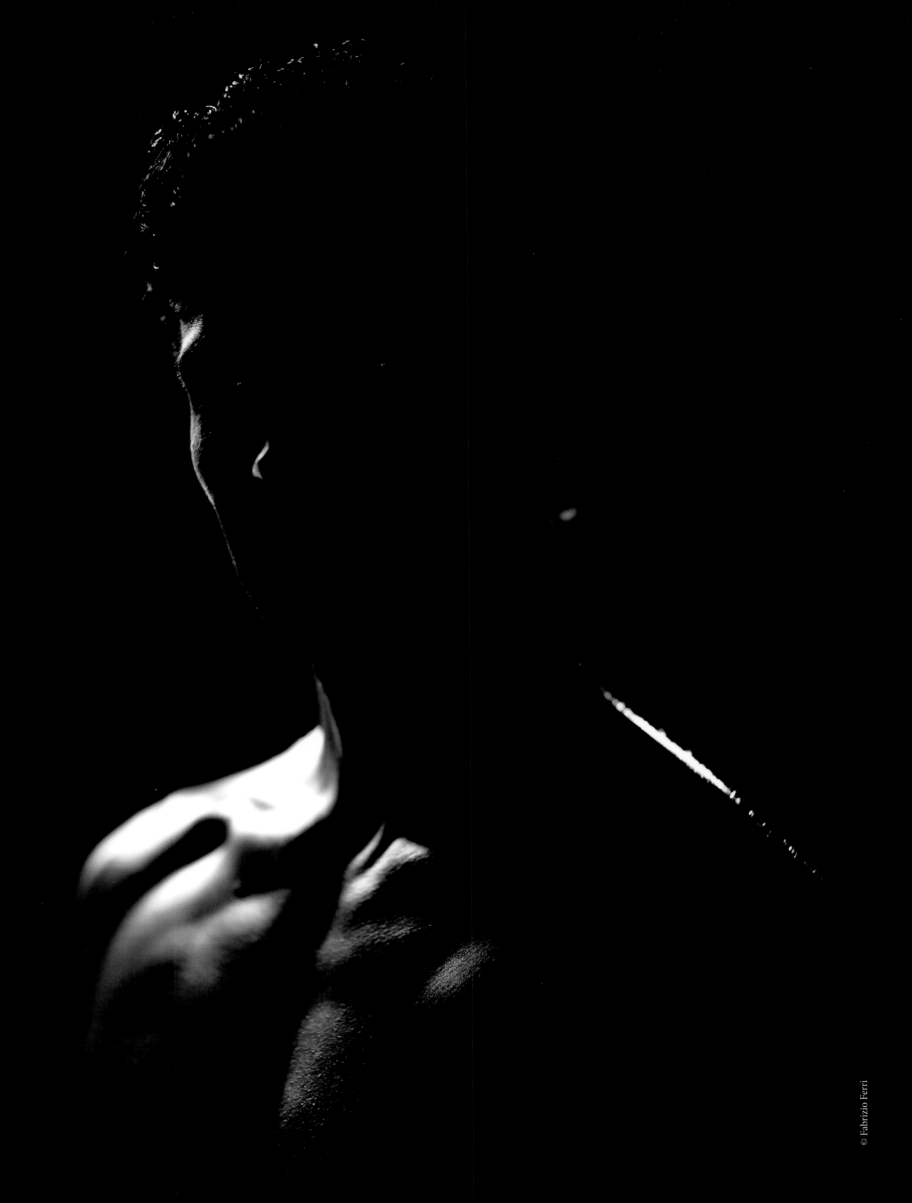

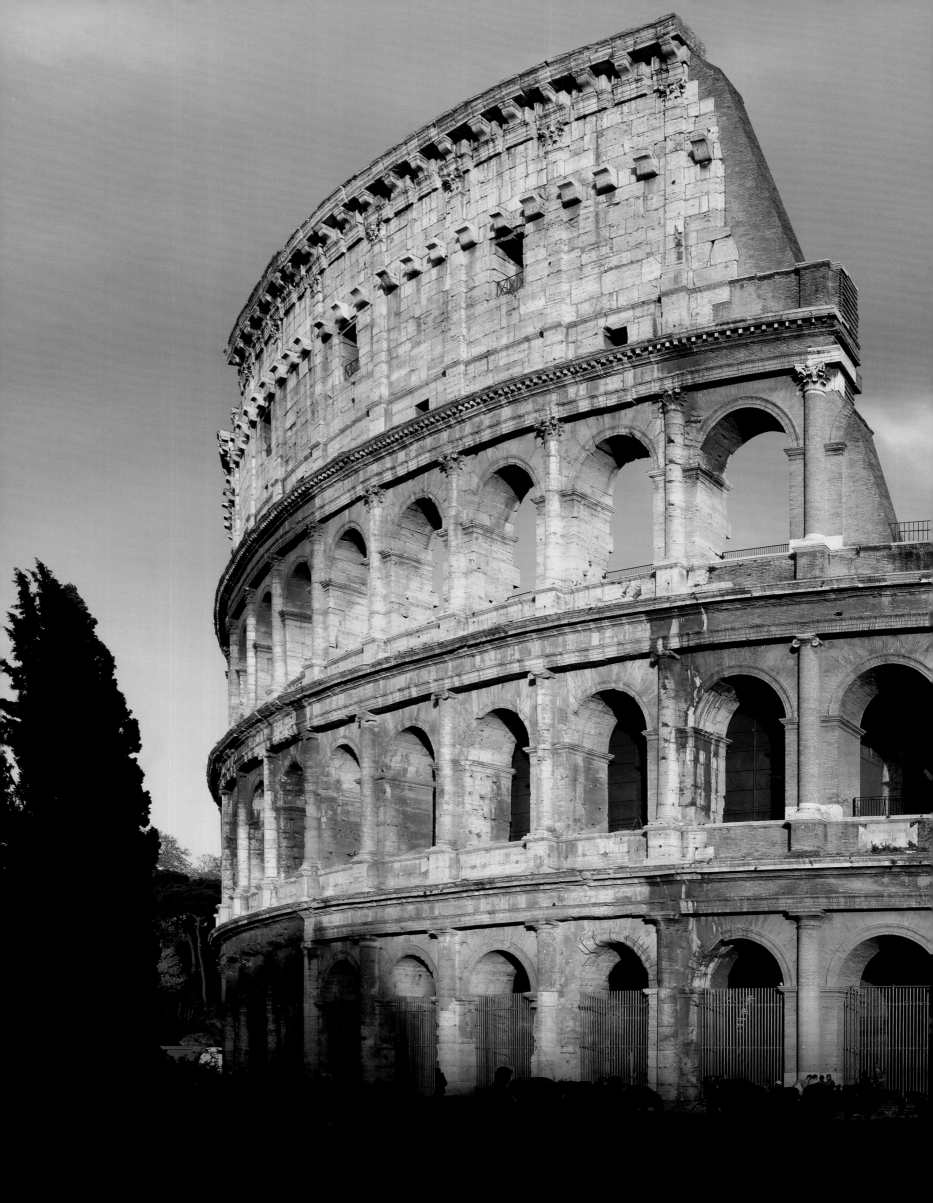

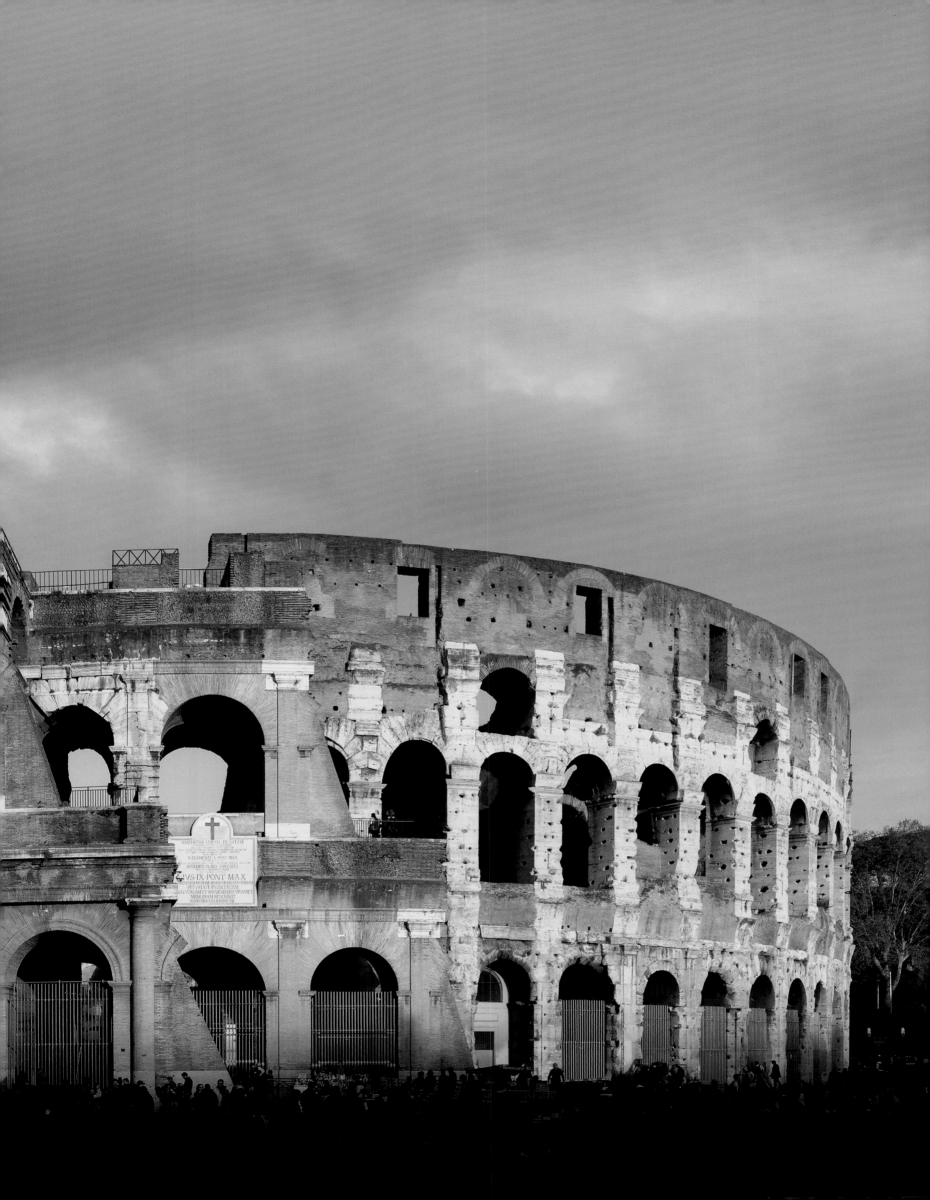

Photo by Luciano Romano

The Colosseum still resounds with the echo
of gladiators' battles in the arena and the courage of their broken
lives. That intense energy takes possession of the dance and
suggests new frontiers to be overcome.

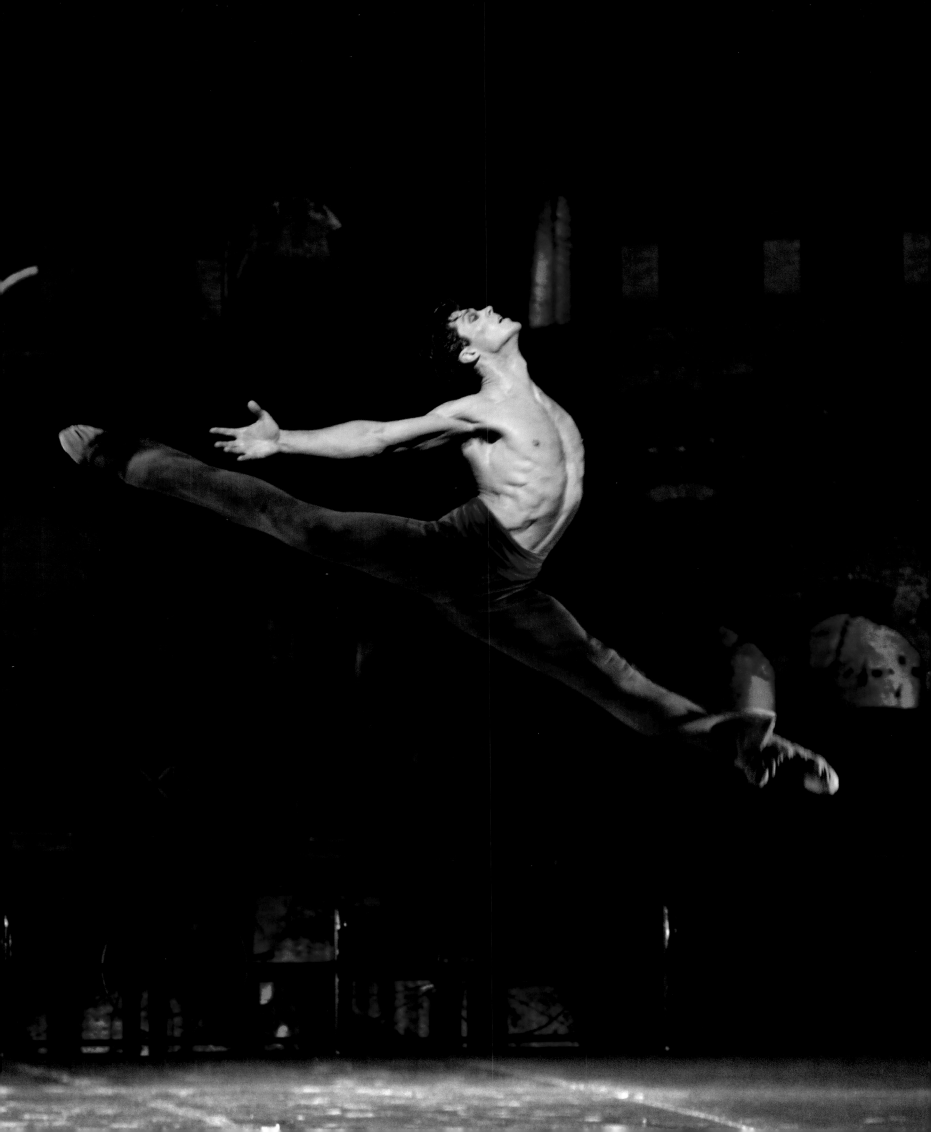

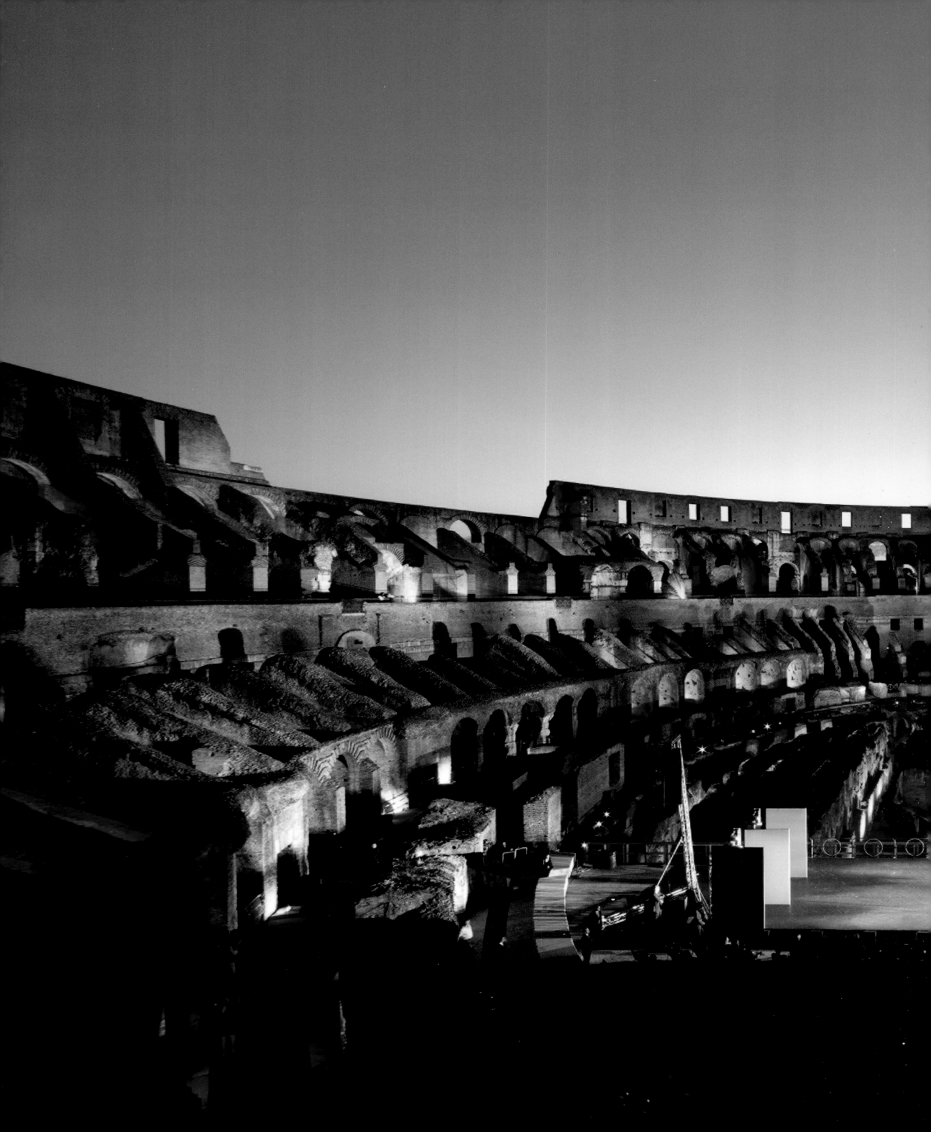

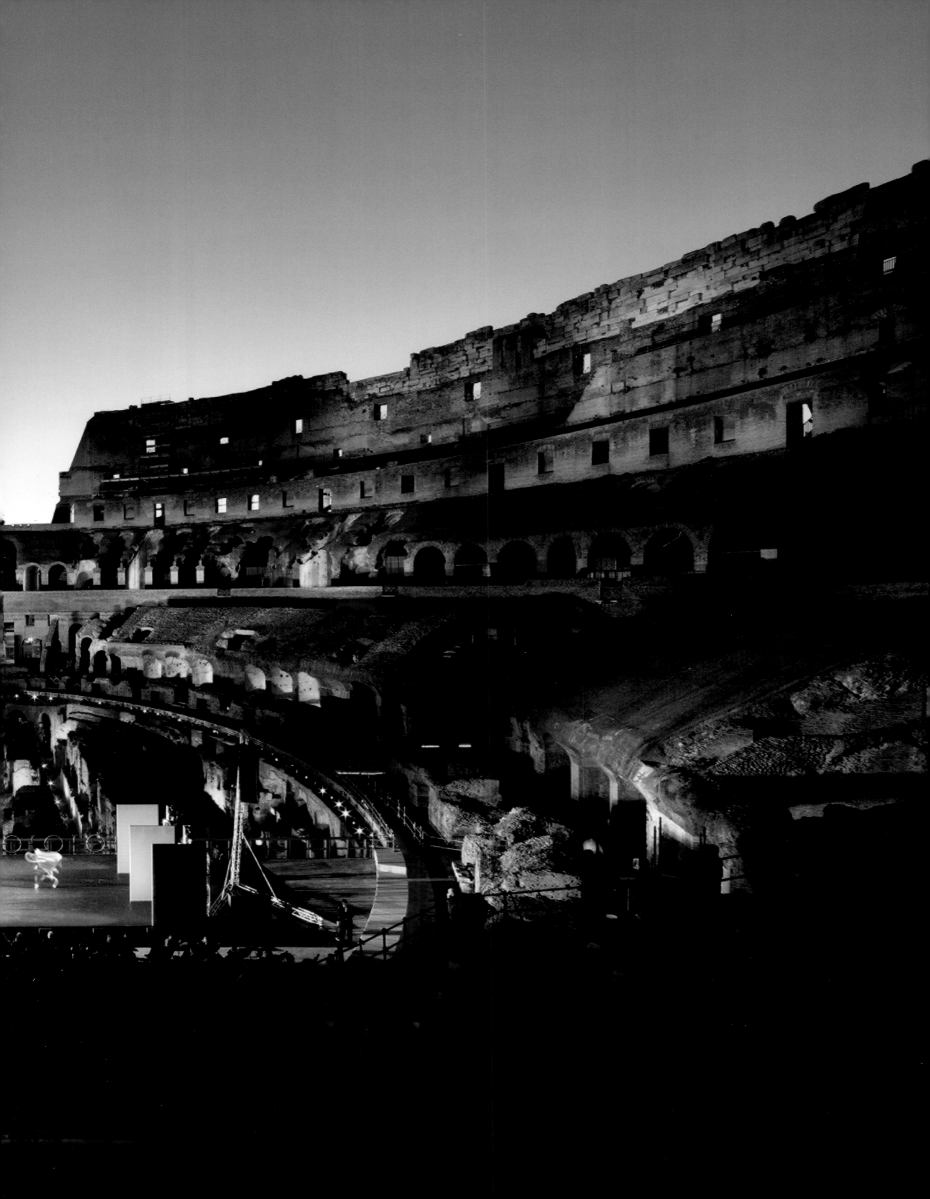

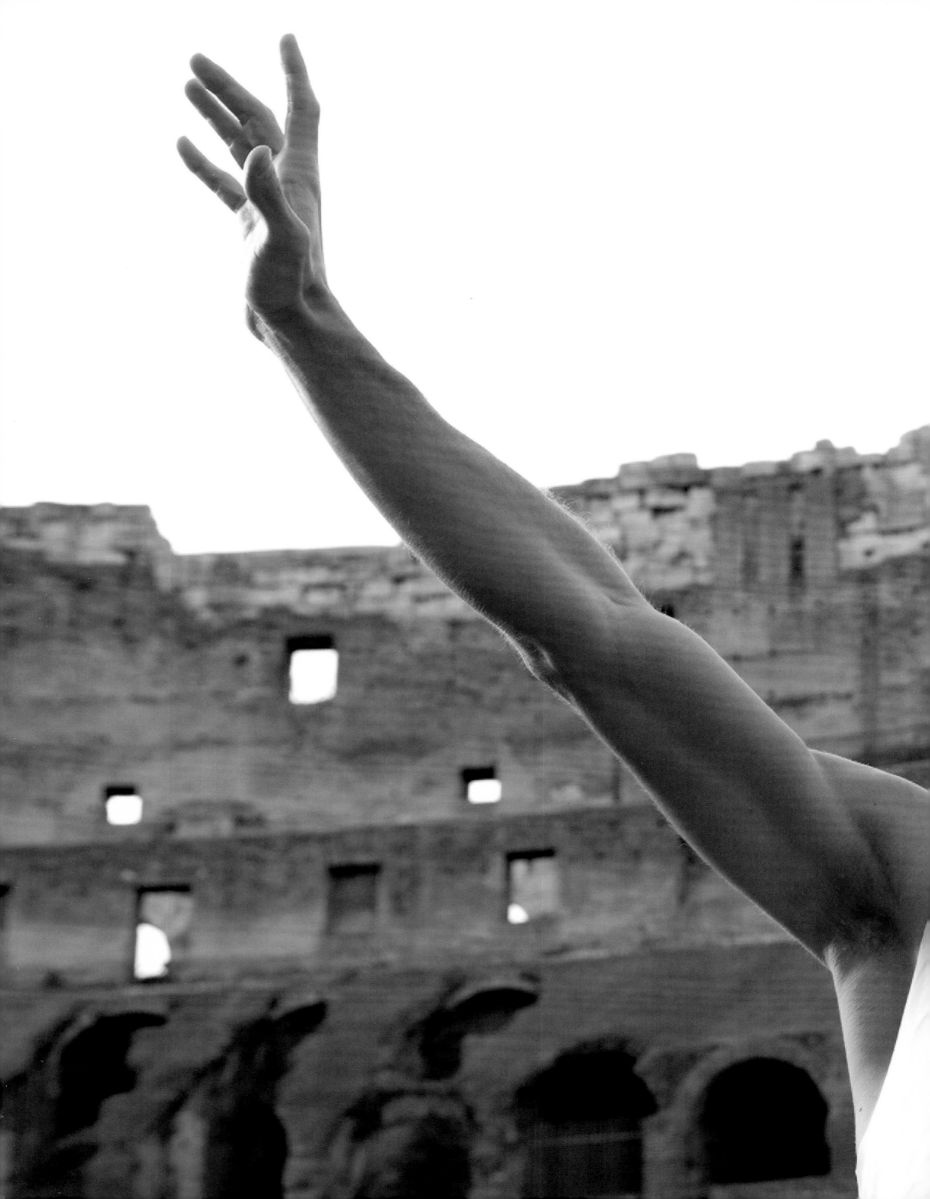

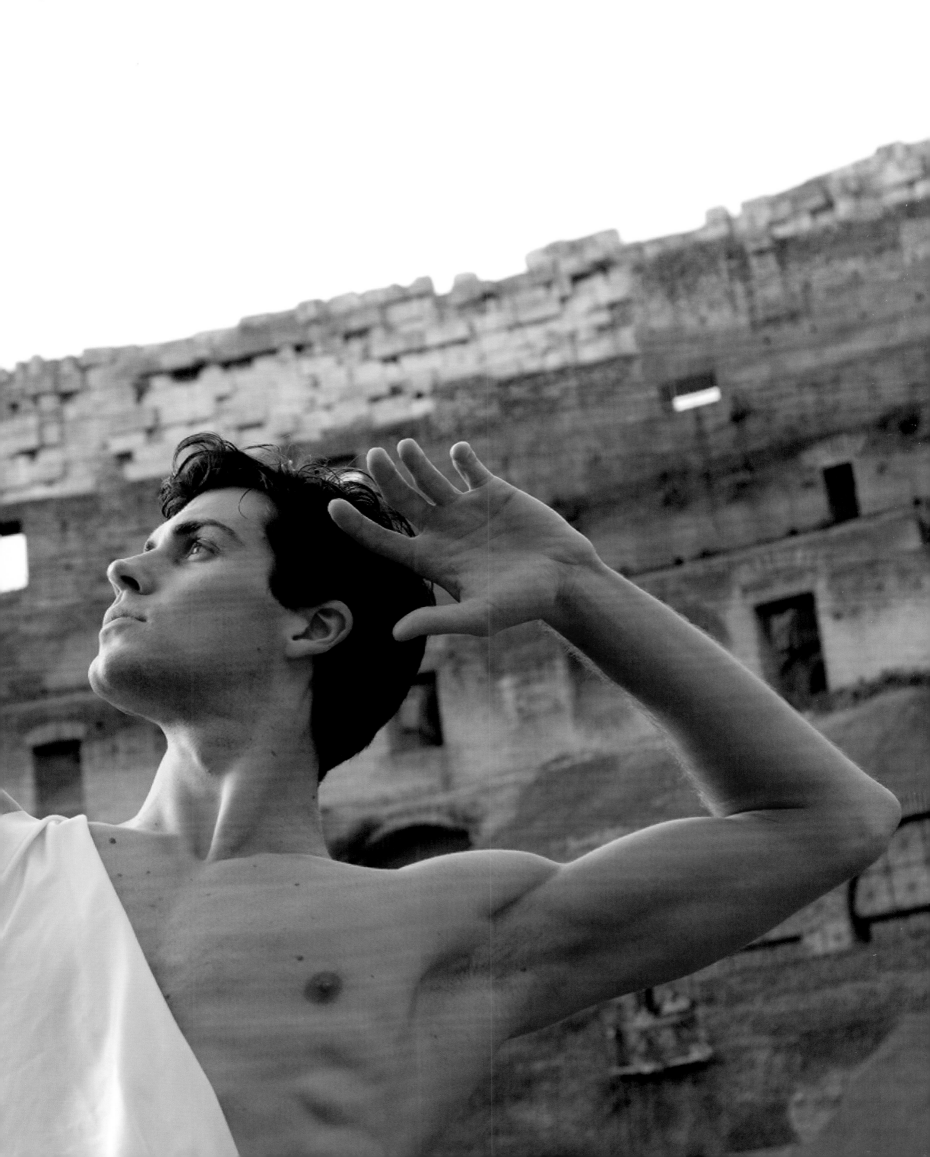

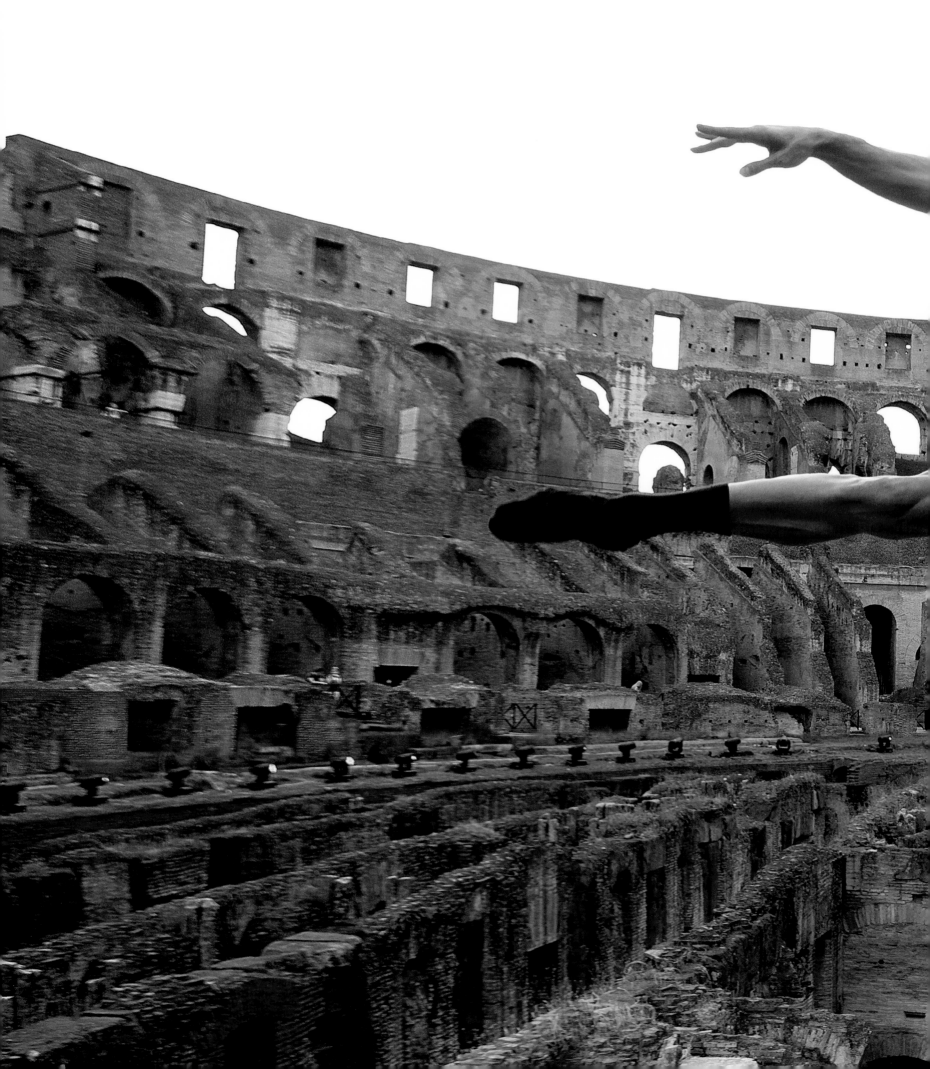

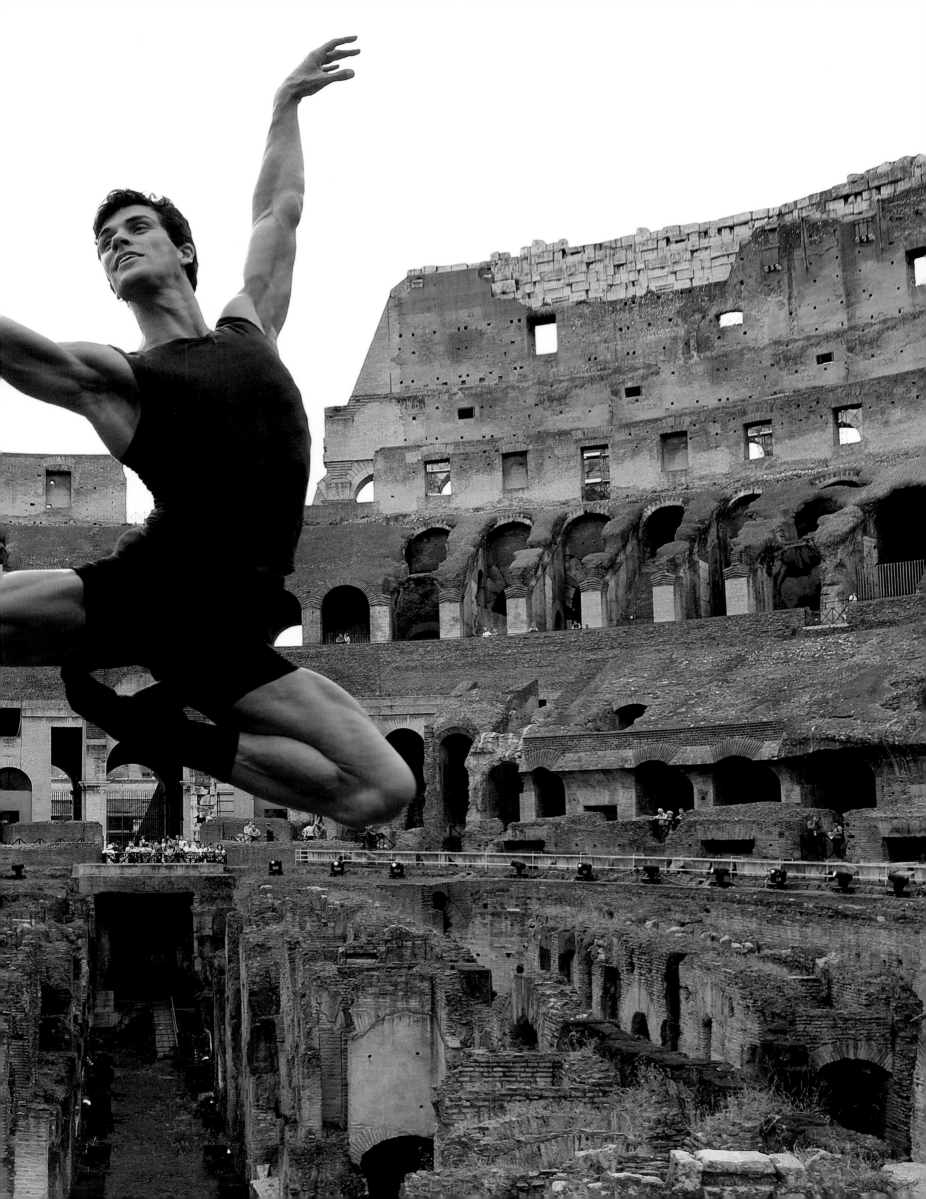

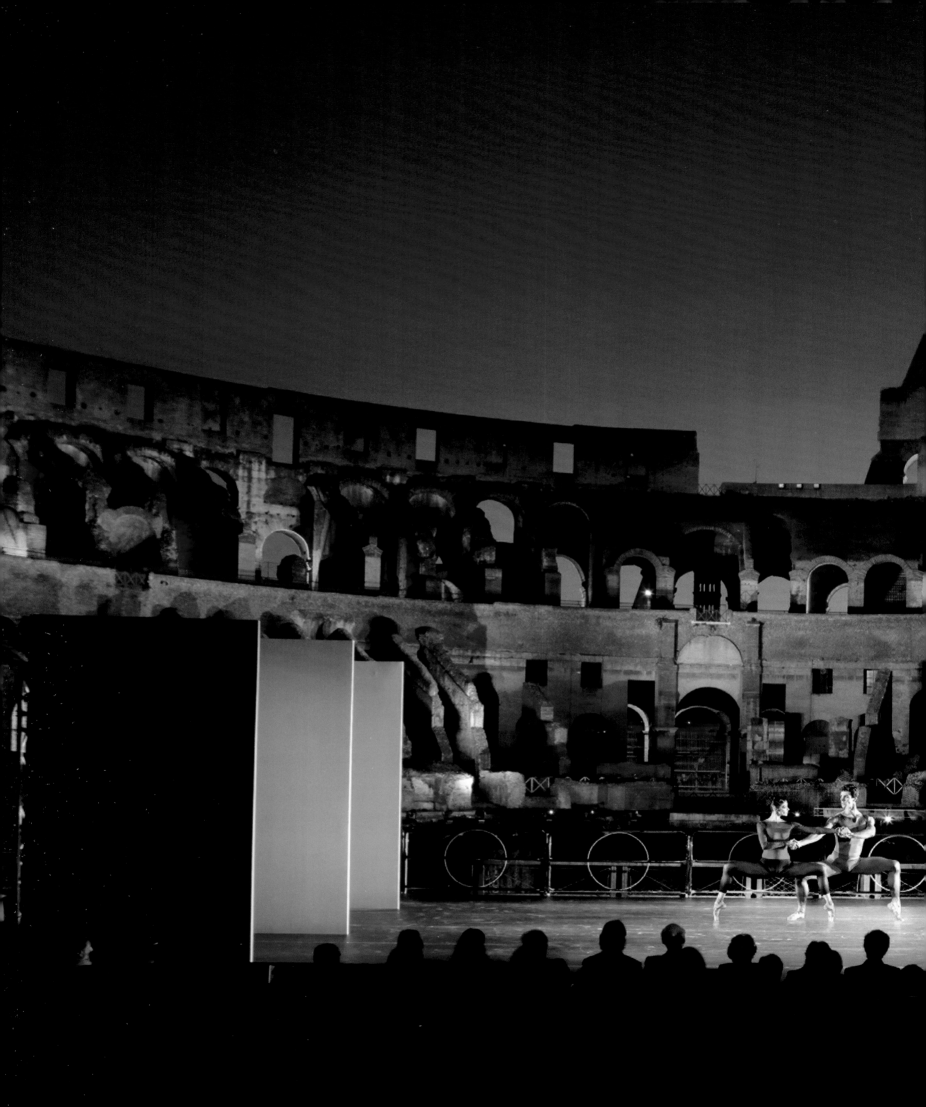

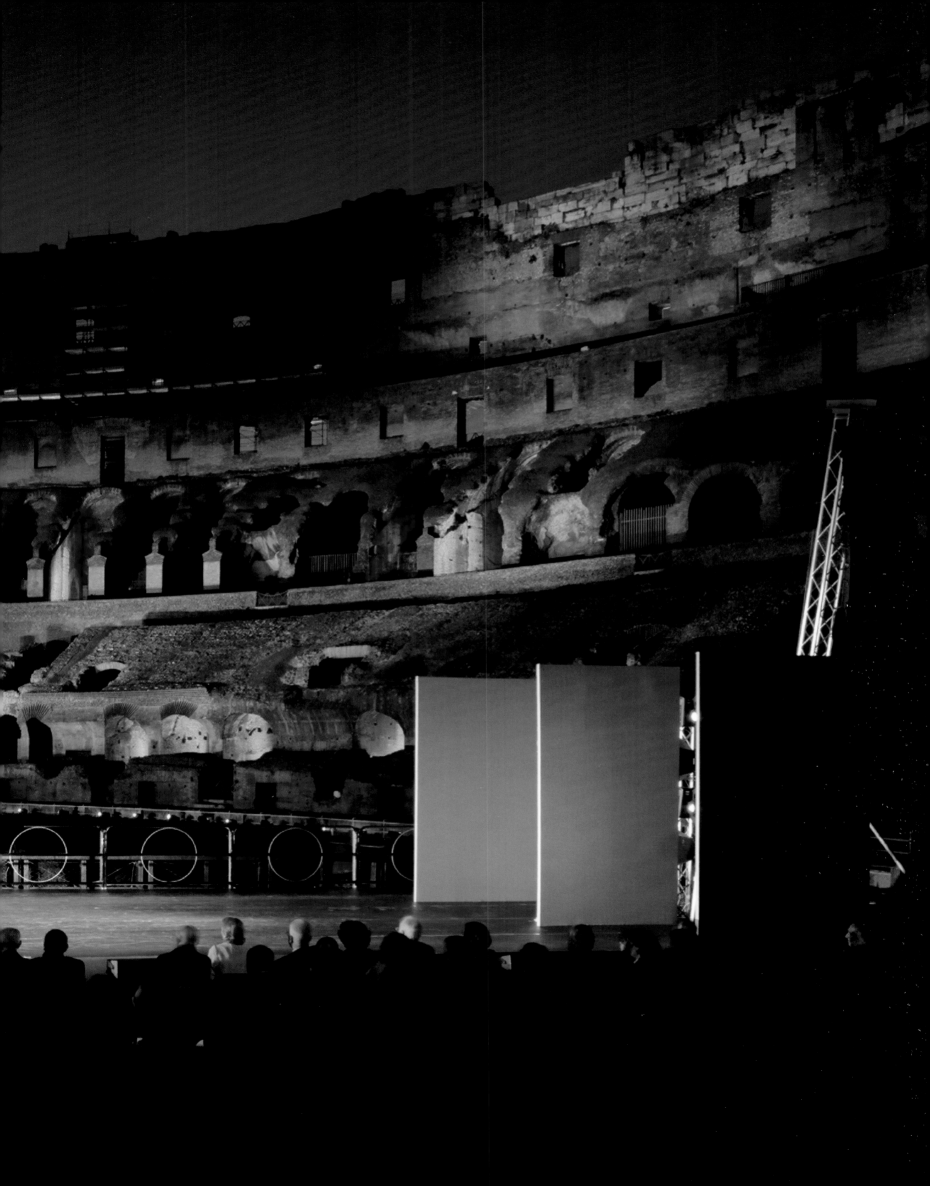

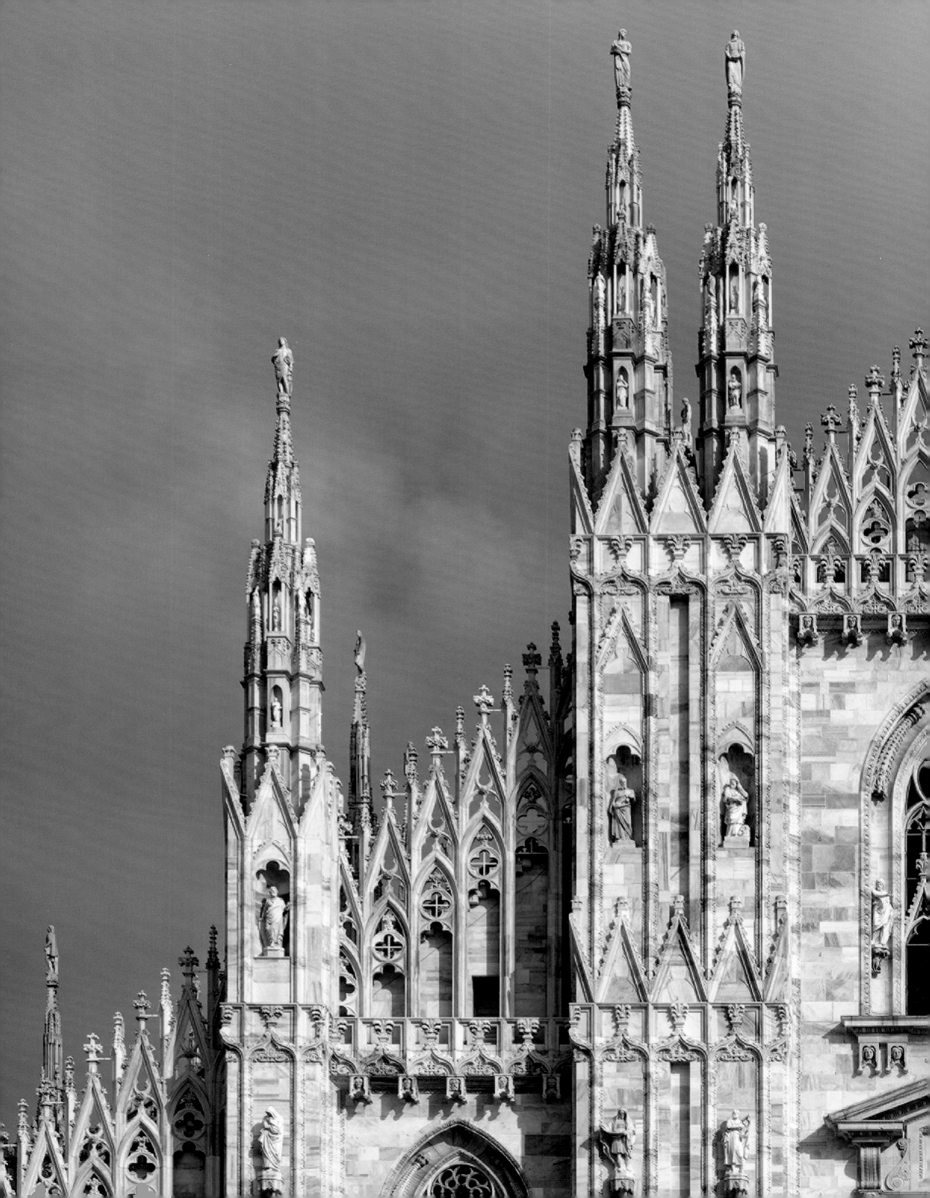

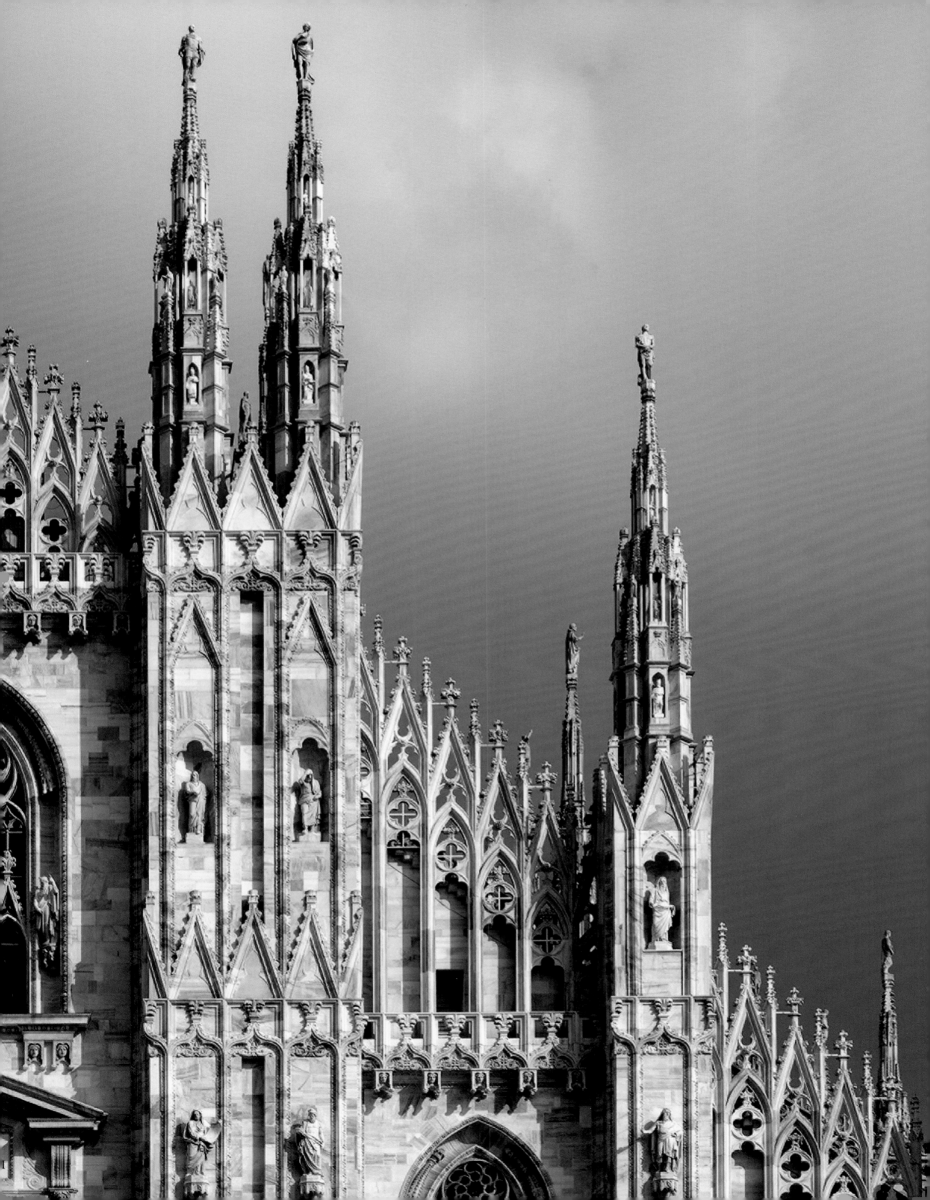

Dancing arouses emotions, generates beauty,
and elevates it toward a superior dimension.
Thus, dance tends toward the sublime.

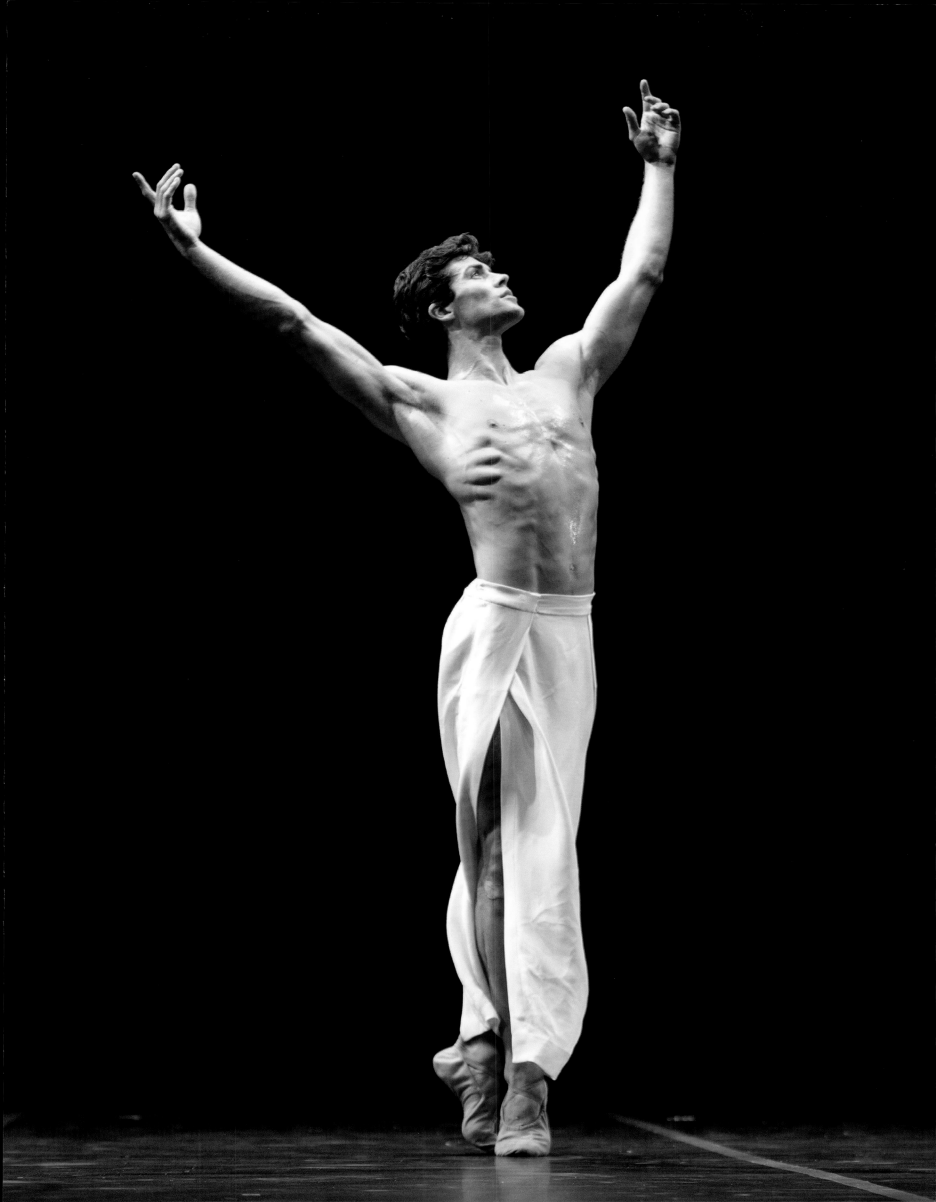

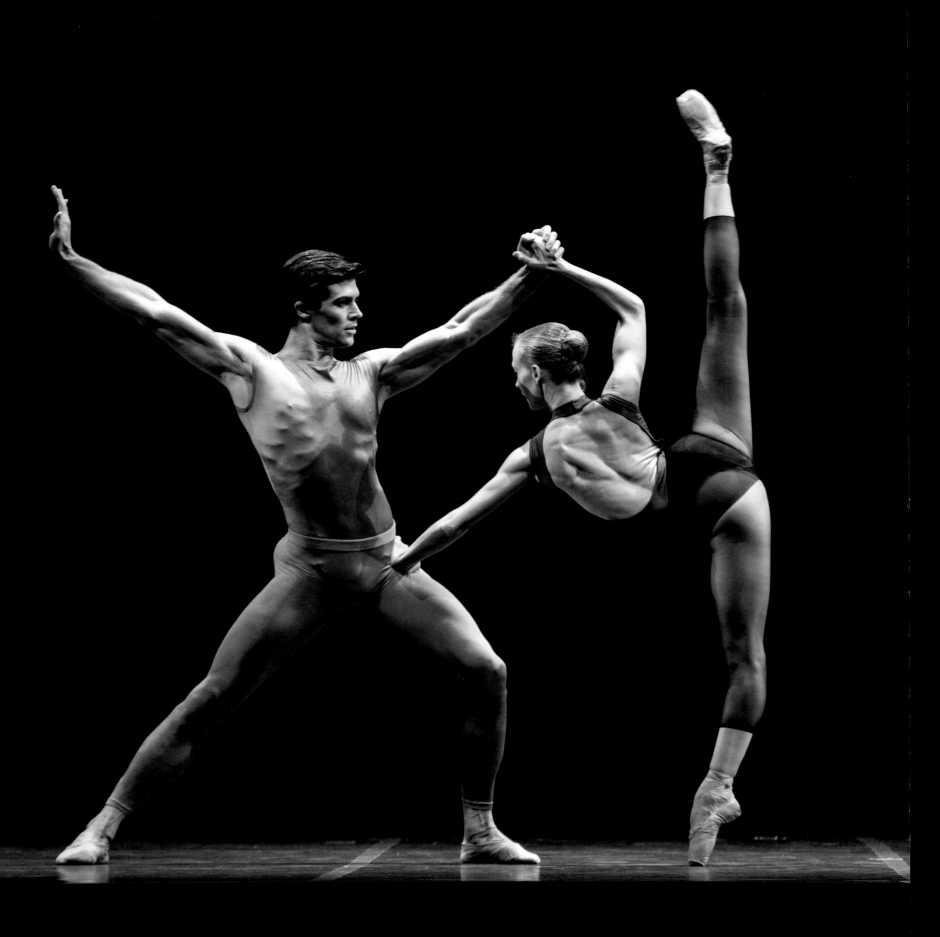

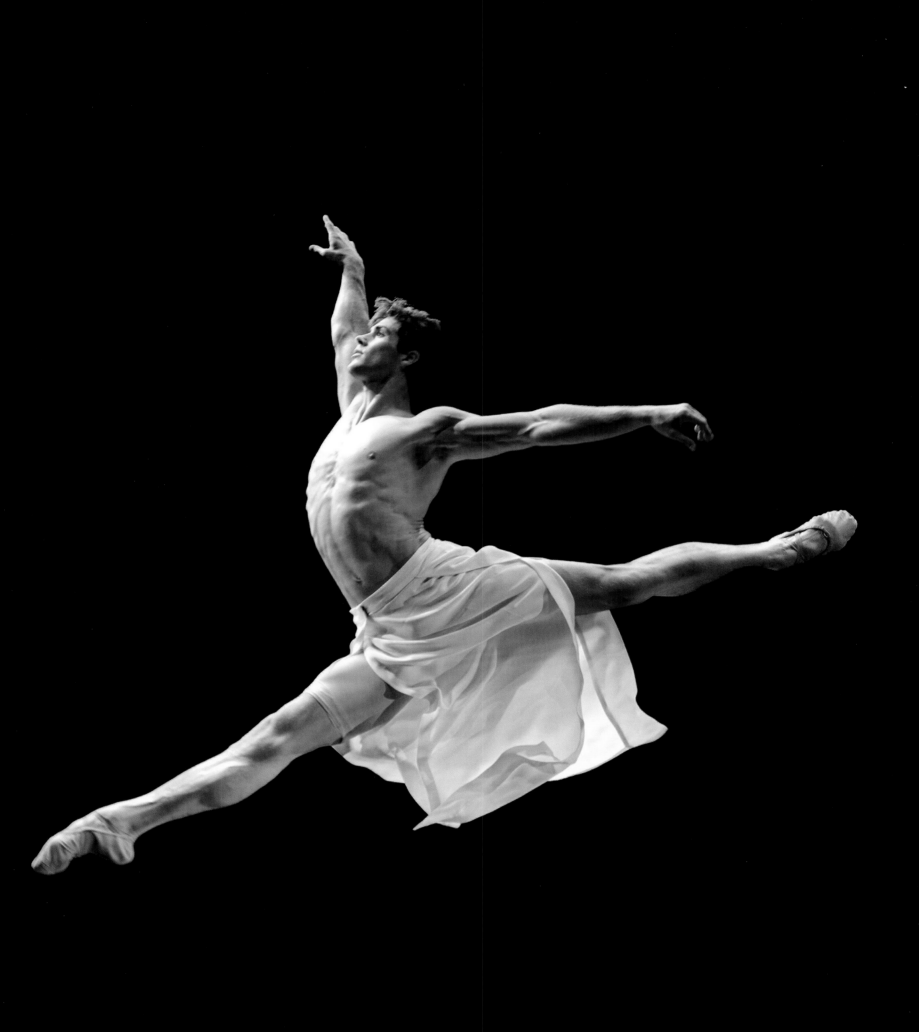

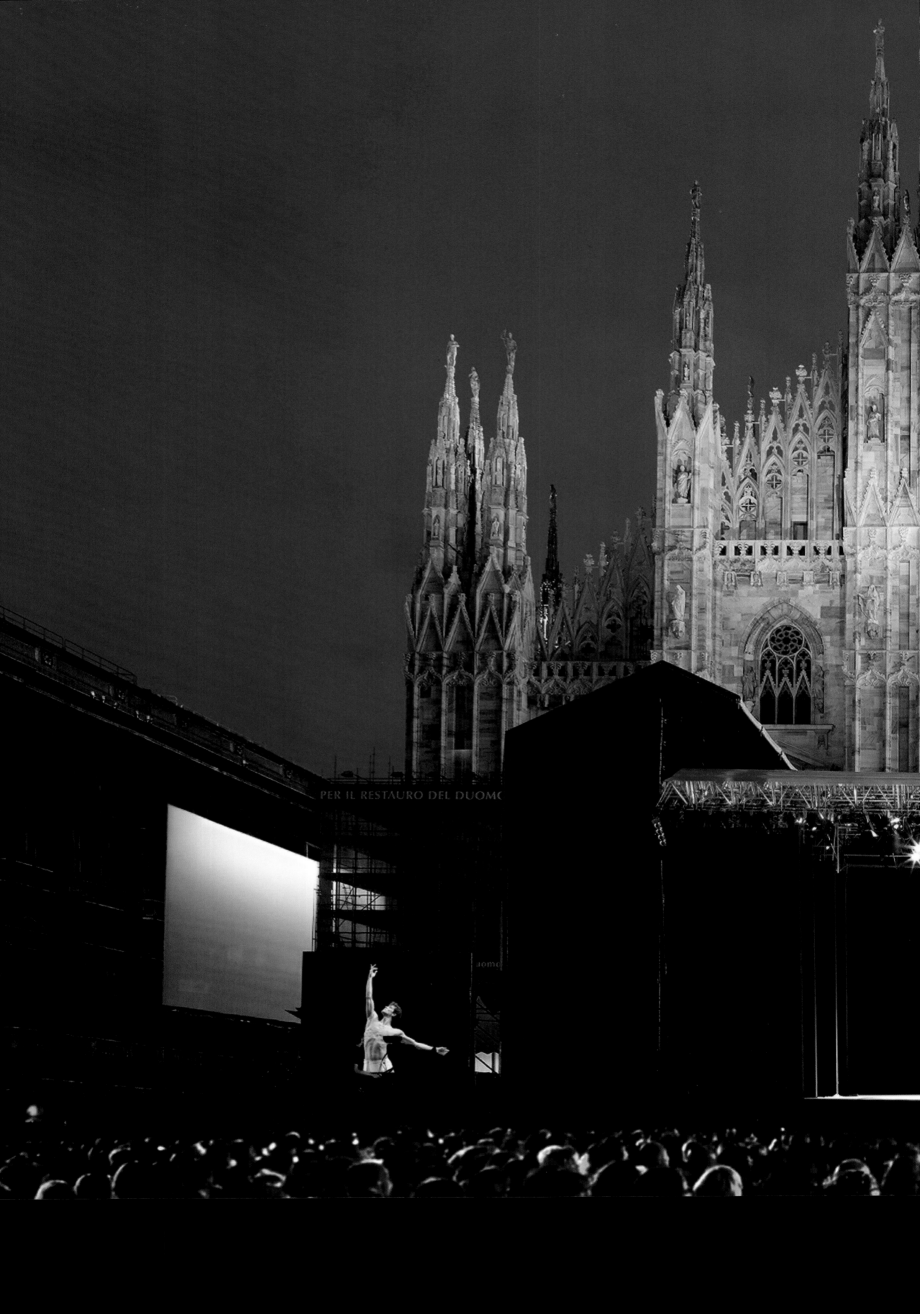

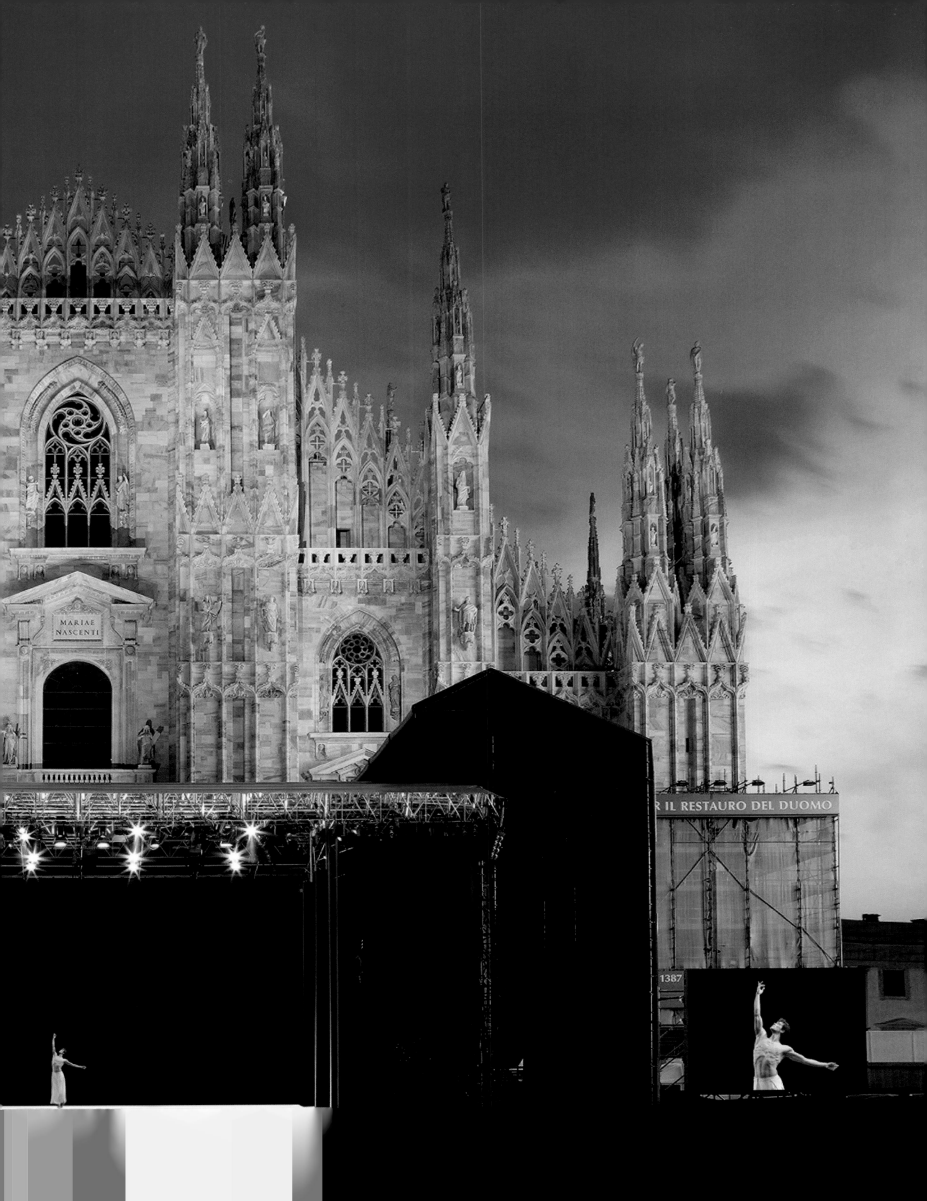

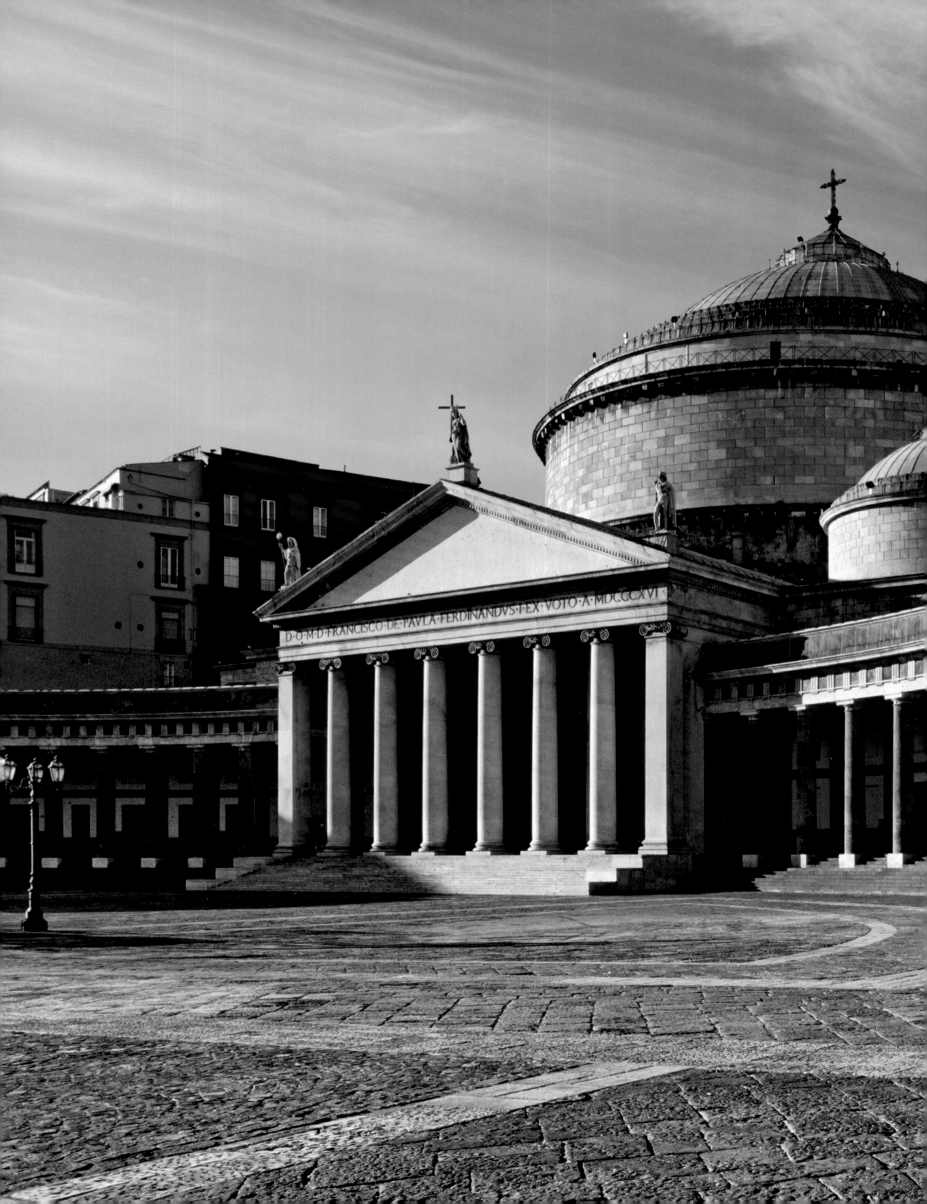

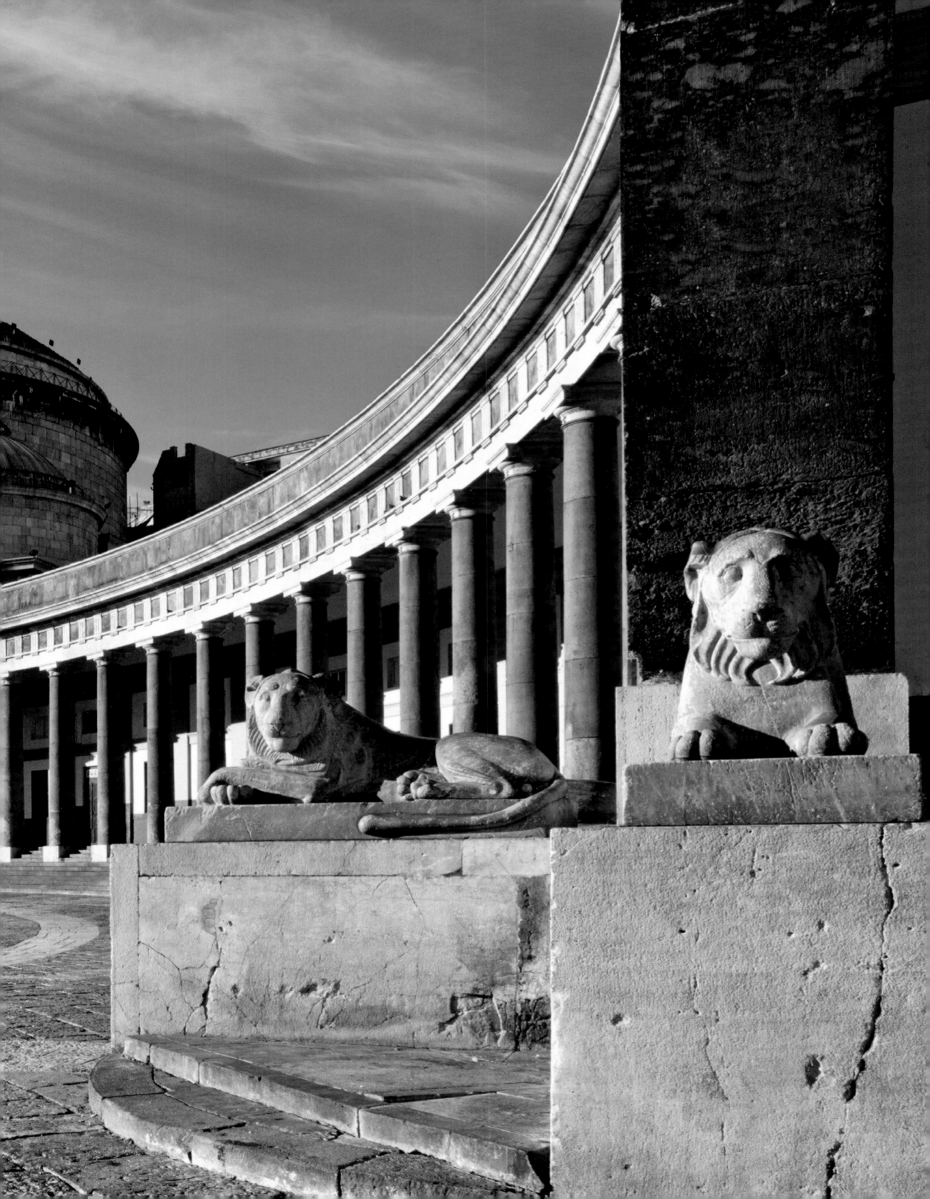

Passion, warmth, creative flair, and musicality.
In Naples, the popular spirit vibrates,
touched by the Mediterranean—a sea that welcomes,
a sea of tolerance that creates a dialogue between cultures.

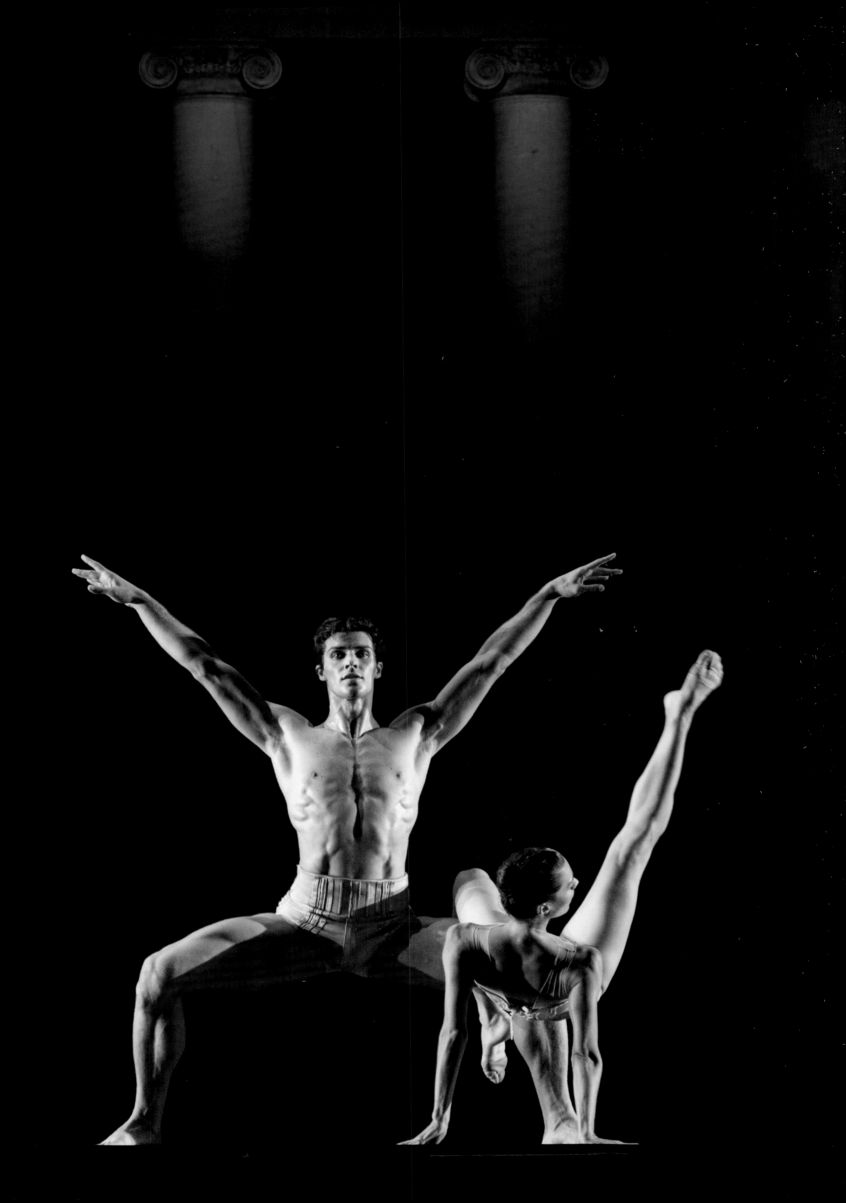

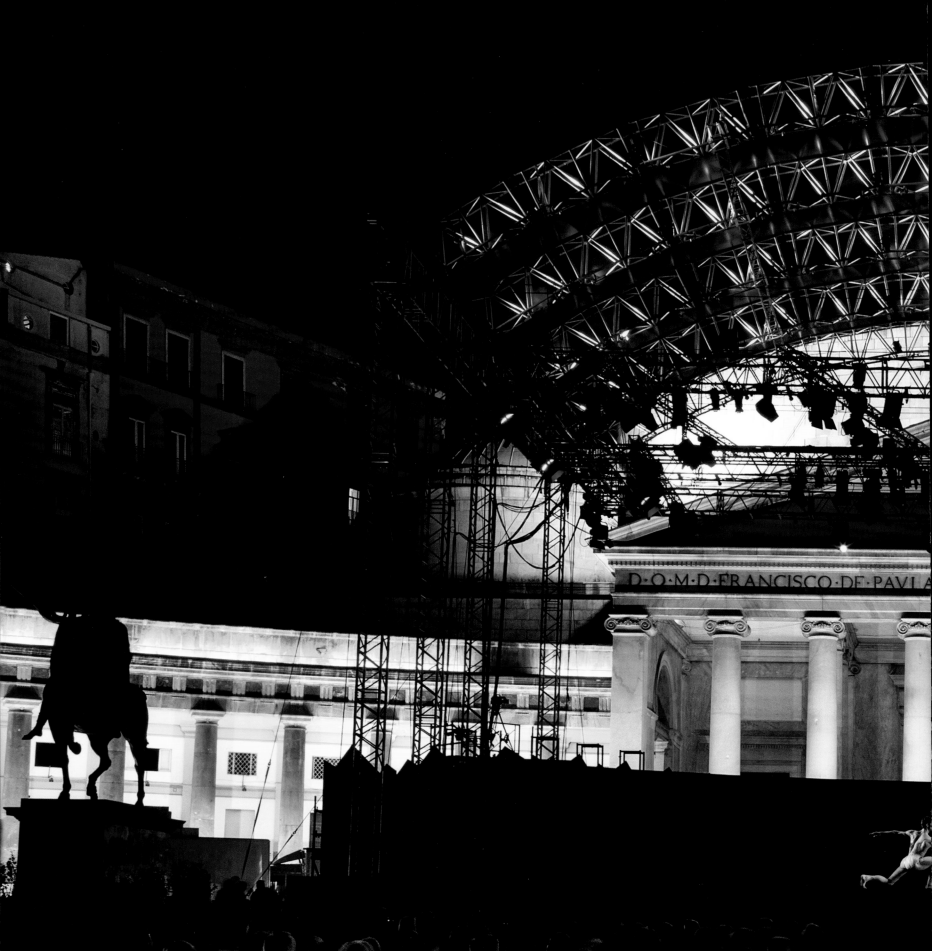

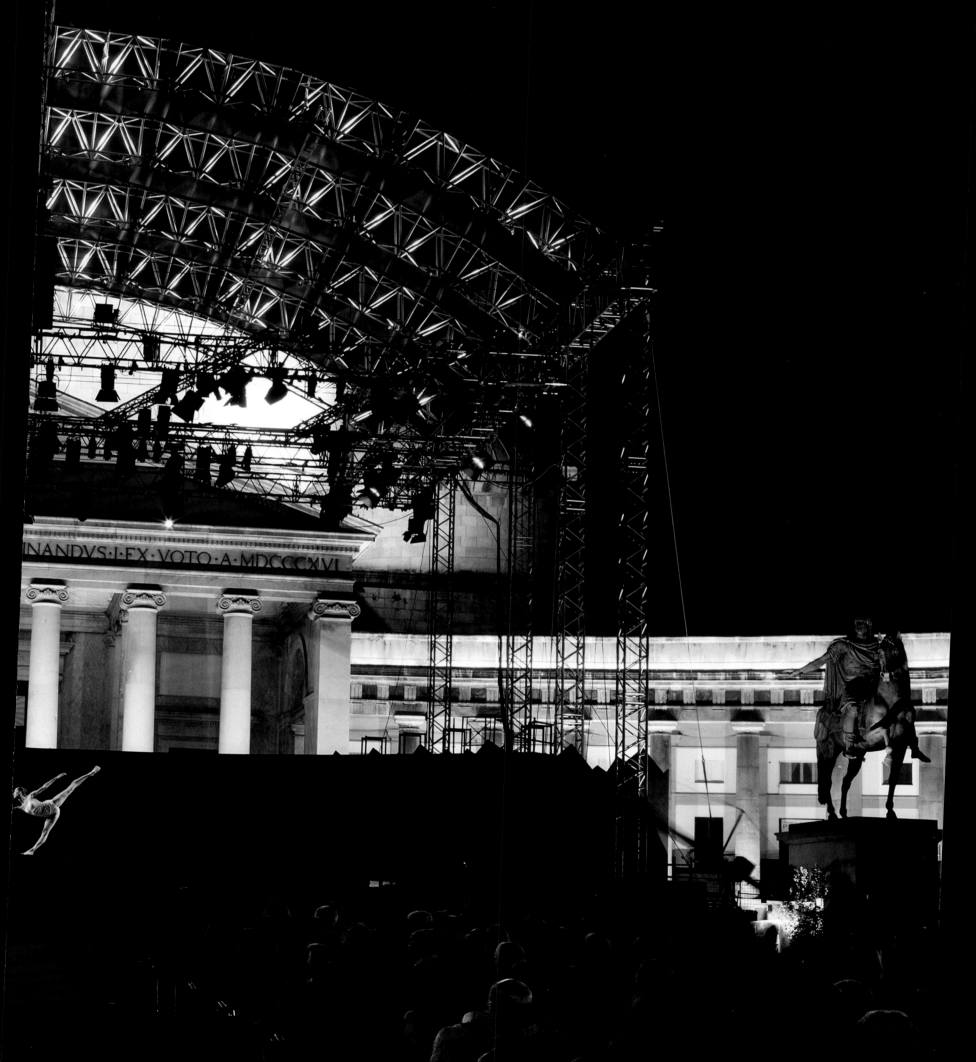

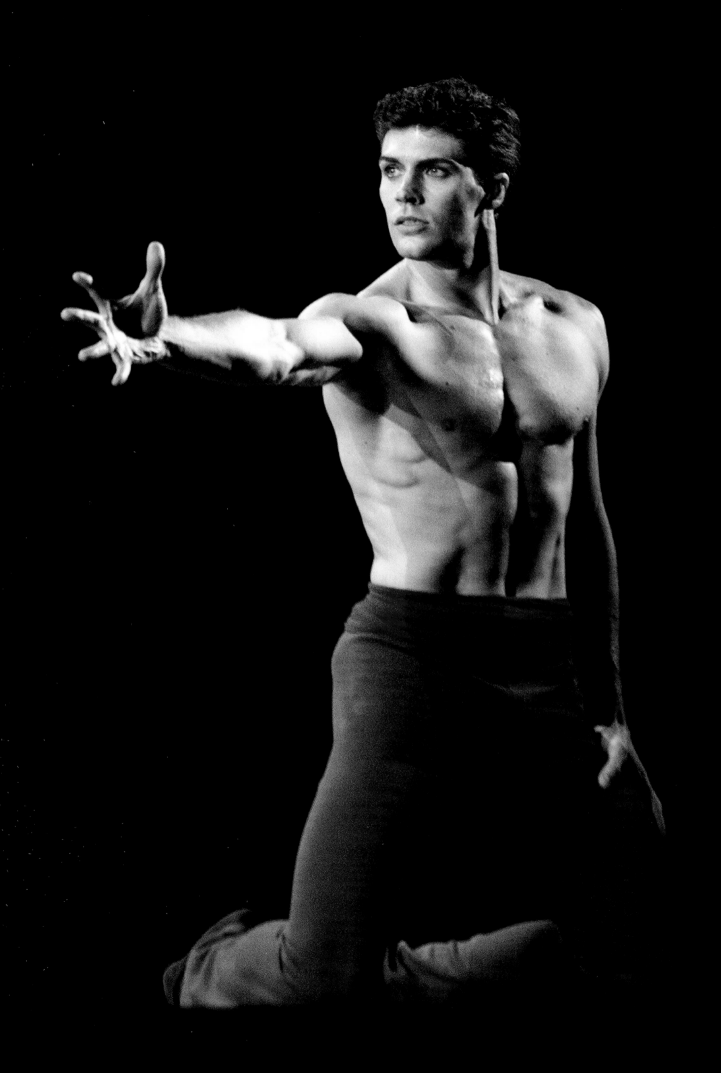

Dance is a collective force, with
the capacity to unite through one universal language.

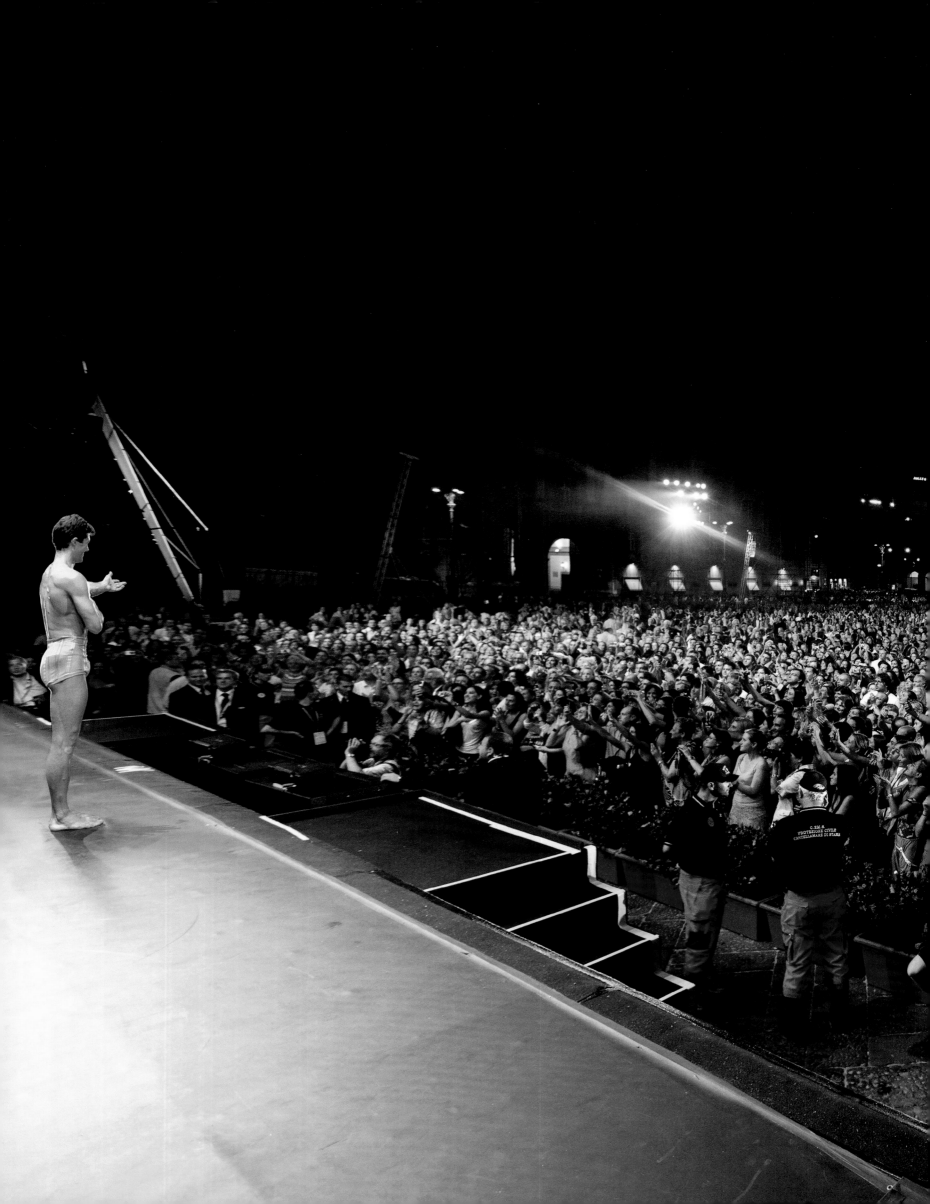

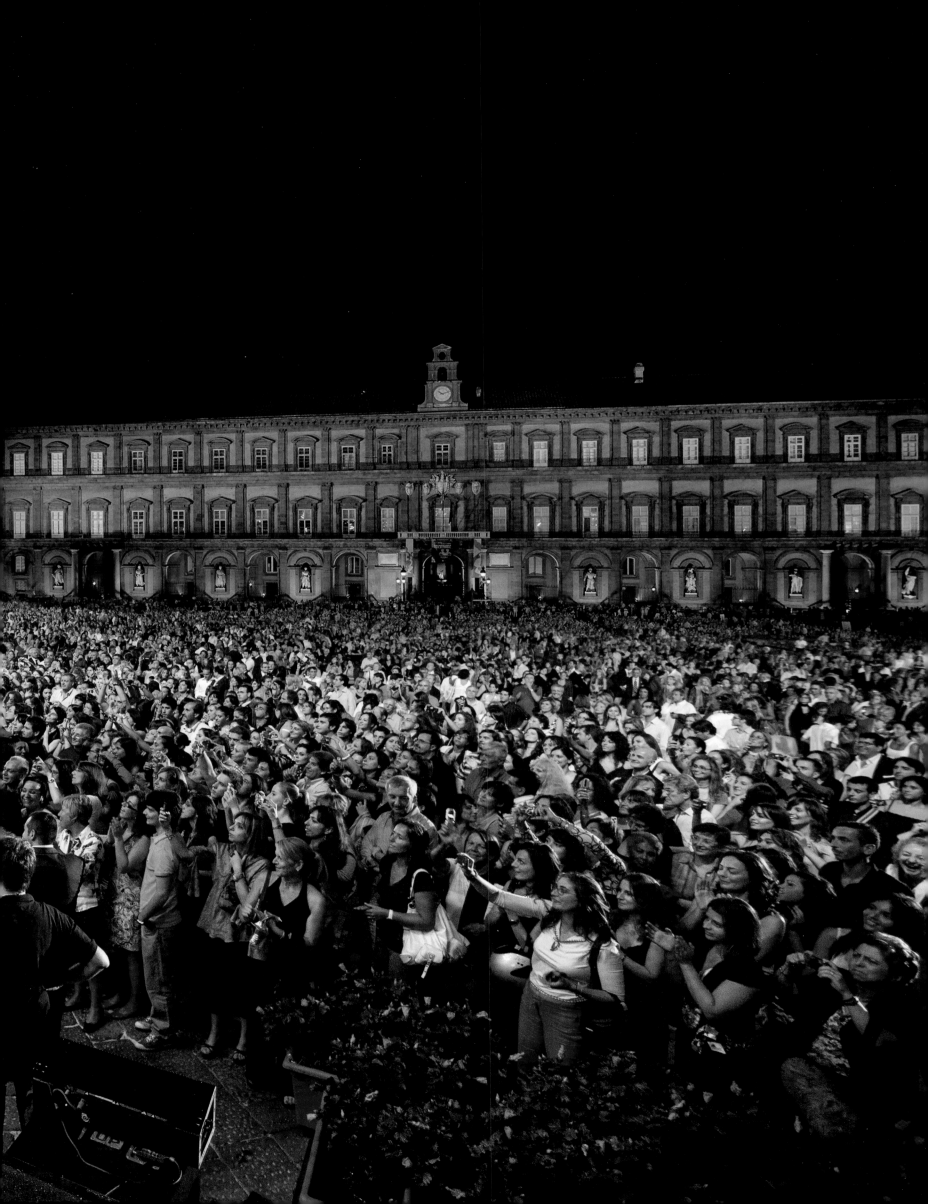

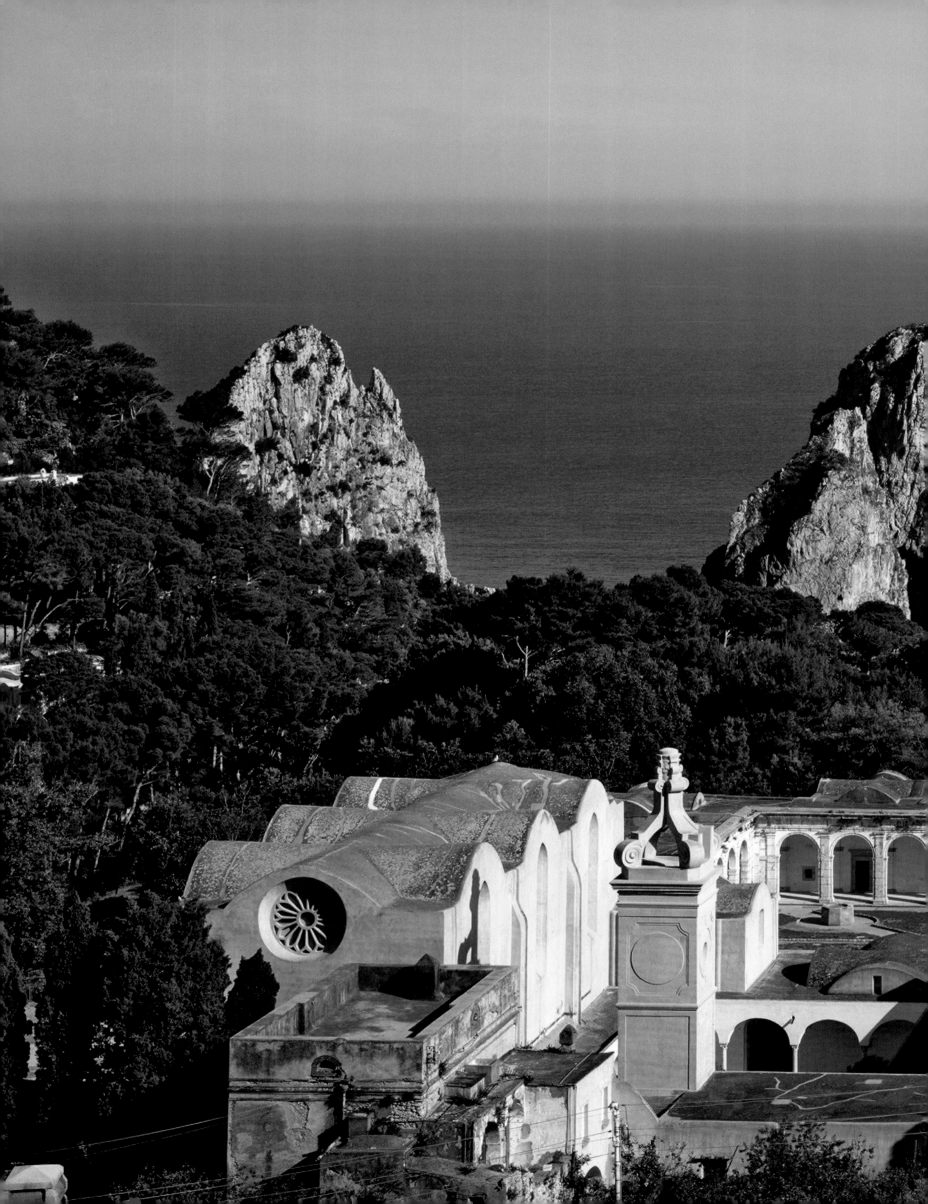

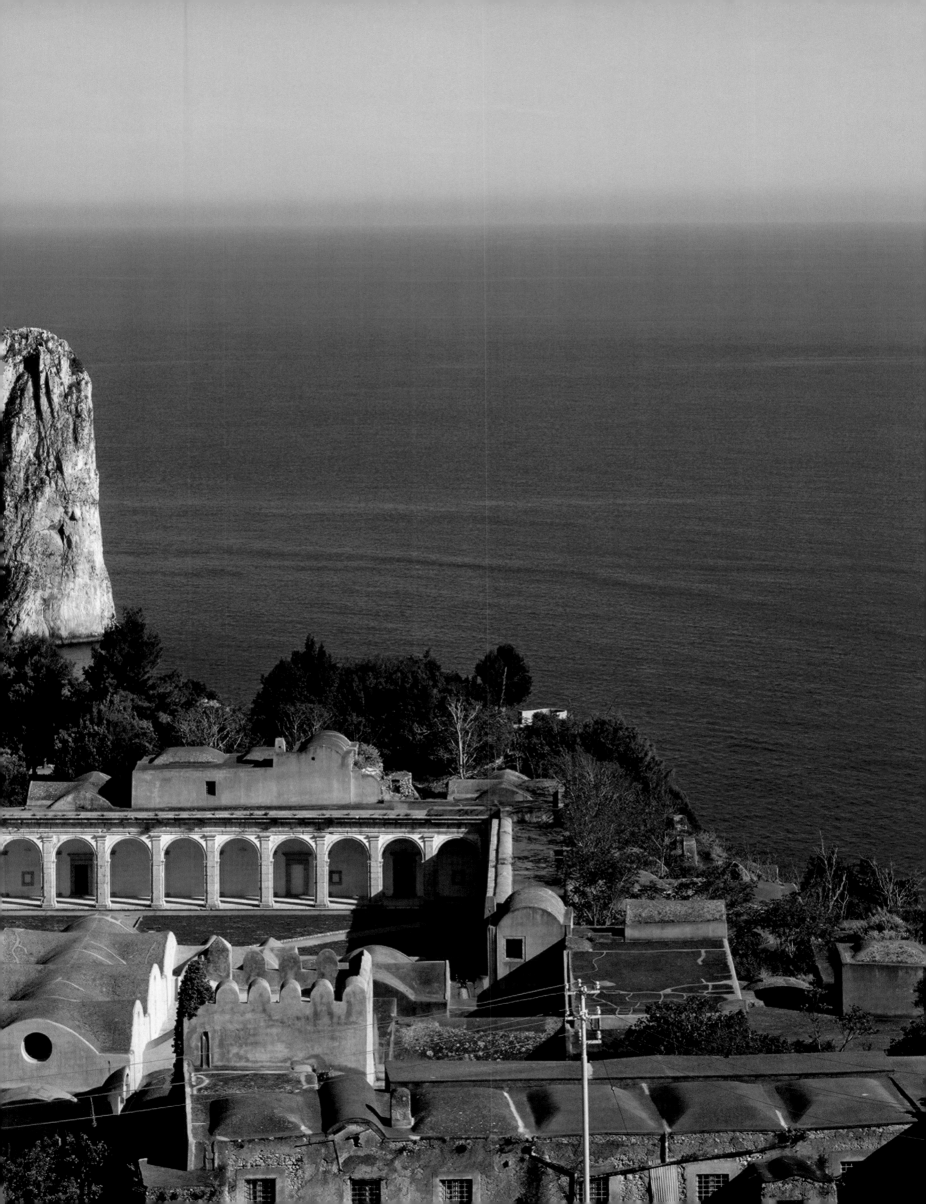

A light touch on the body, the sea breeze,
the scent of jasmine, the bitter juice of lemons.
The senses expand cradled by the sweetness of Capri, the
heartrending tenderness of the South.

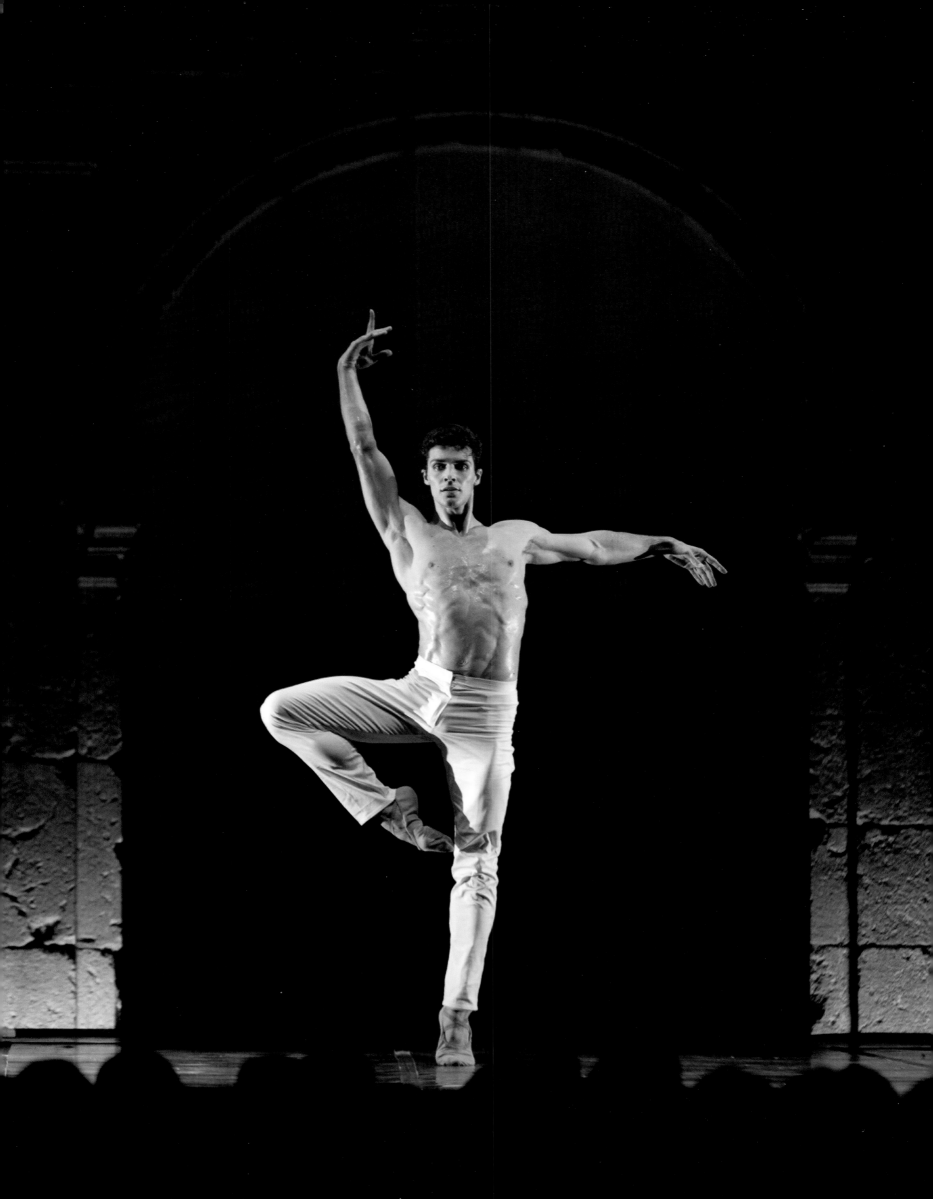

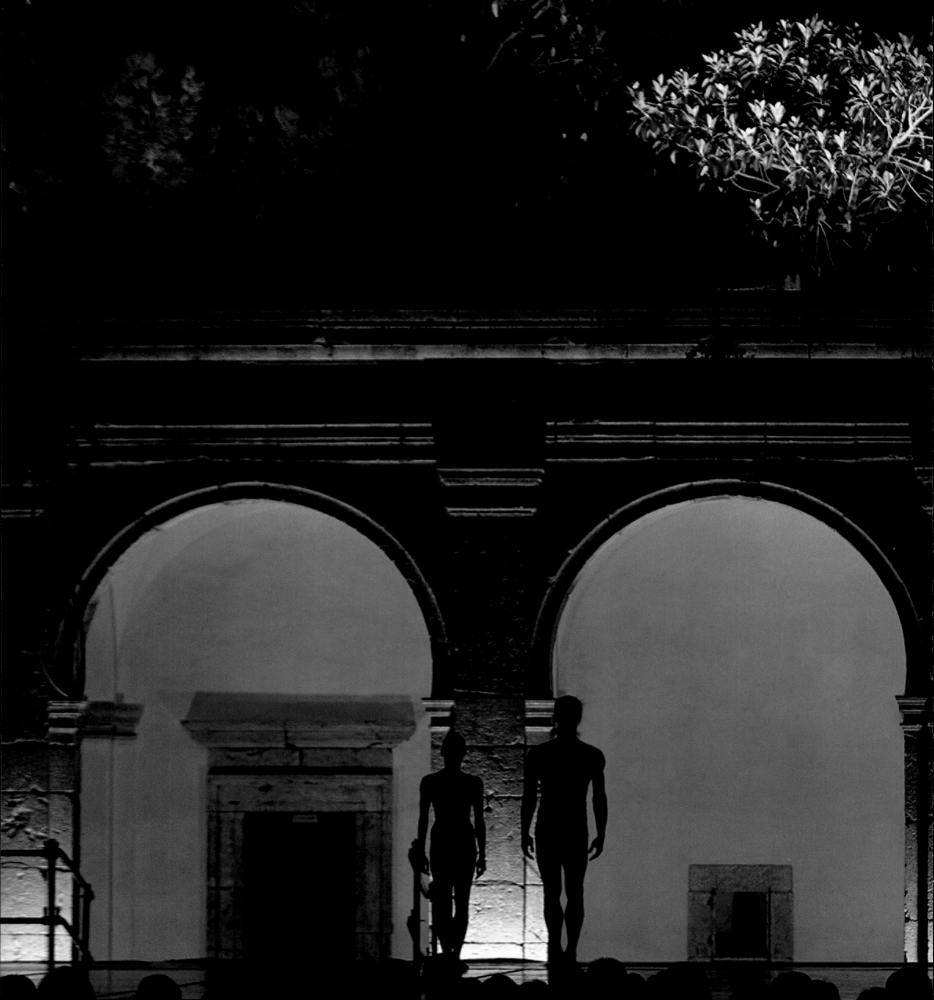

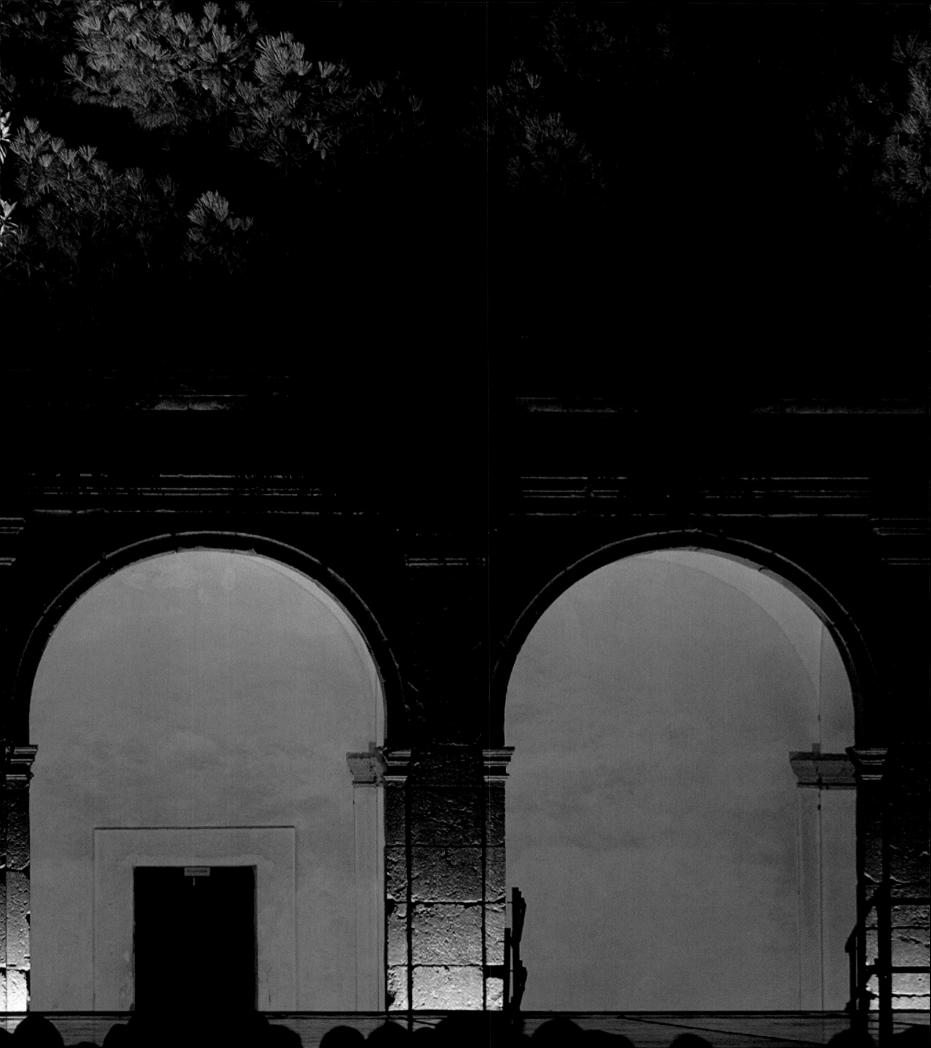

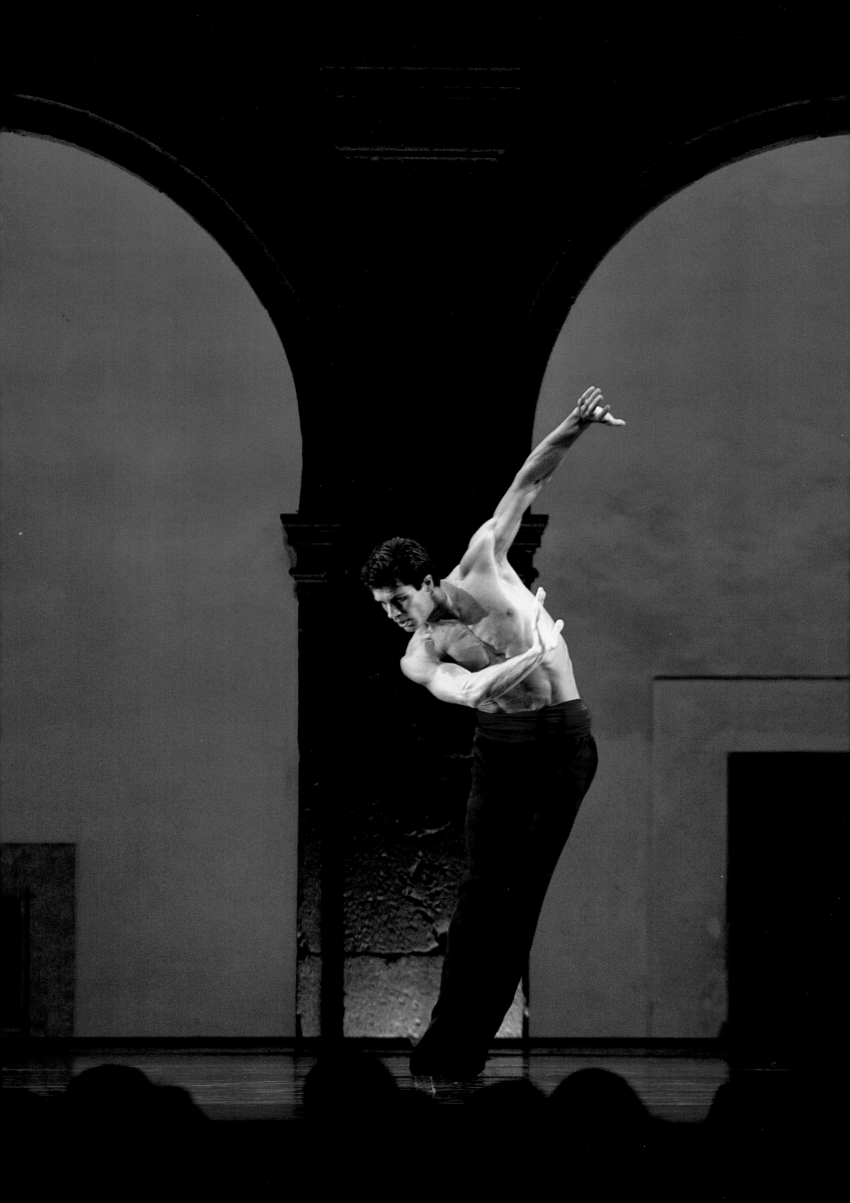

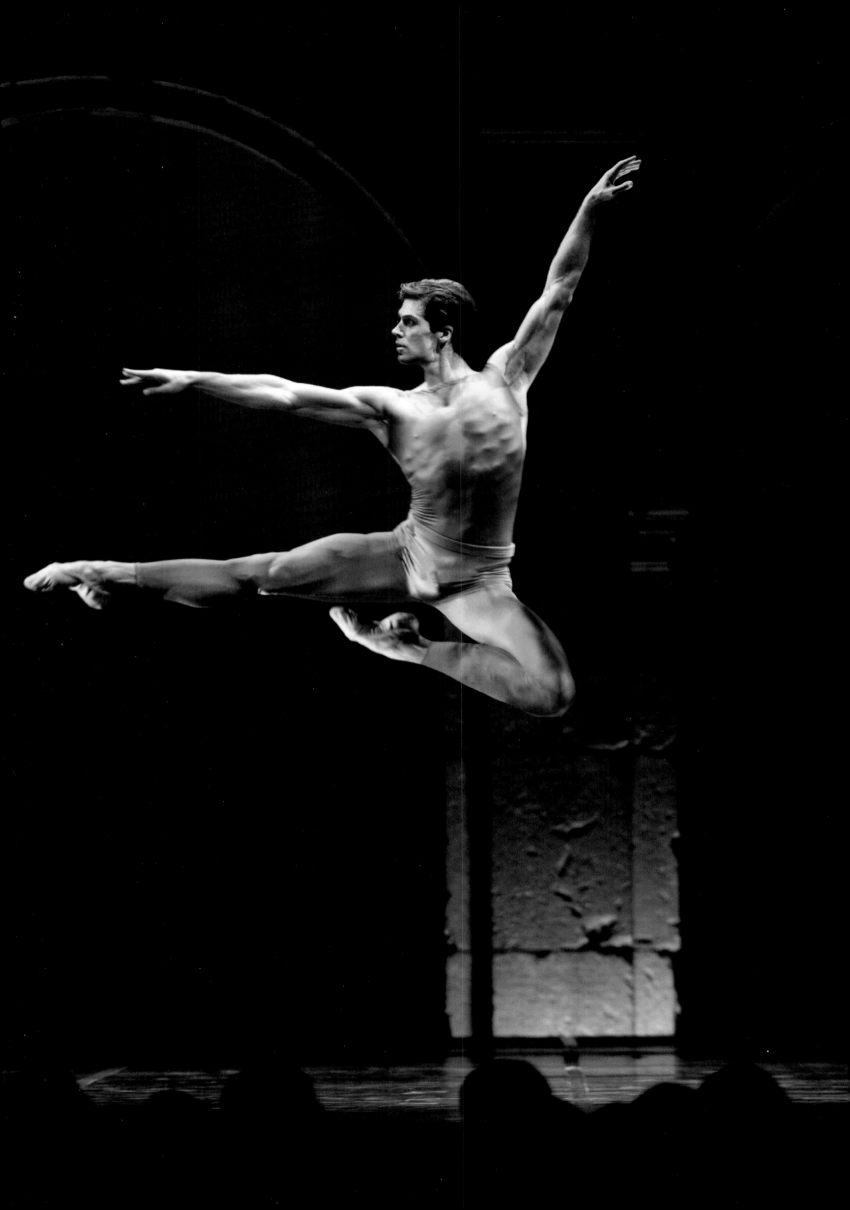

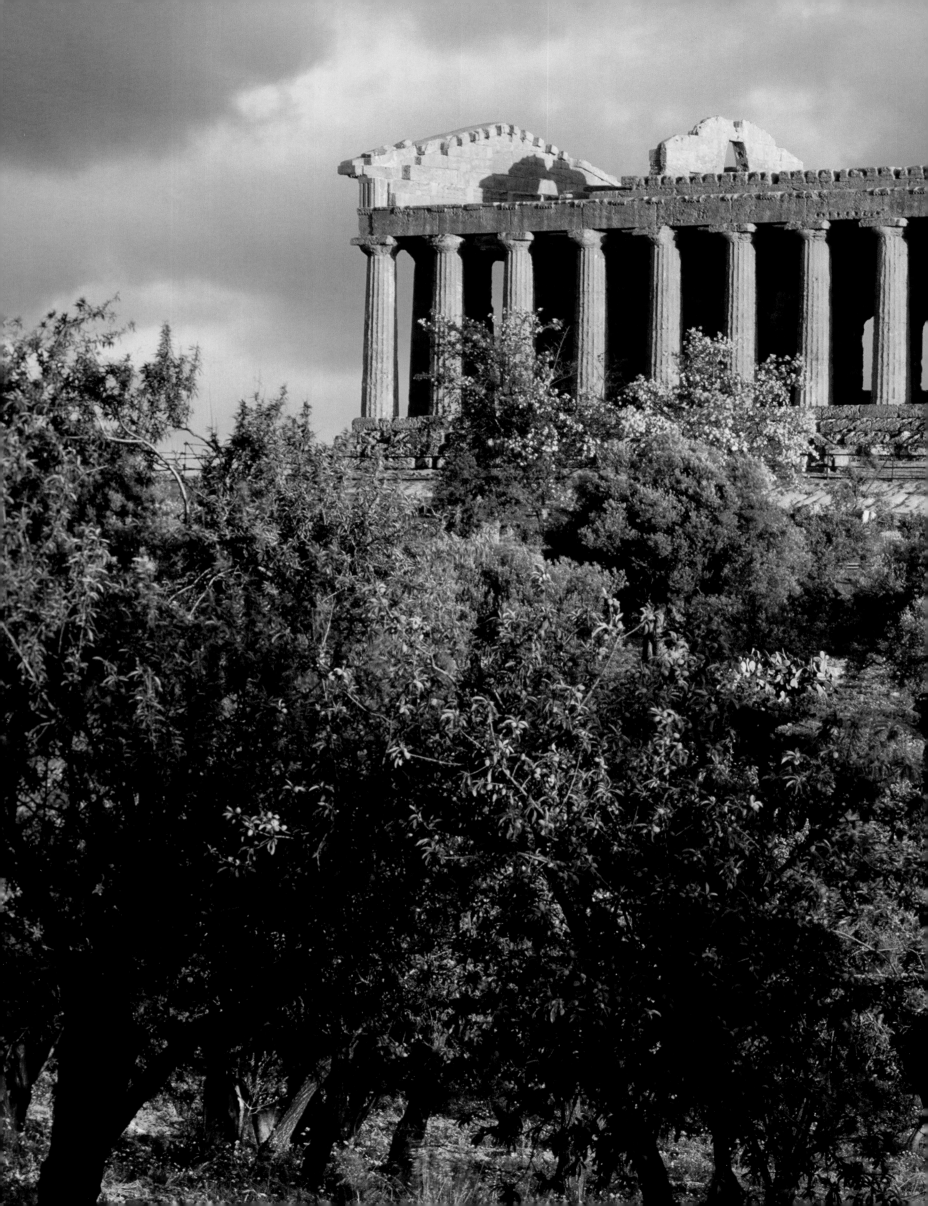

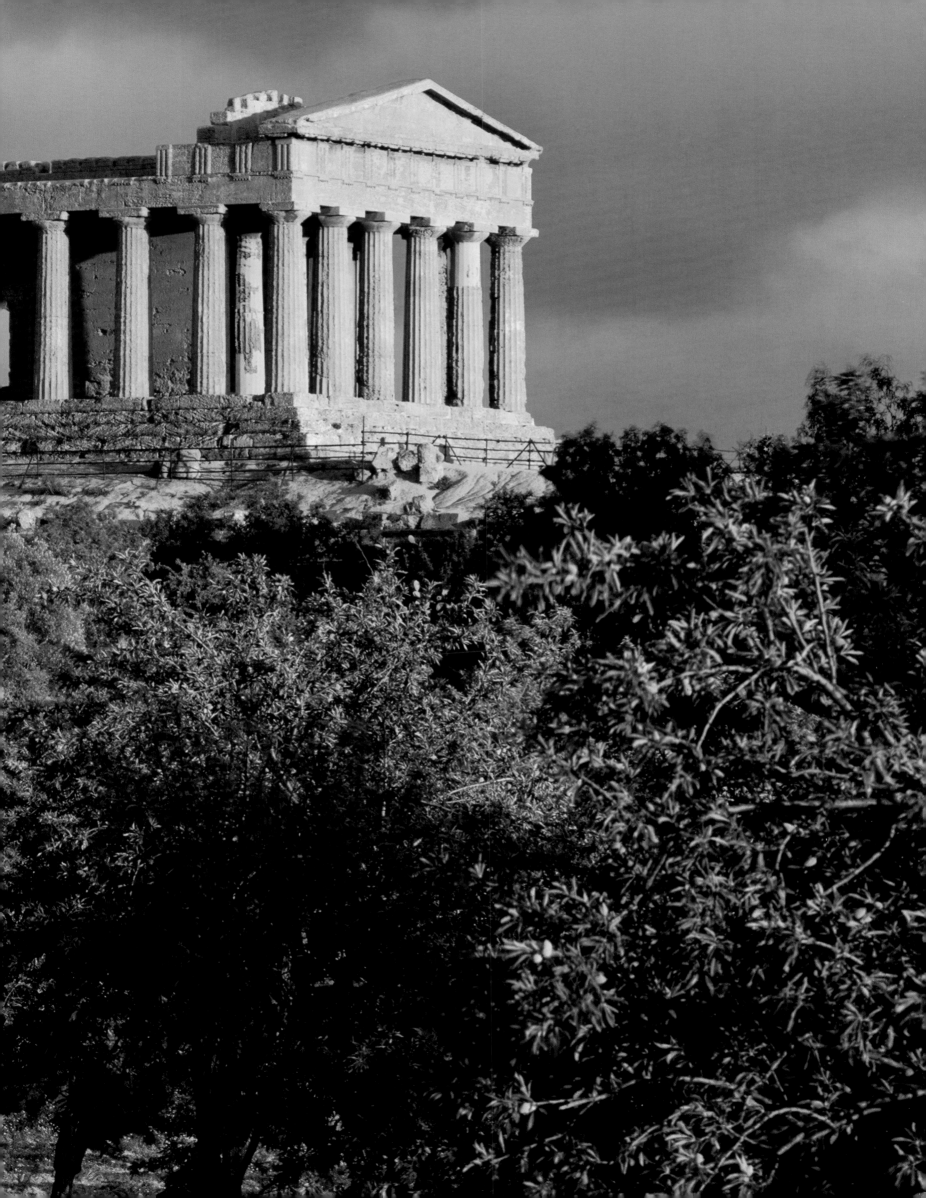

Magna Graecia breathes in the shadow of the temple,
while Apollo unveils art's secrets to the Muses.

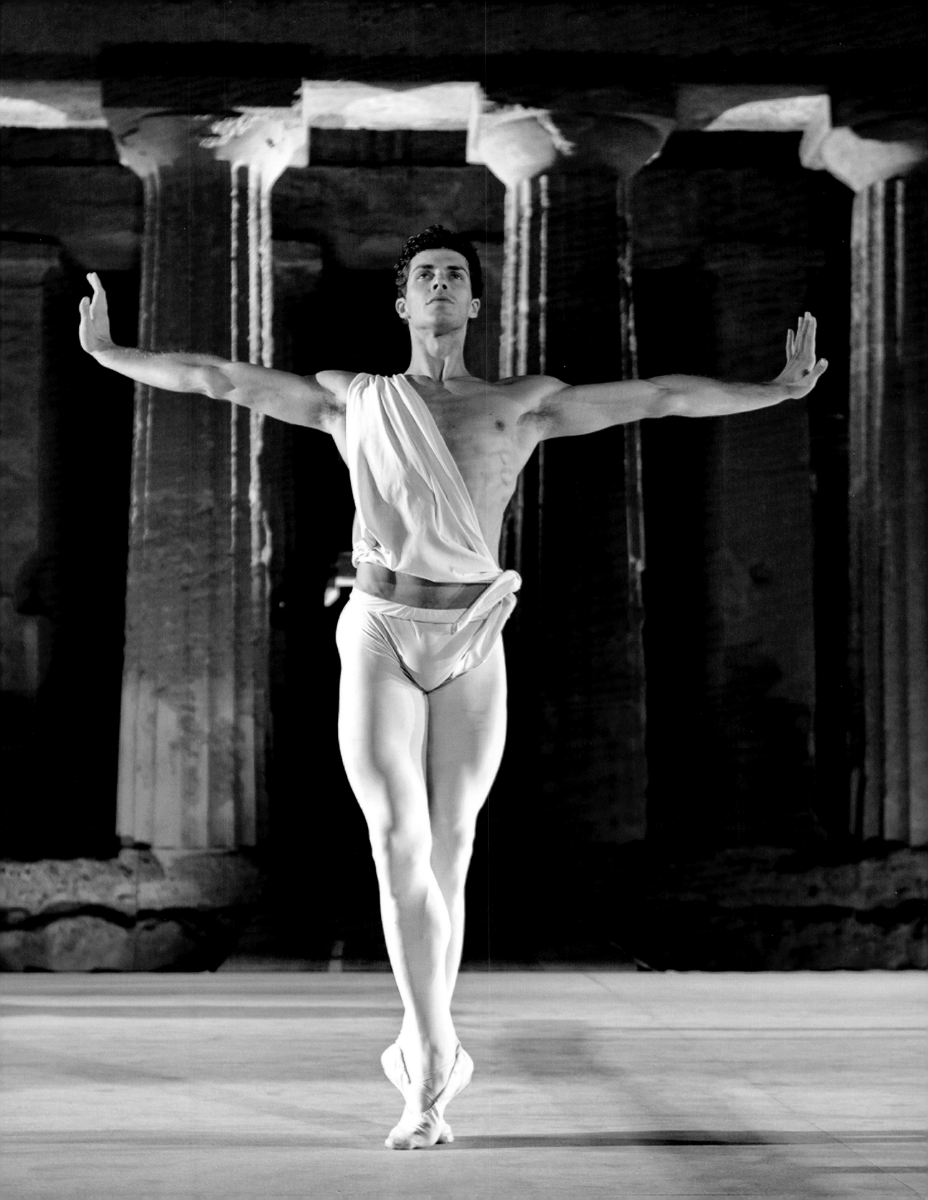

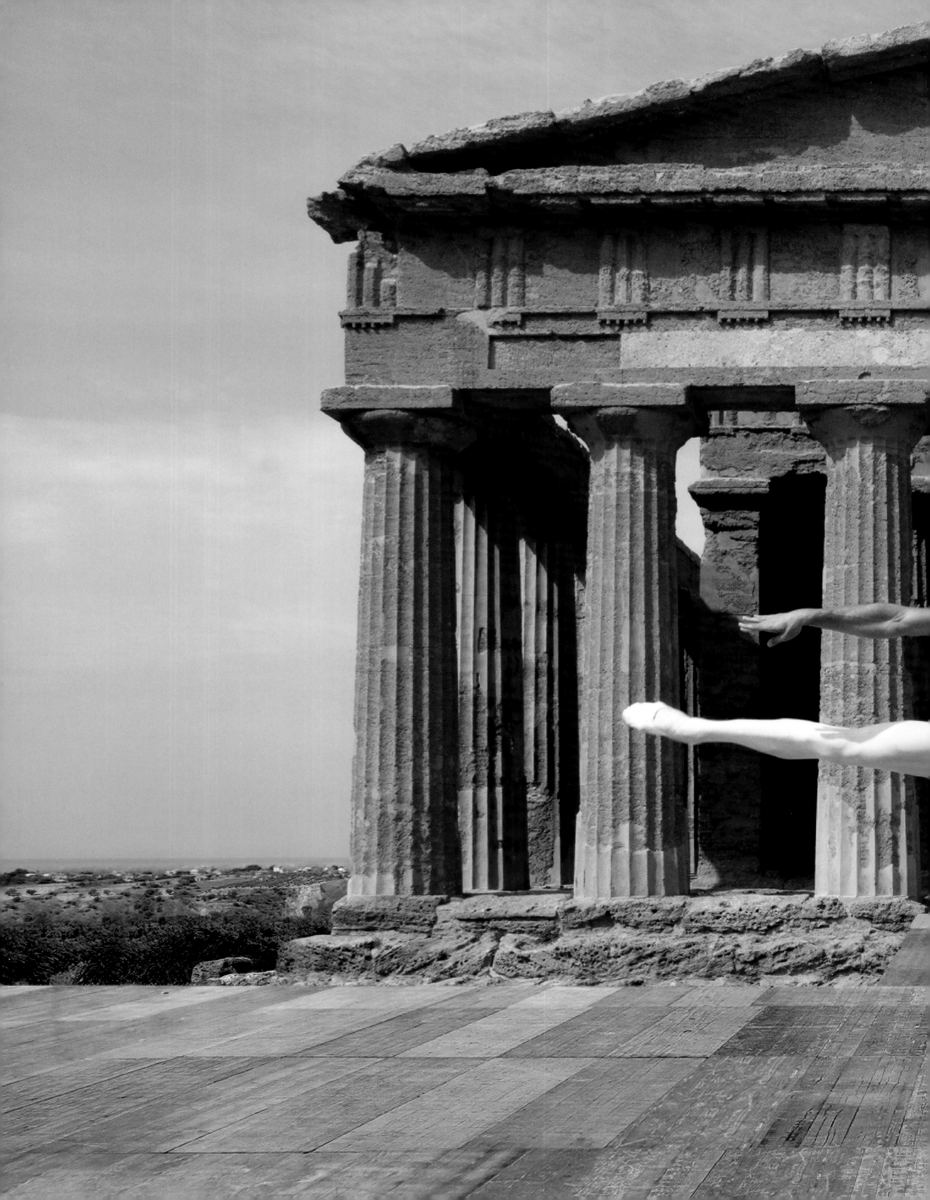

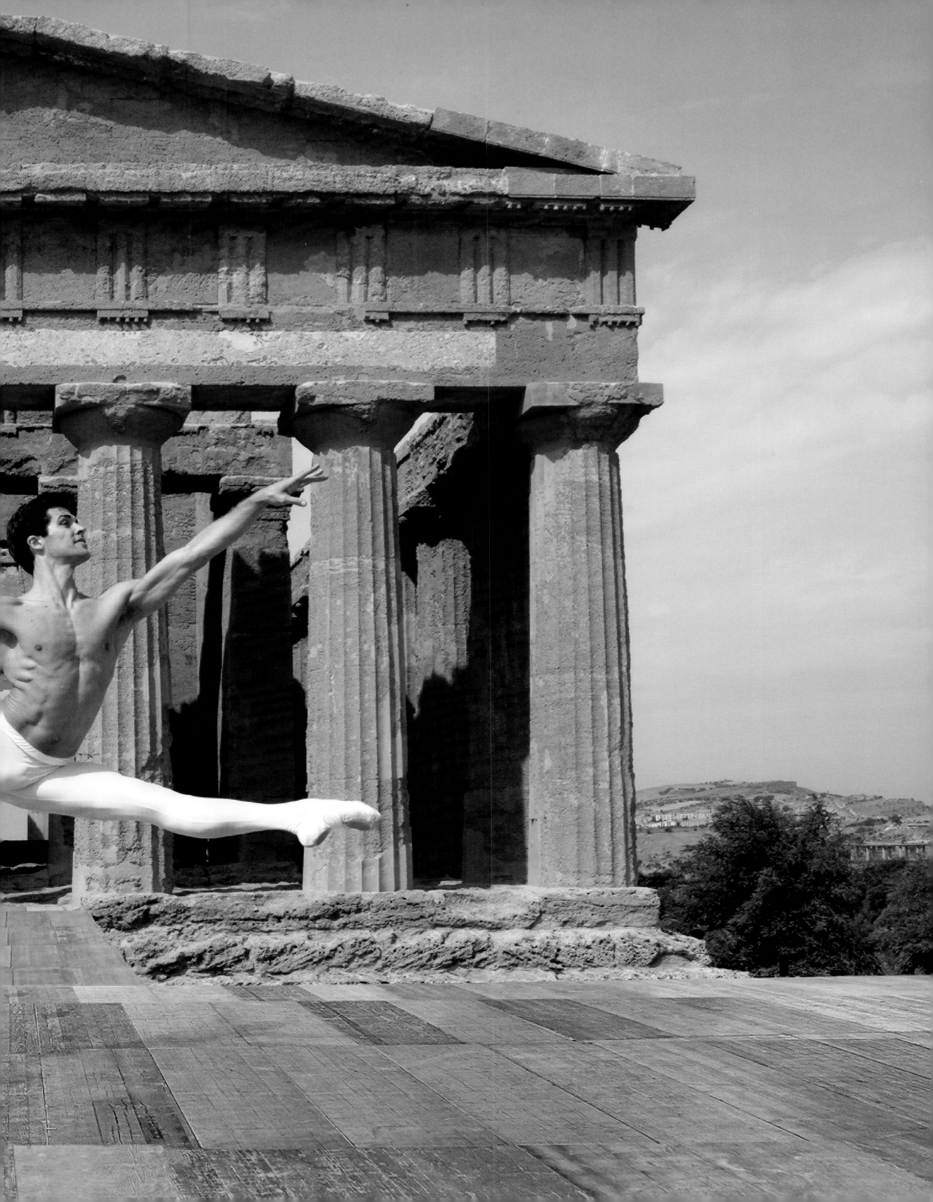

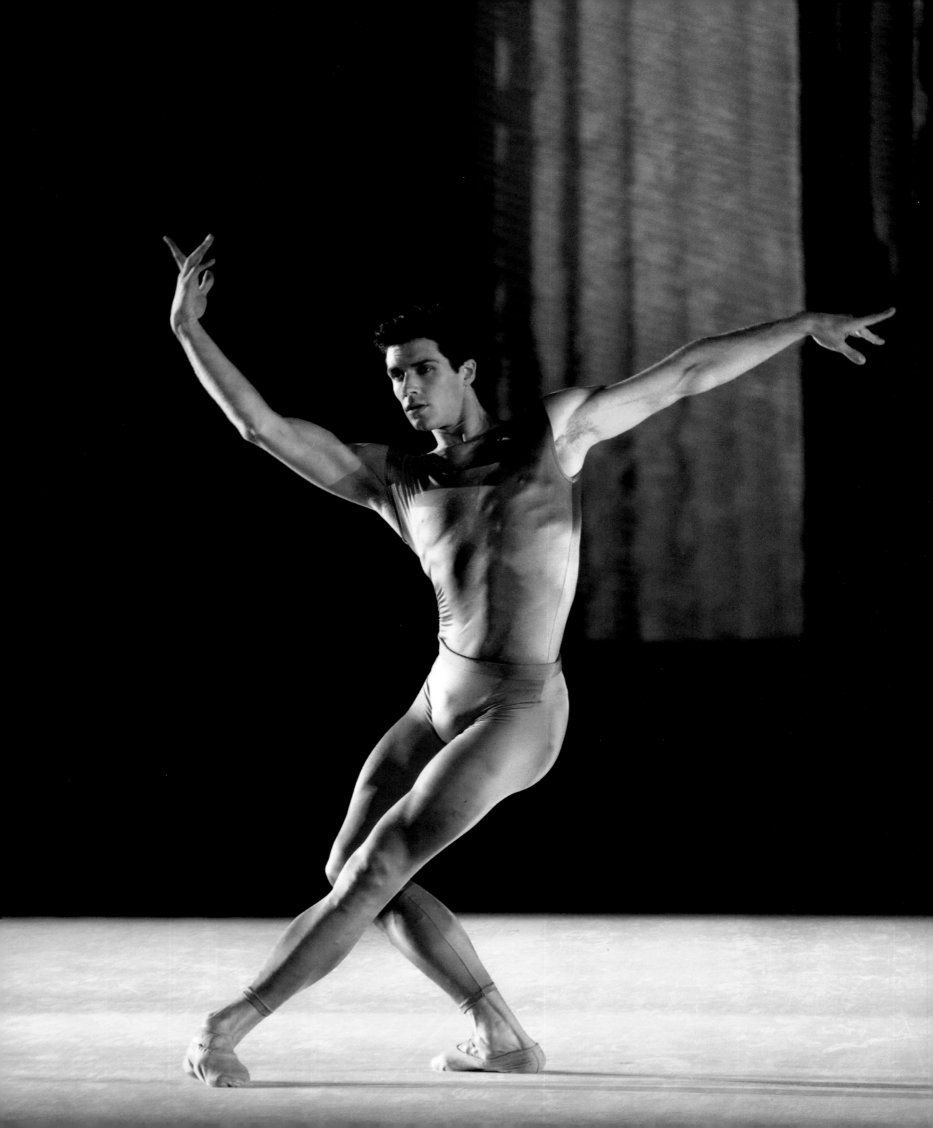

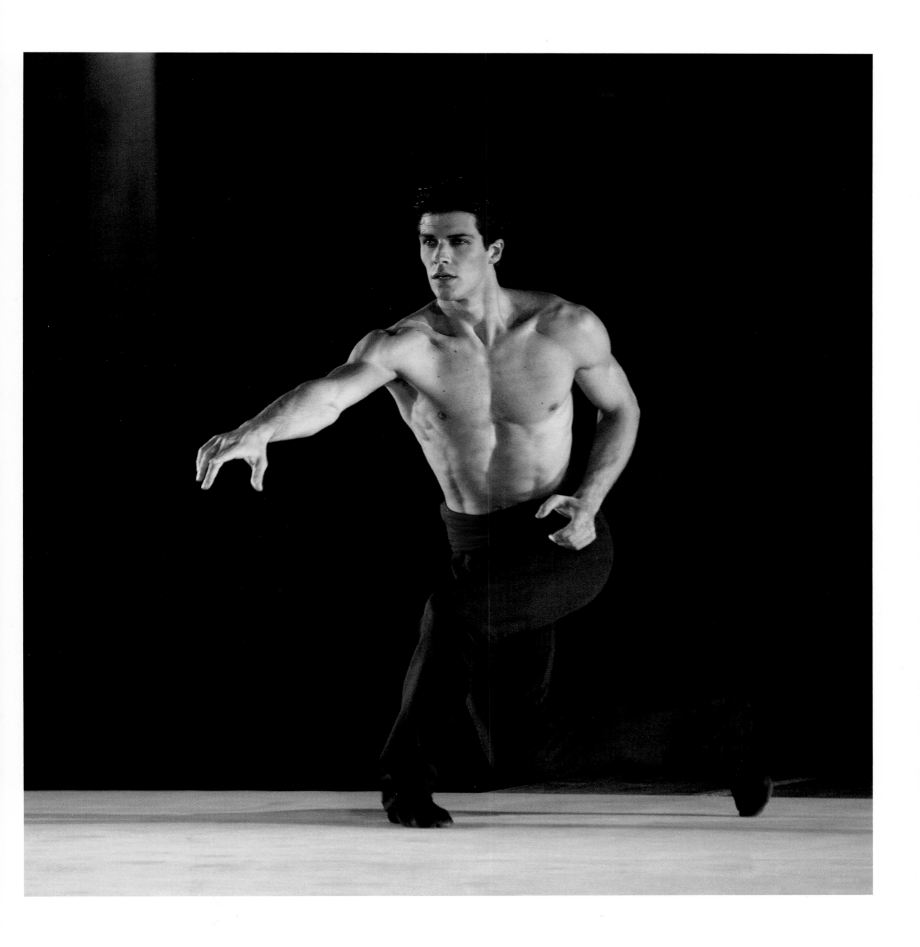

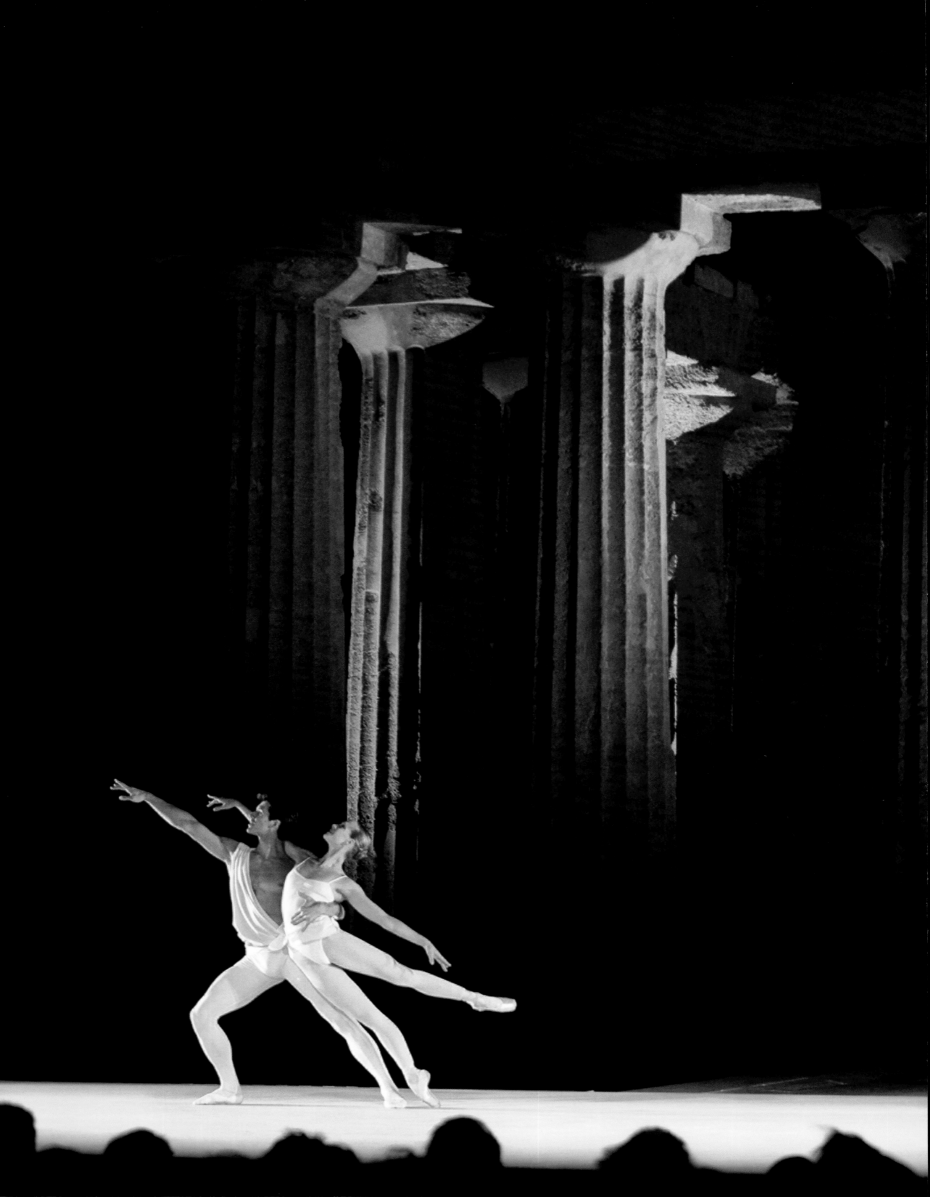

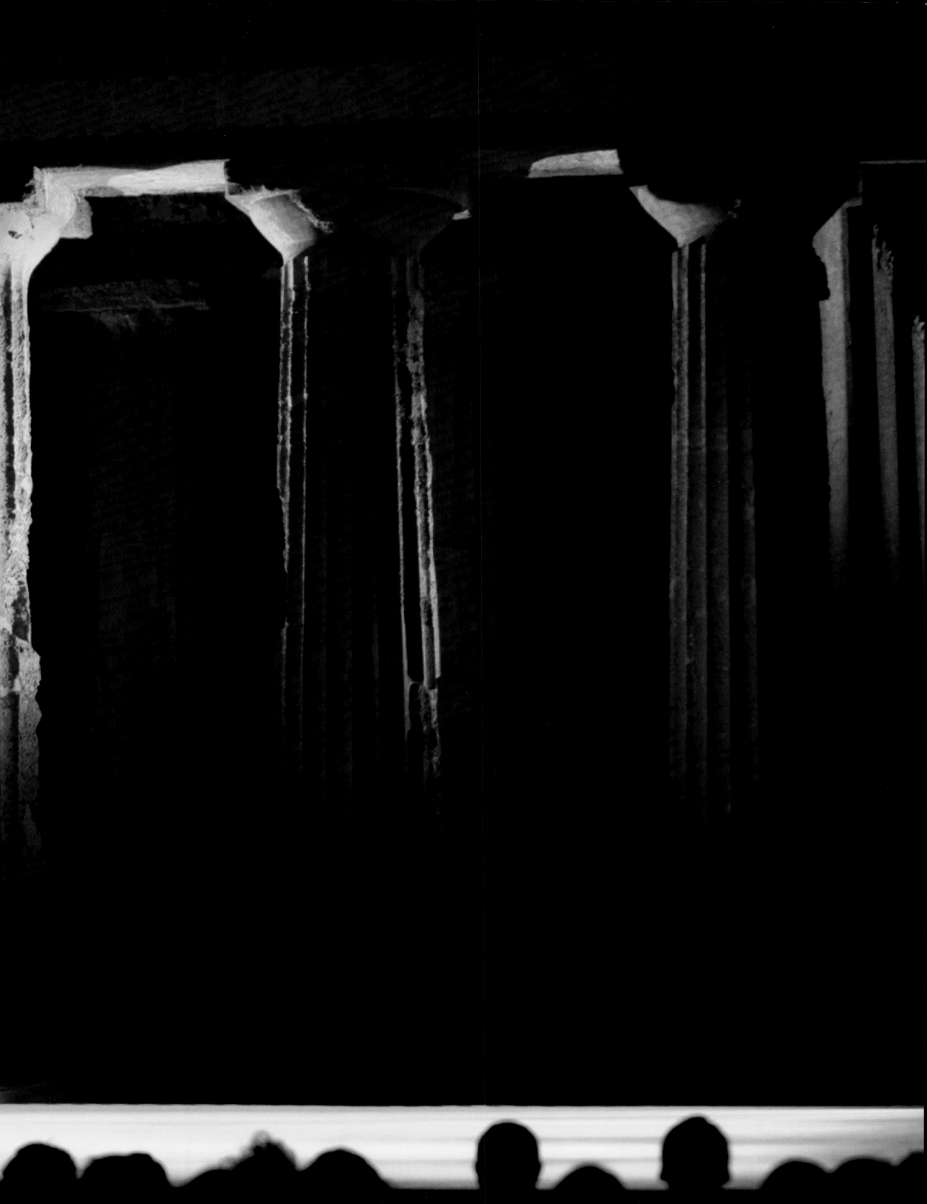

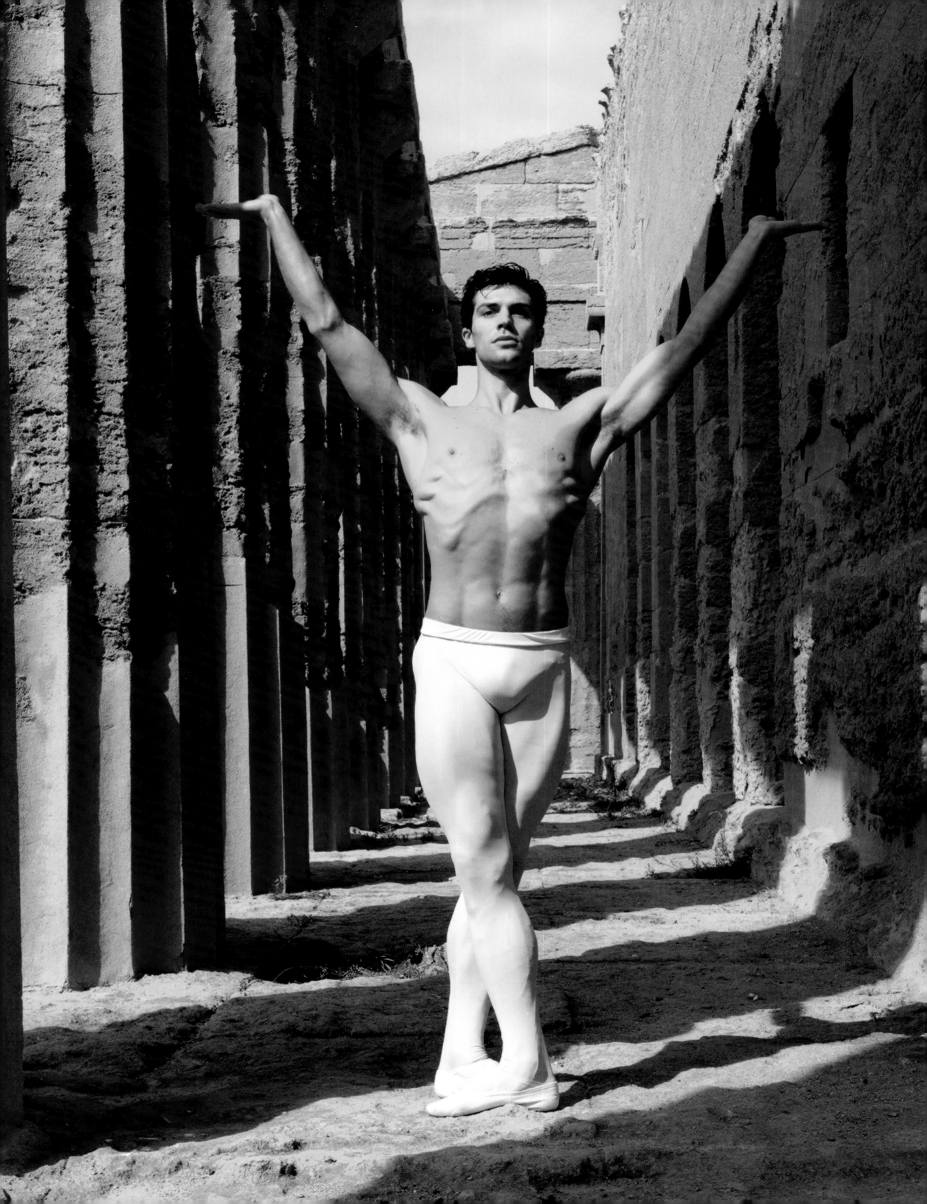

Mighty columns support the vault of heaven.
It is here where dance is connected to the cosmos.

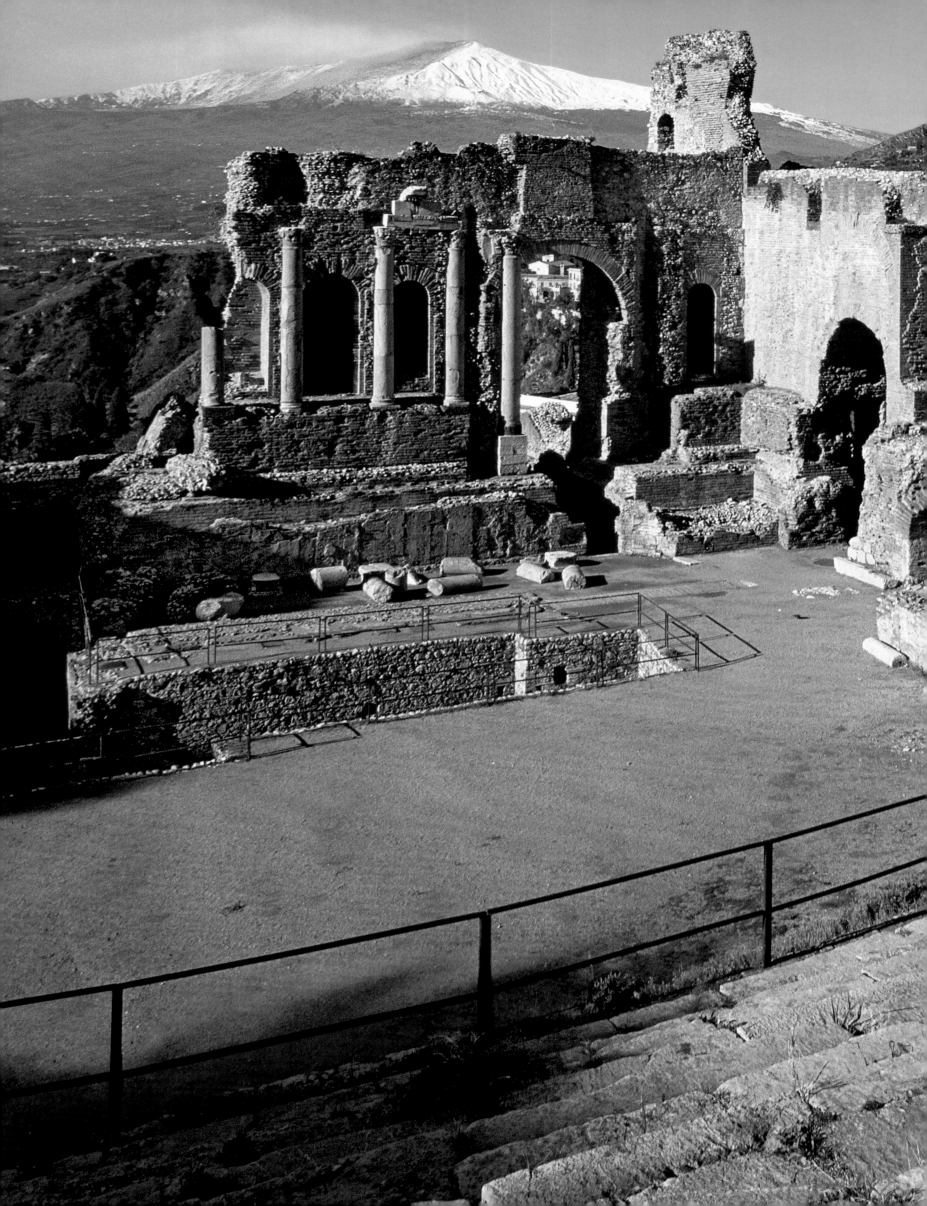

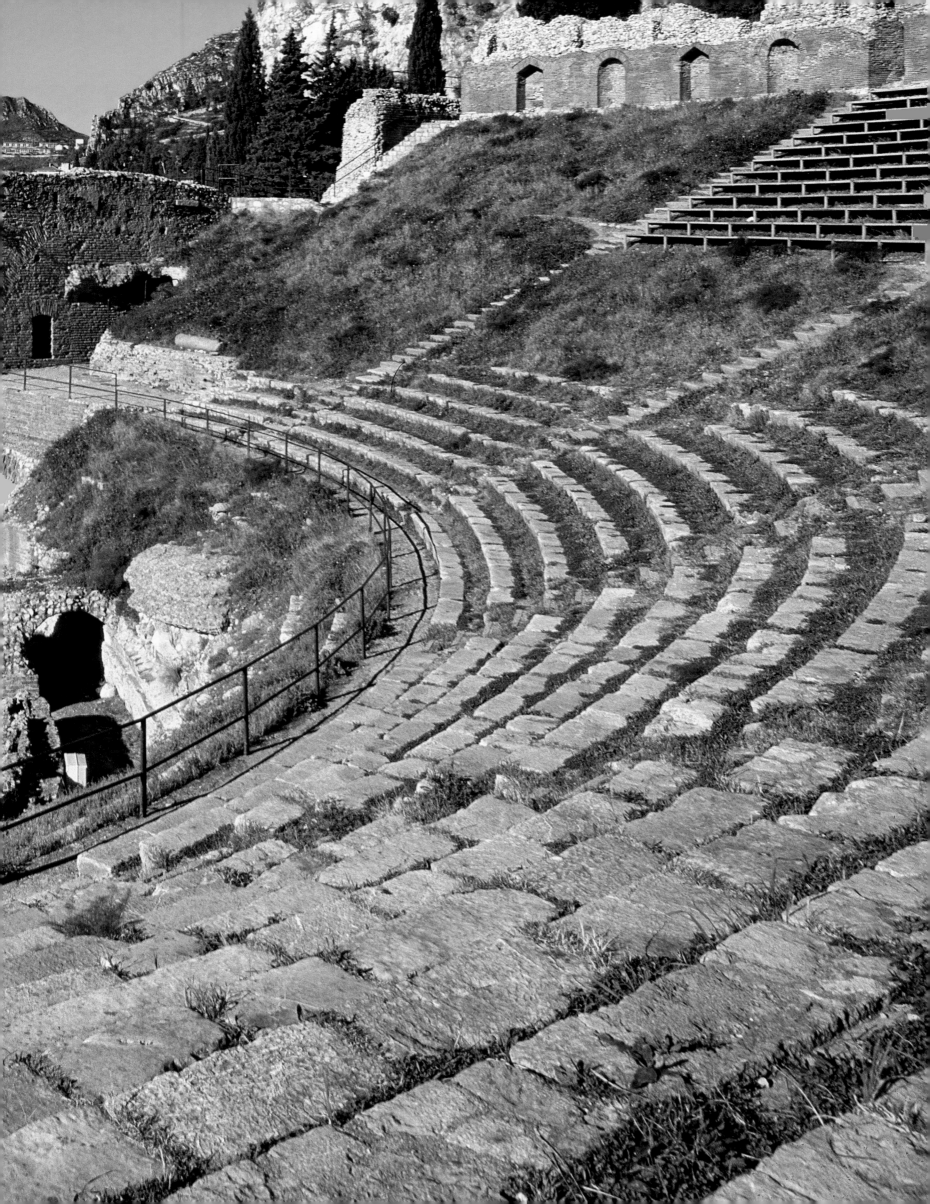

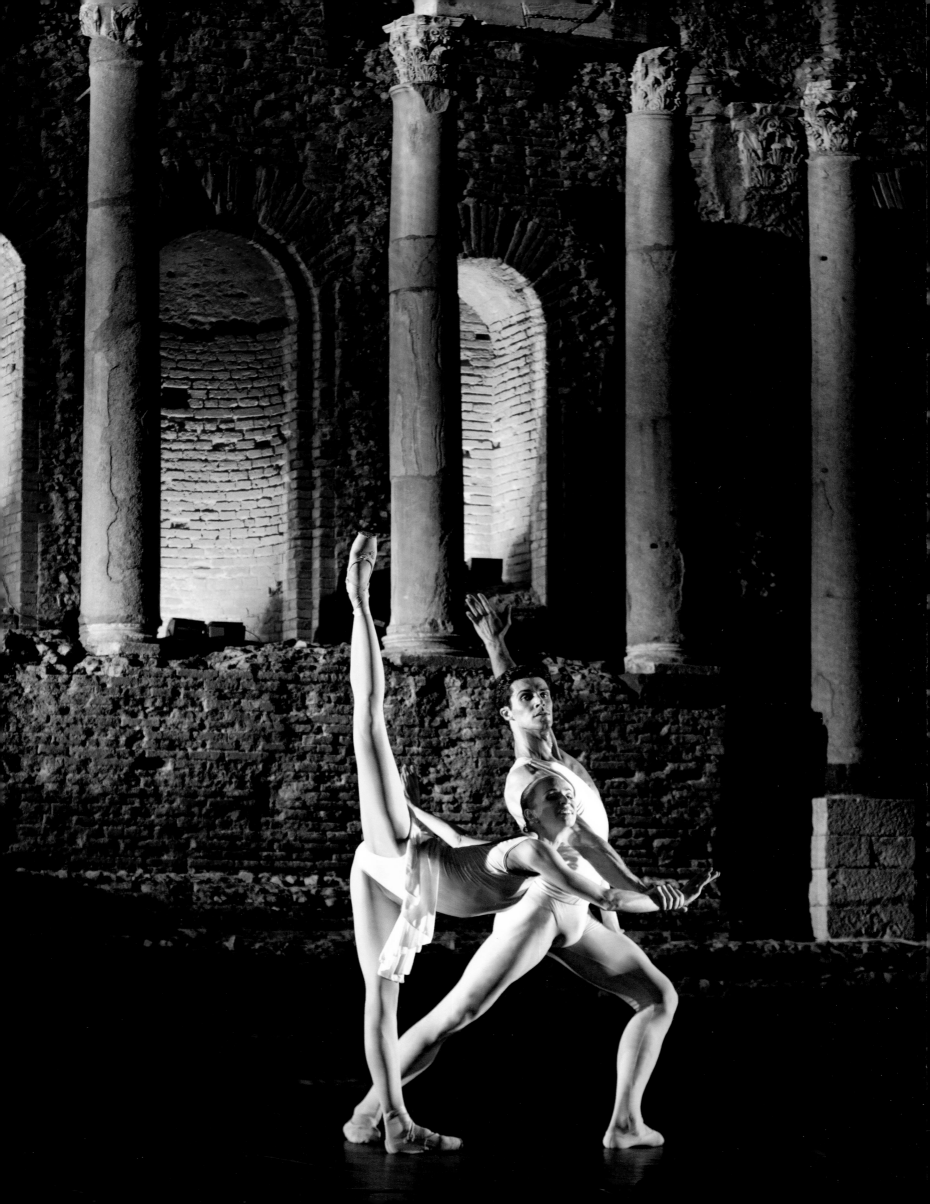

At Taormina's Teatro Antico, the architecture
of 2,000 years ago is suspended above the sea,
watched over by the austere profile of Mount Etna.
Time seems to stop here, bewitched by dance.

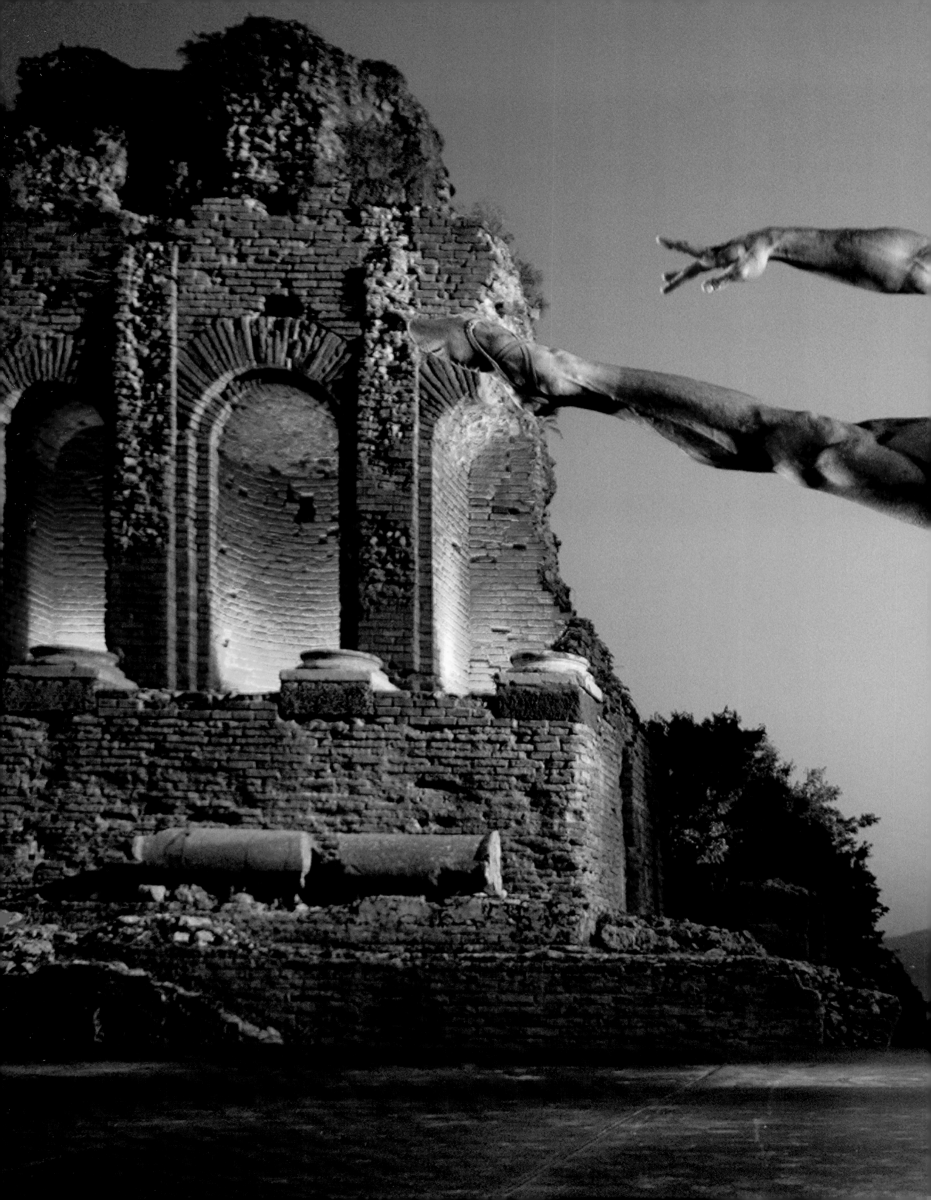

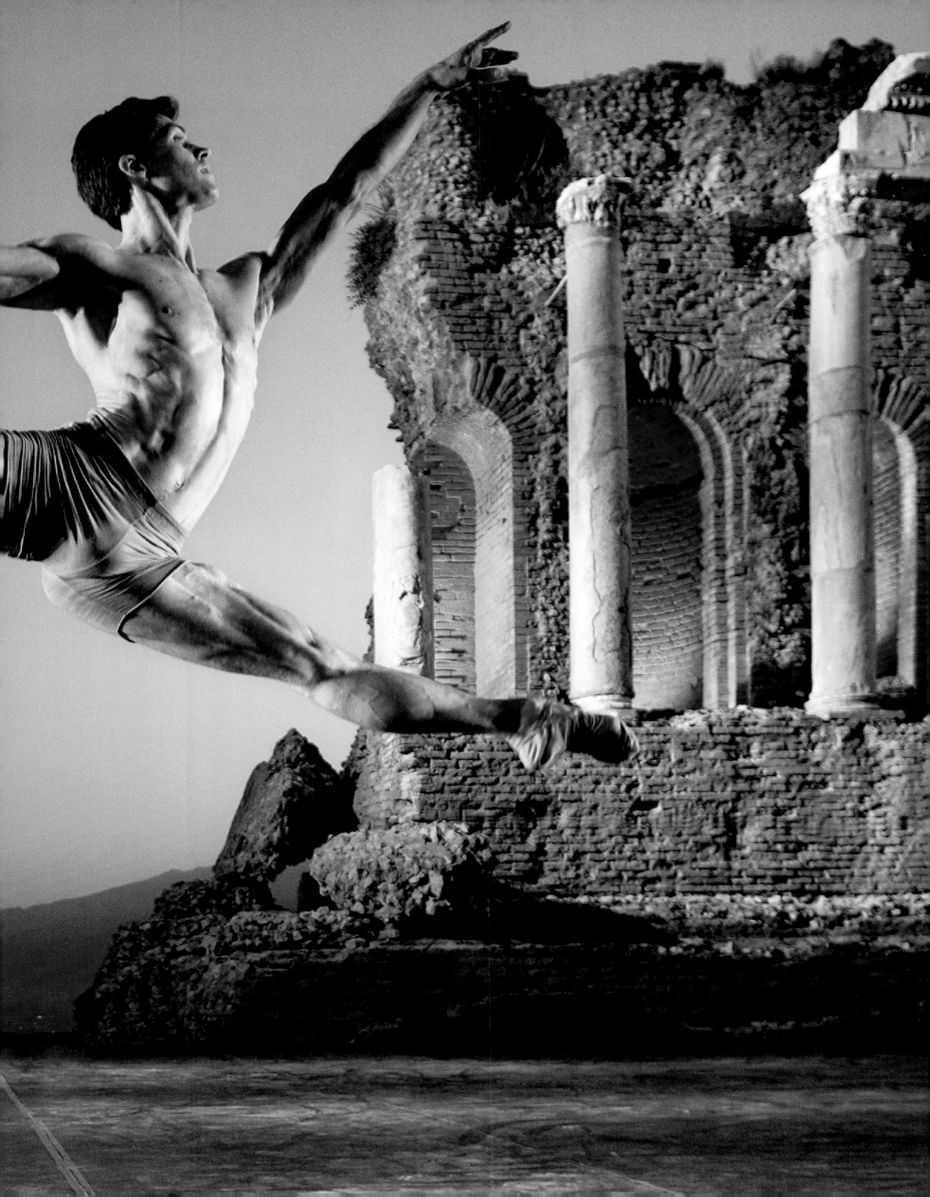

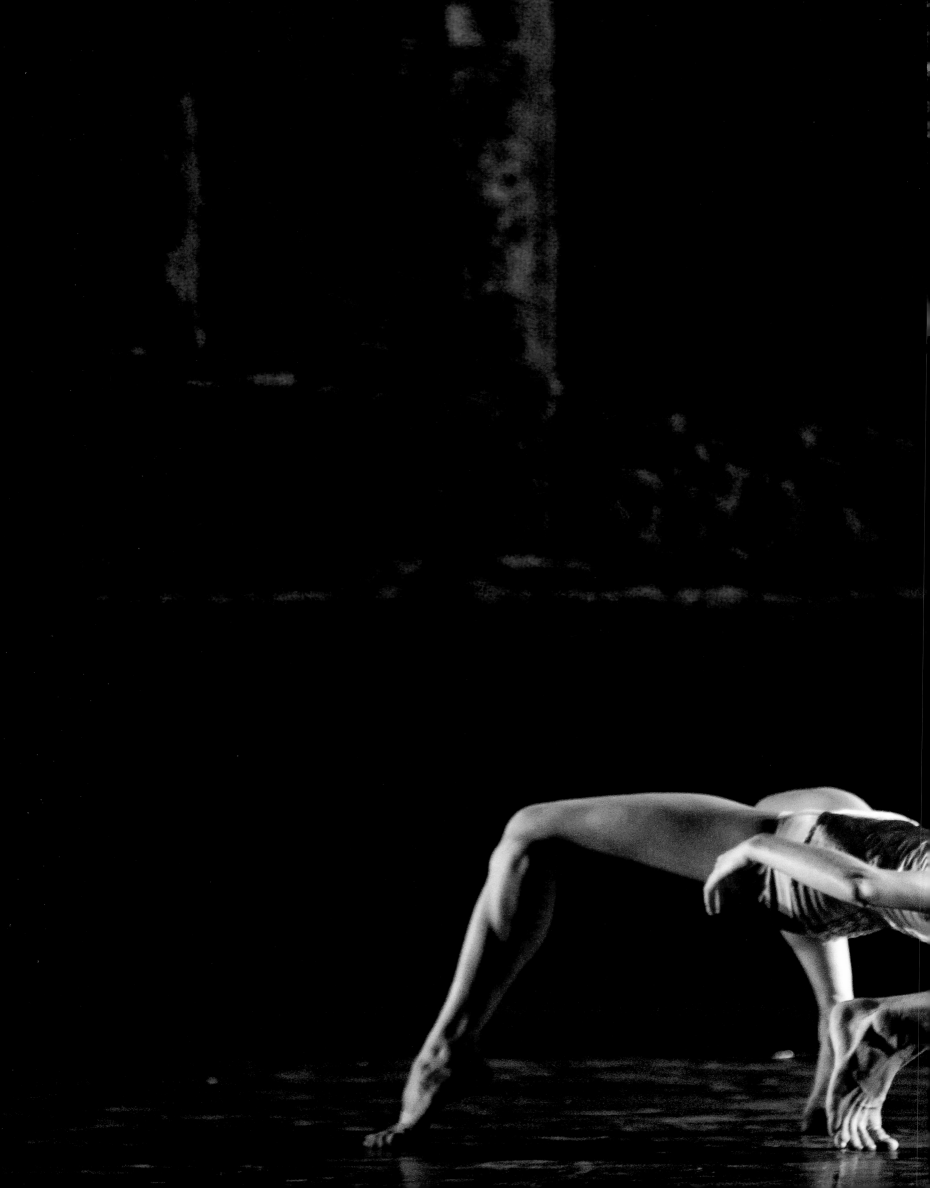

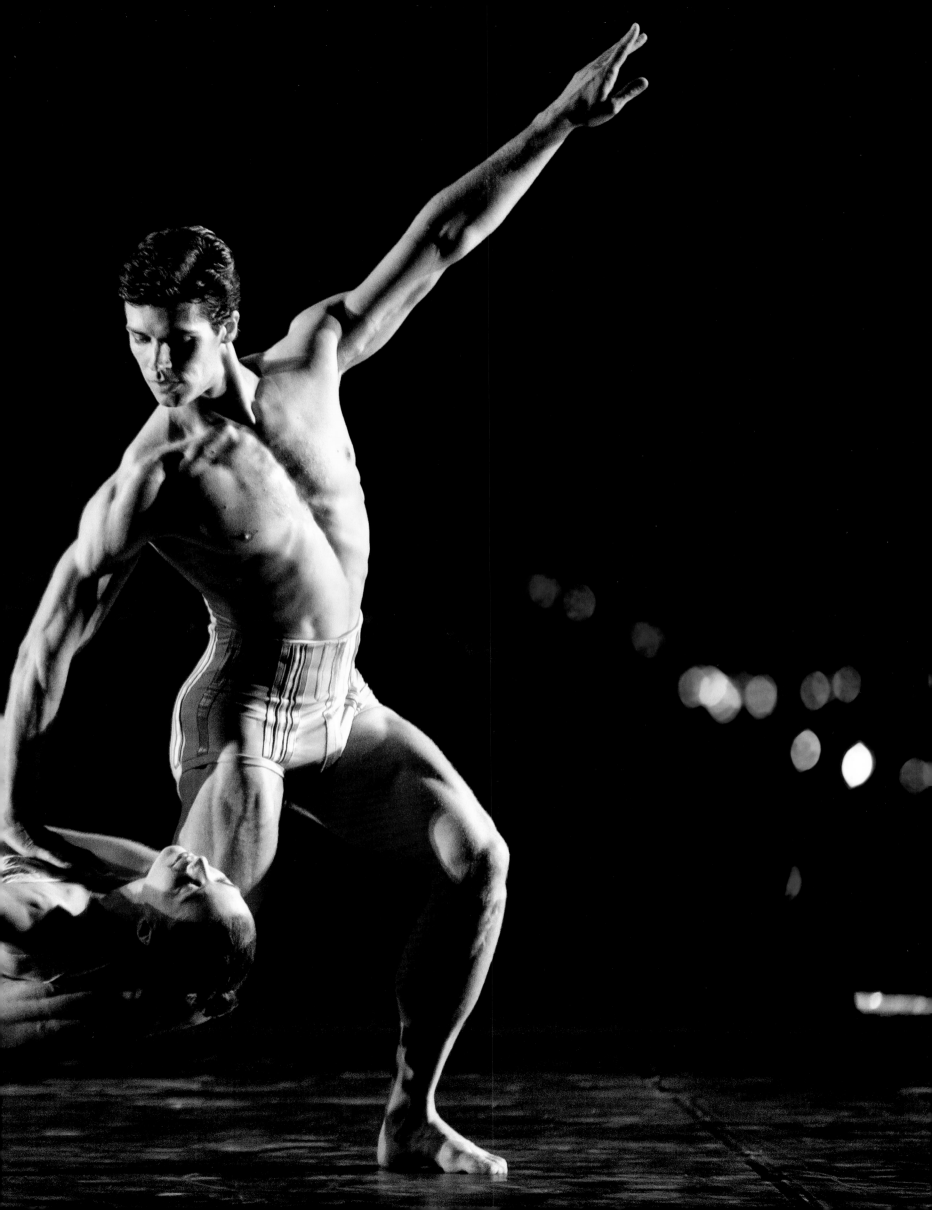

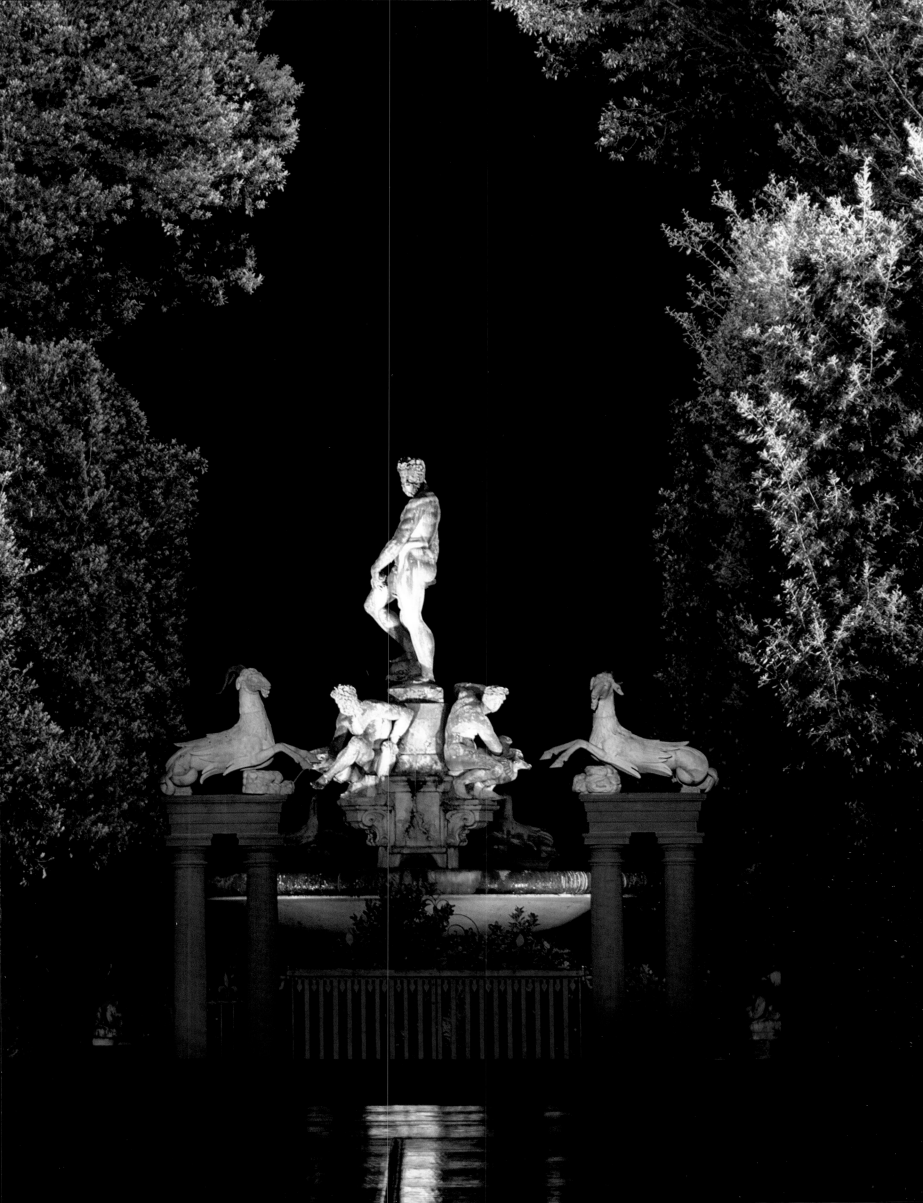

In Florence, city of the Medici family and Machiavelli,
art's ultimate purpose is to stimulate human intellect,
yet to preserve it requires vision.
Patronage is the greatest moral legacy
of the Renaissance.

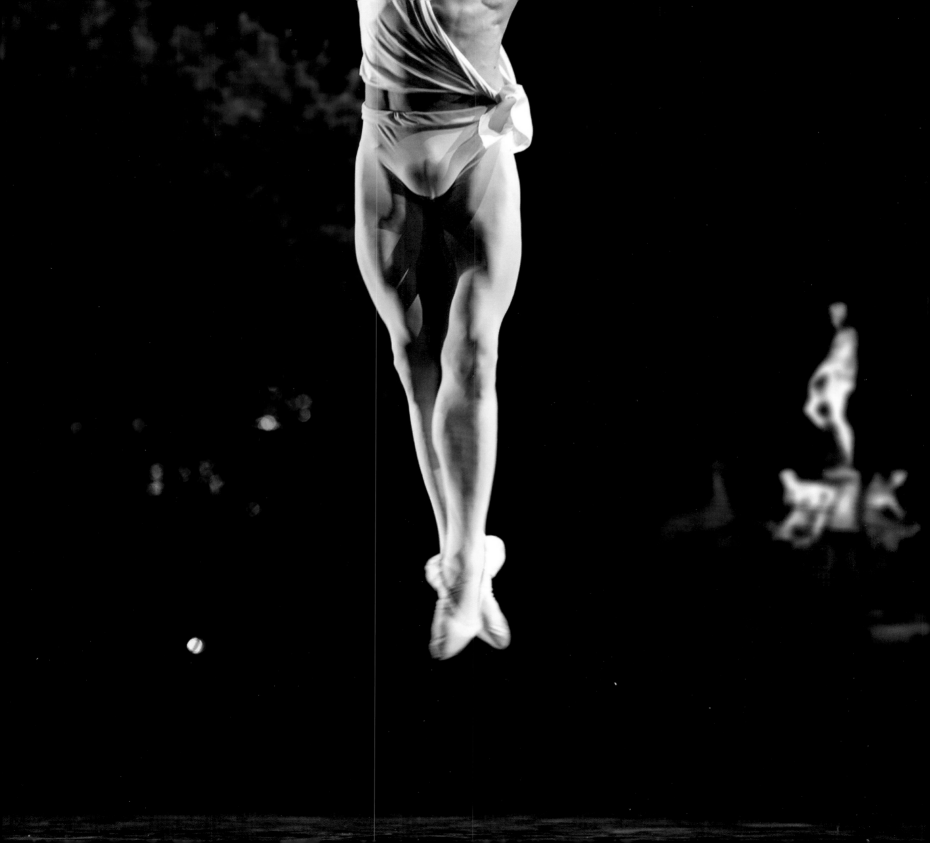

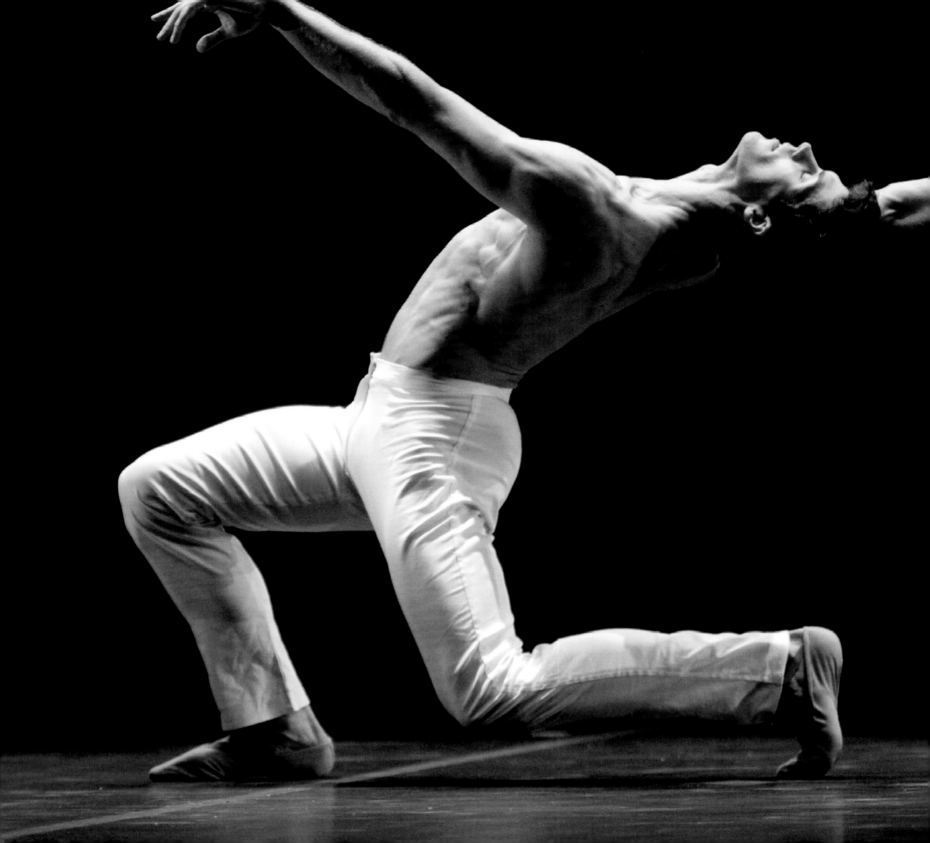

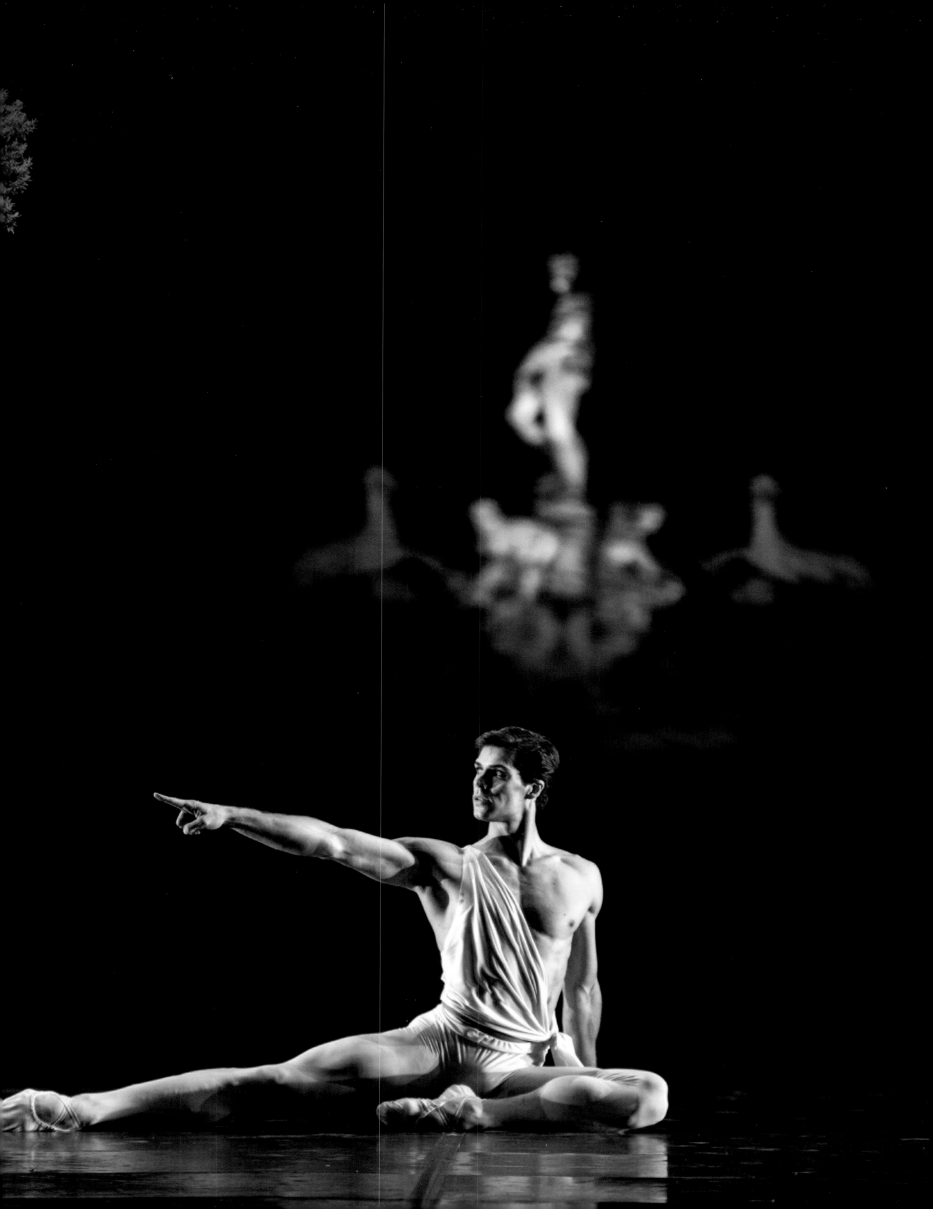

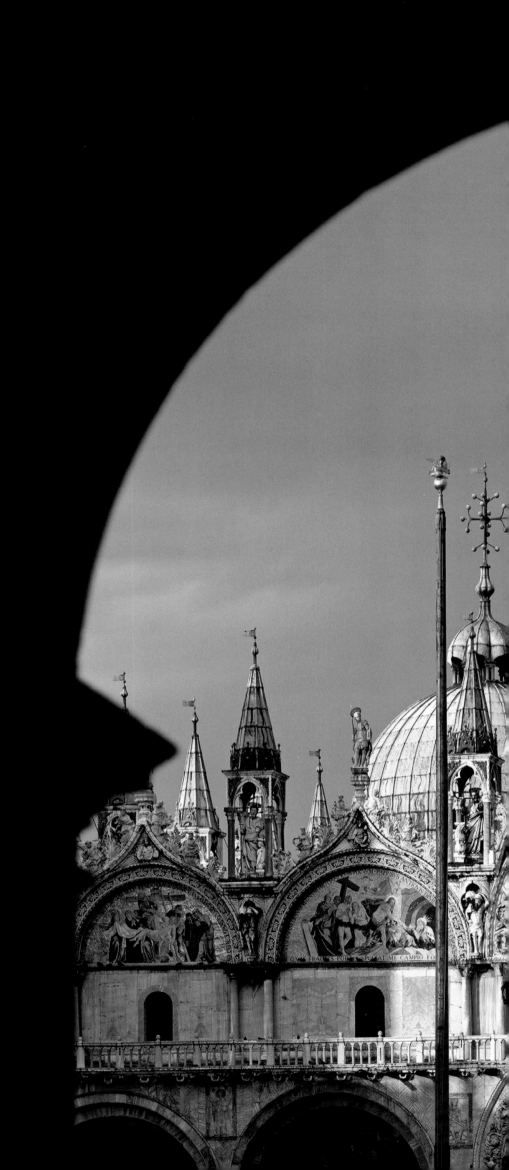

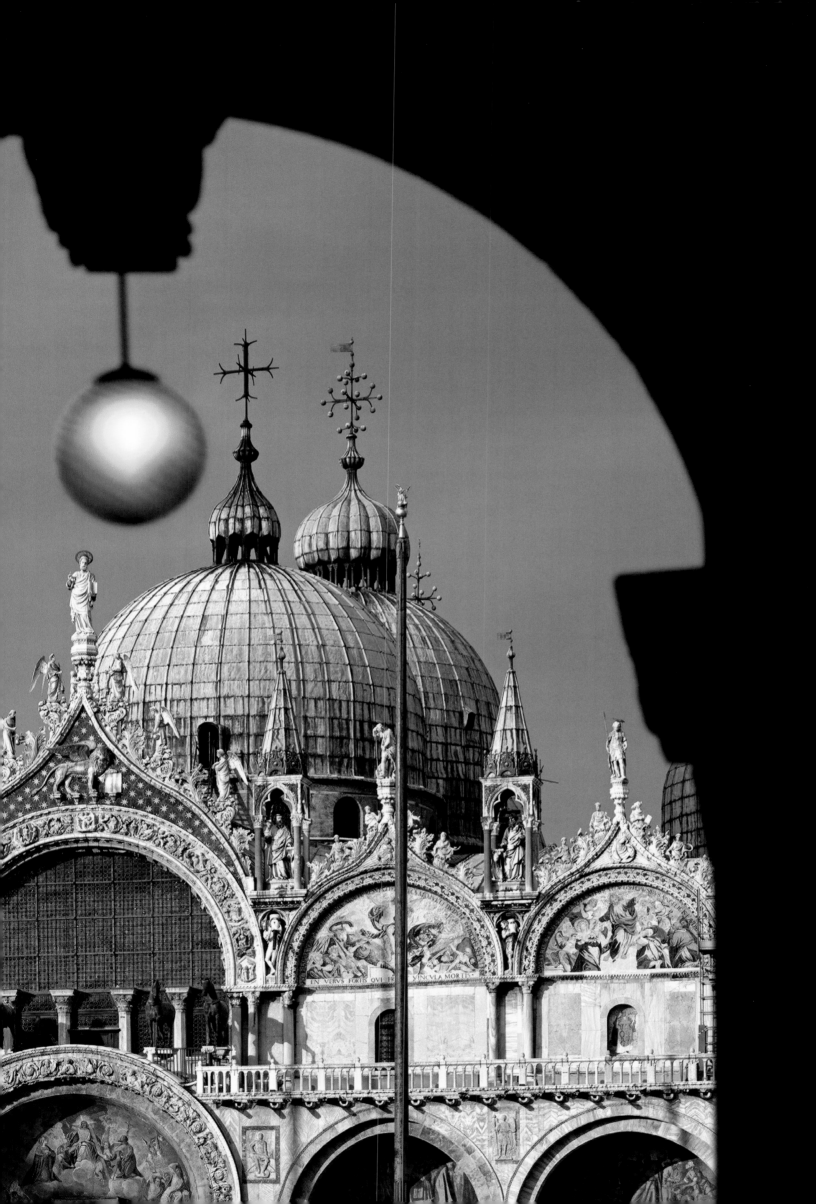

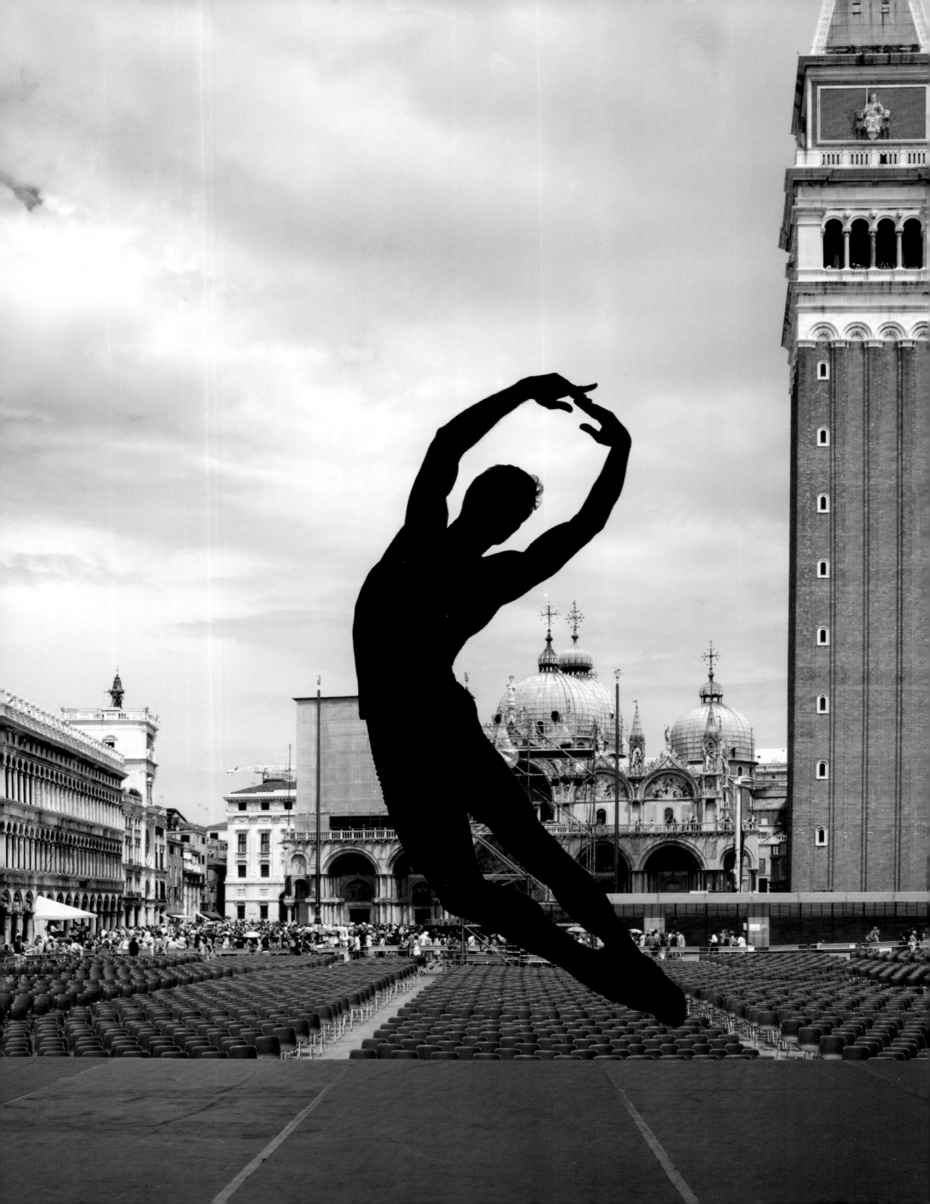

Water erodes the art and history of Venice,
a giant with feet of clay. Like dance,
Venice's beauty is ephemeral, constantly challenging
our ability to safeguard the spell sparked
by the genius of humankind.

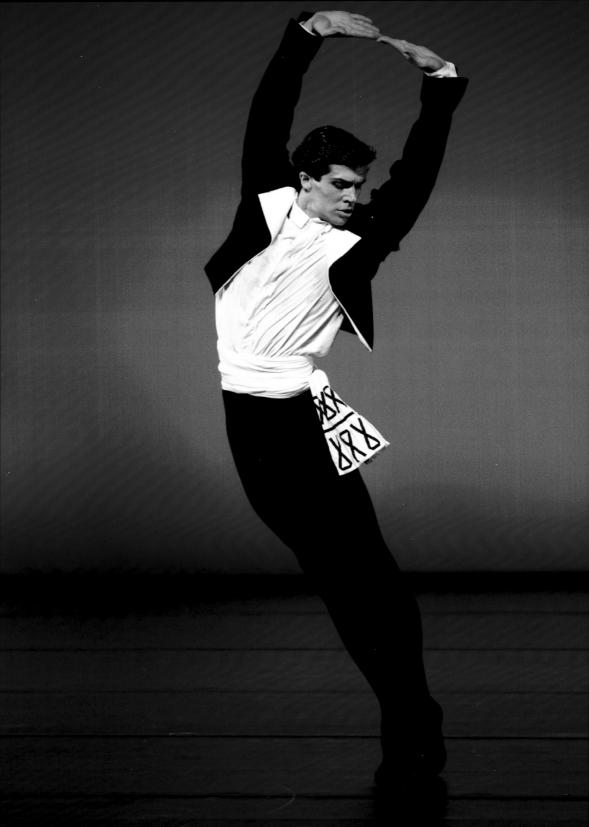

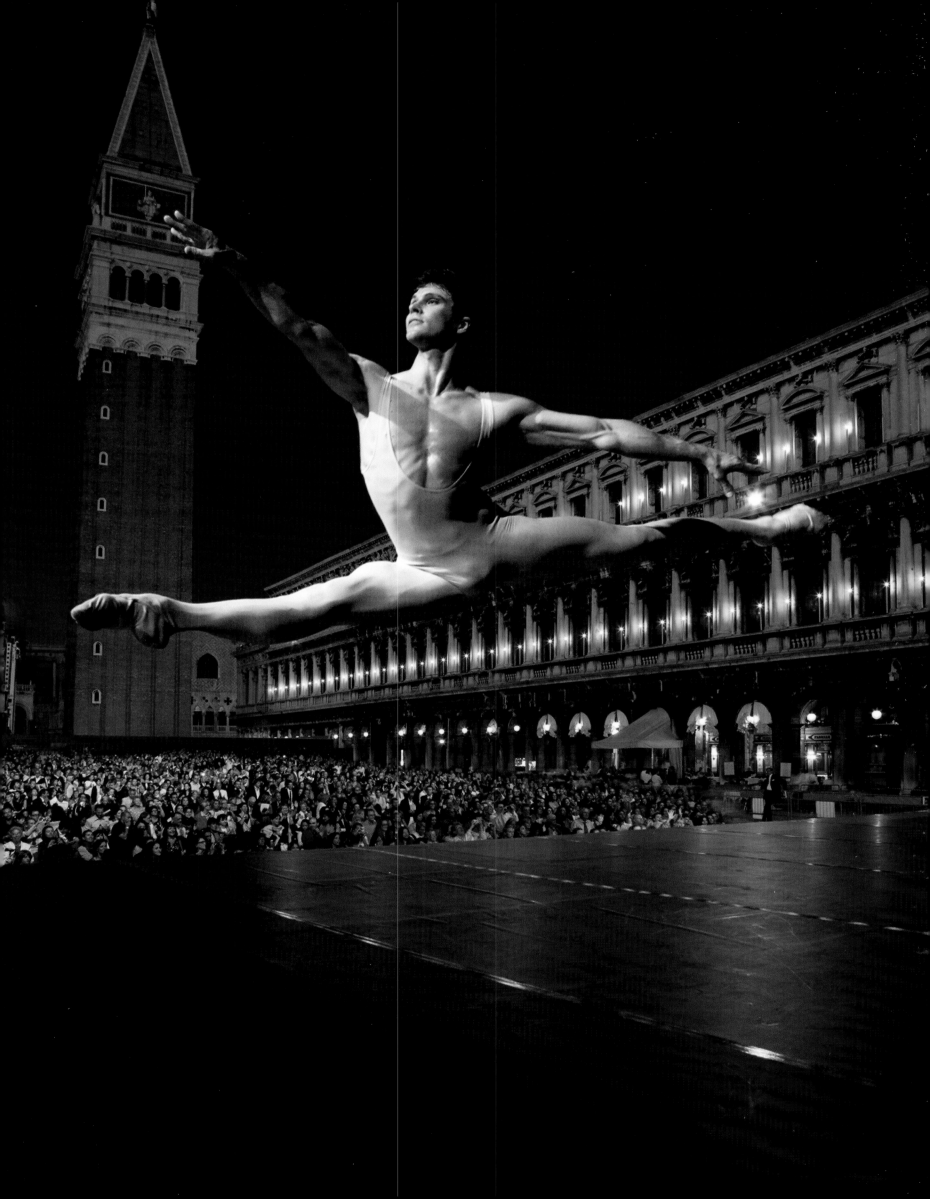

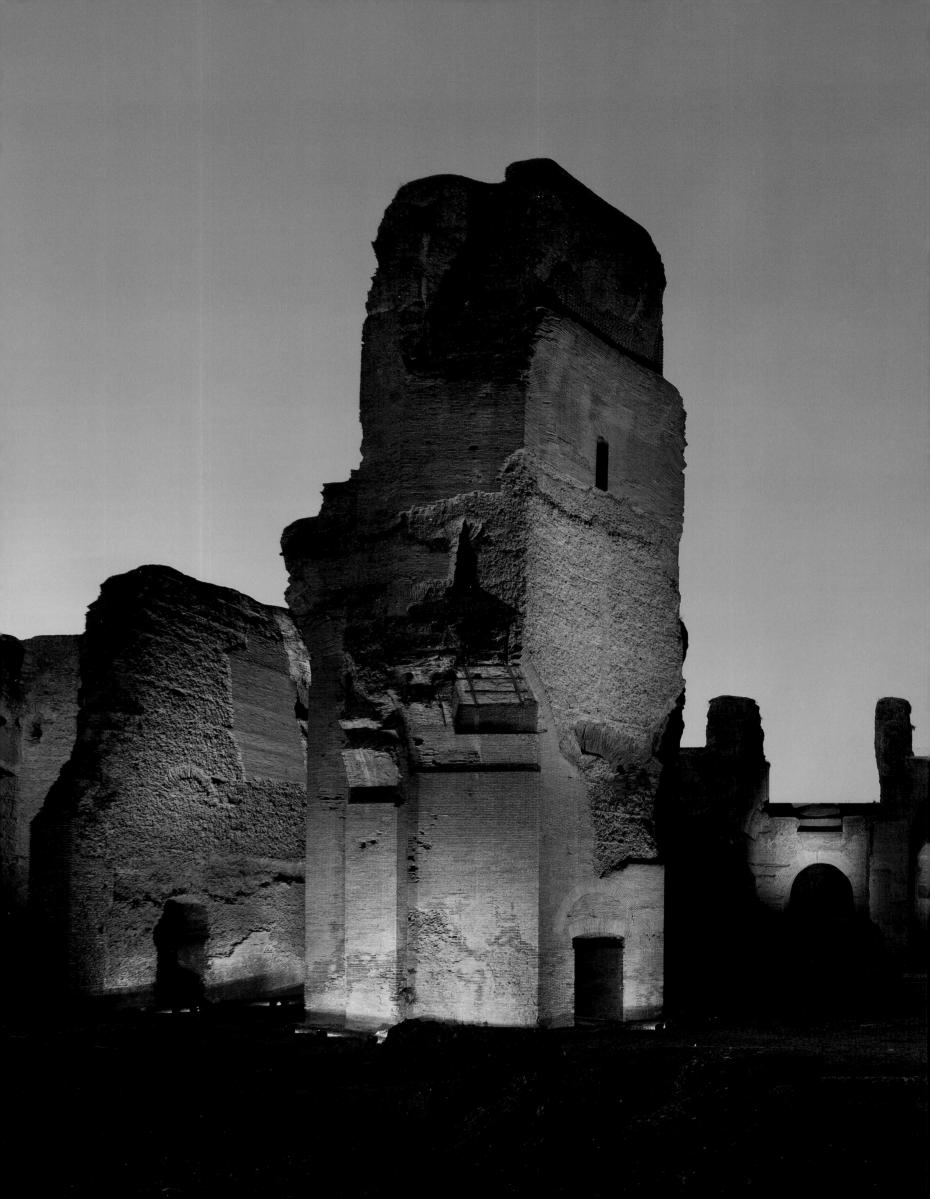

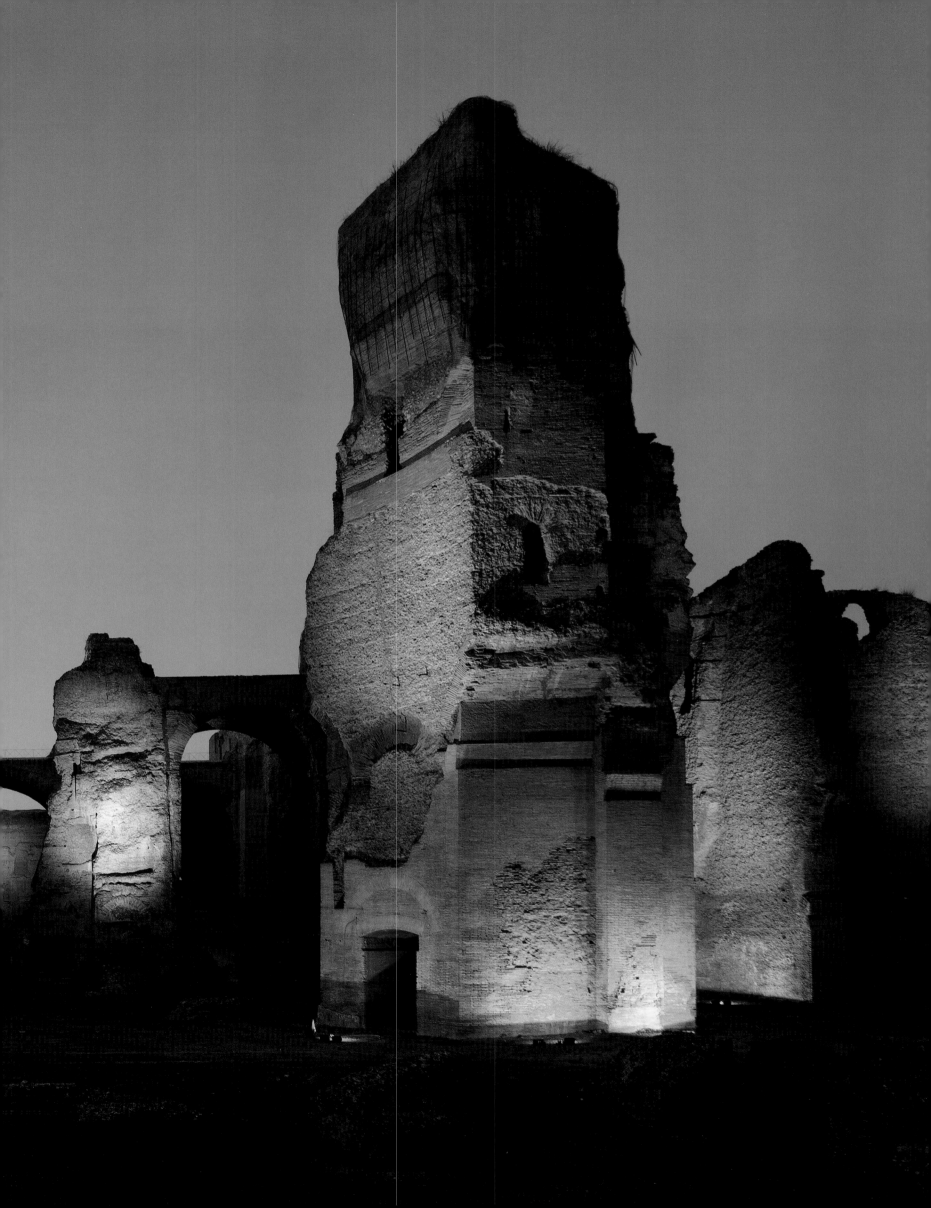

In Ancient Rome, art and culture shaped man.
In Italy today, they are the most precious foundations
upon which to build a new Renaissance.

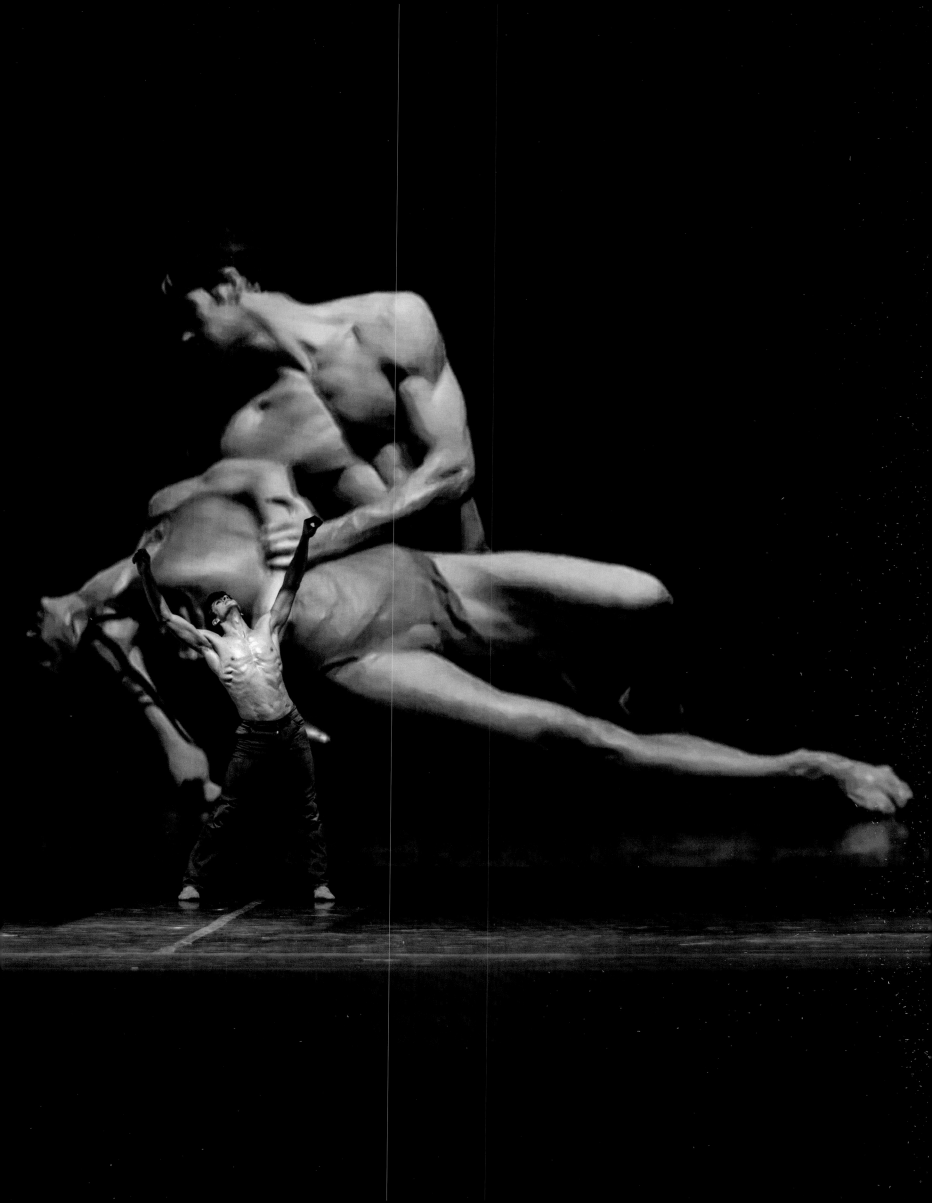

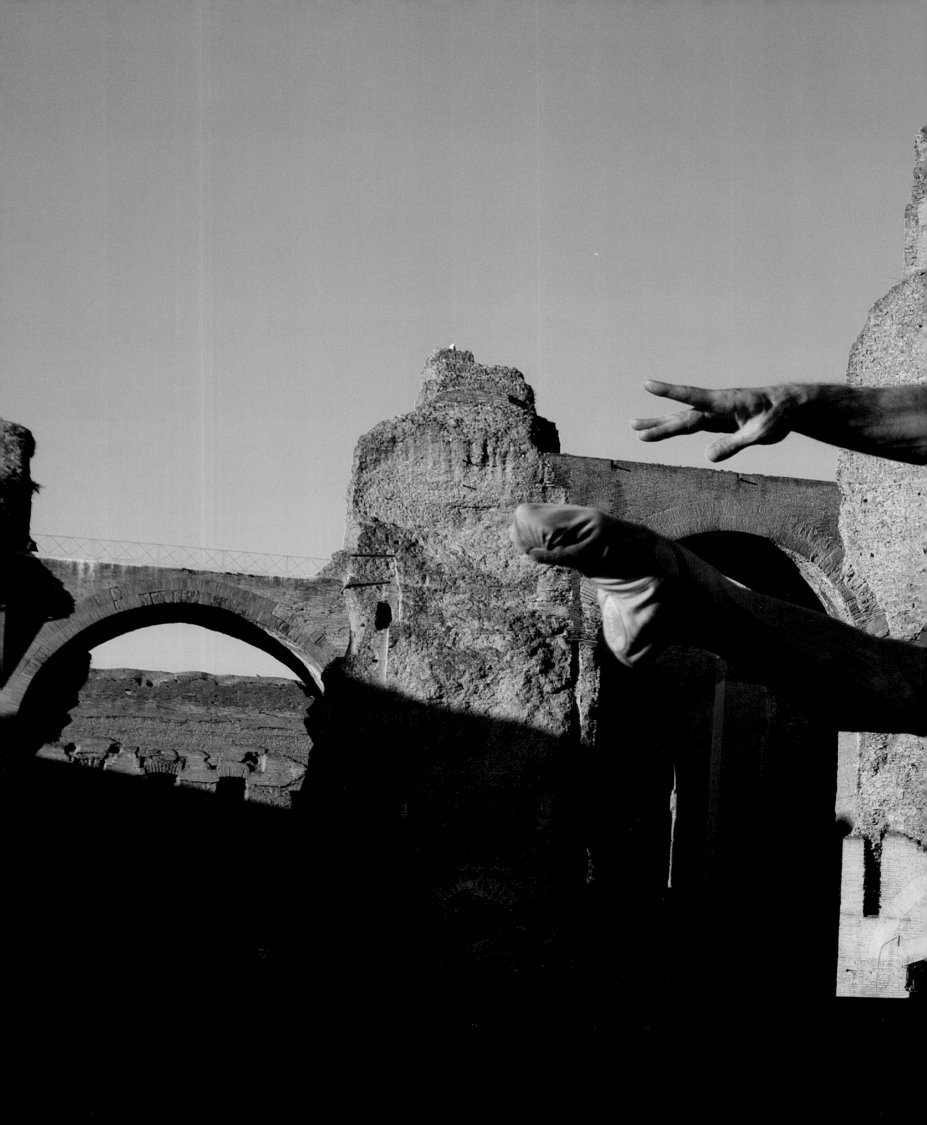

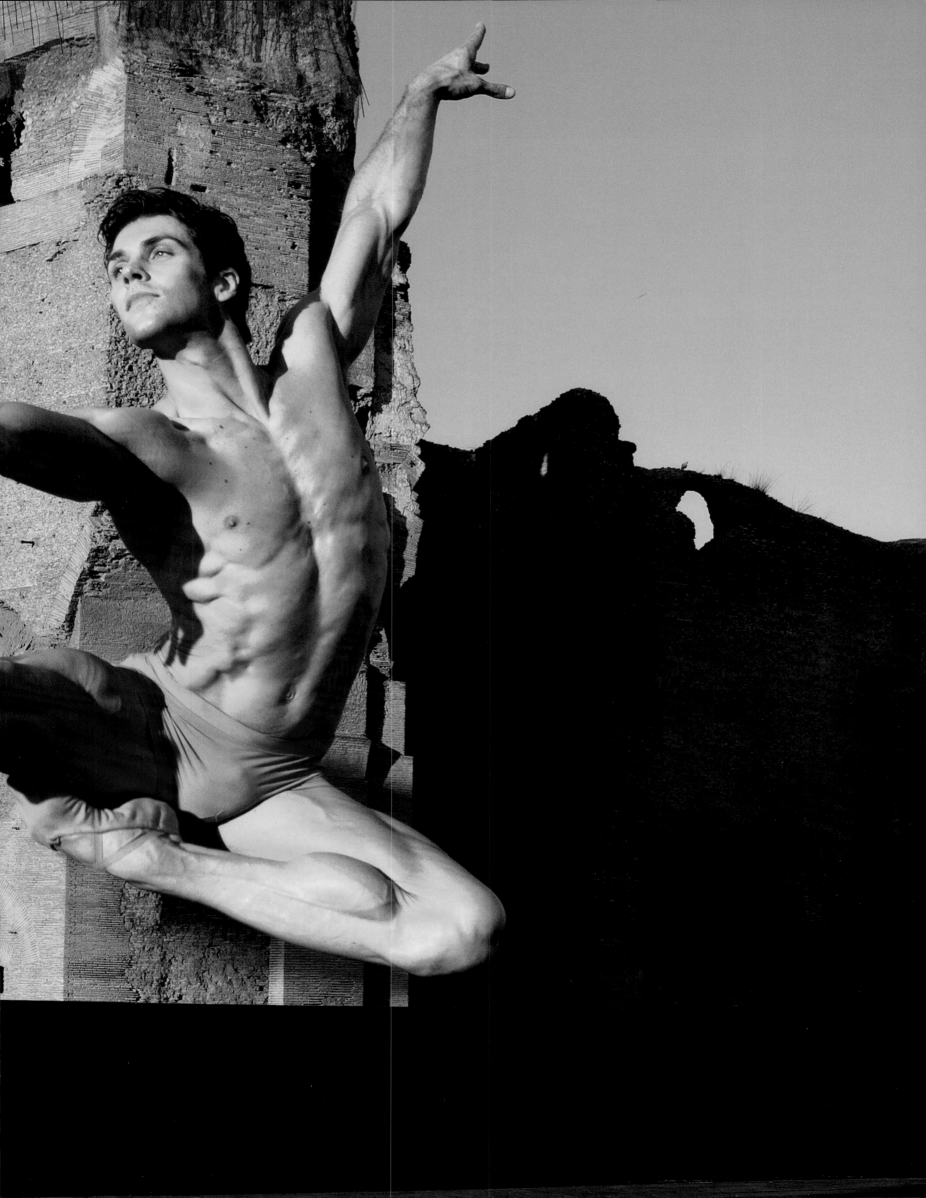

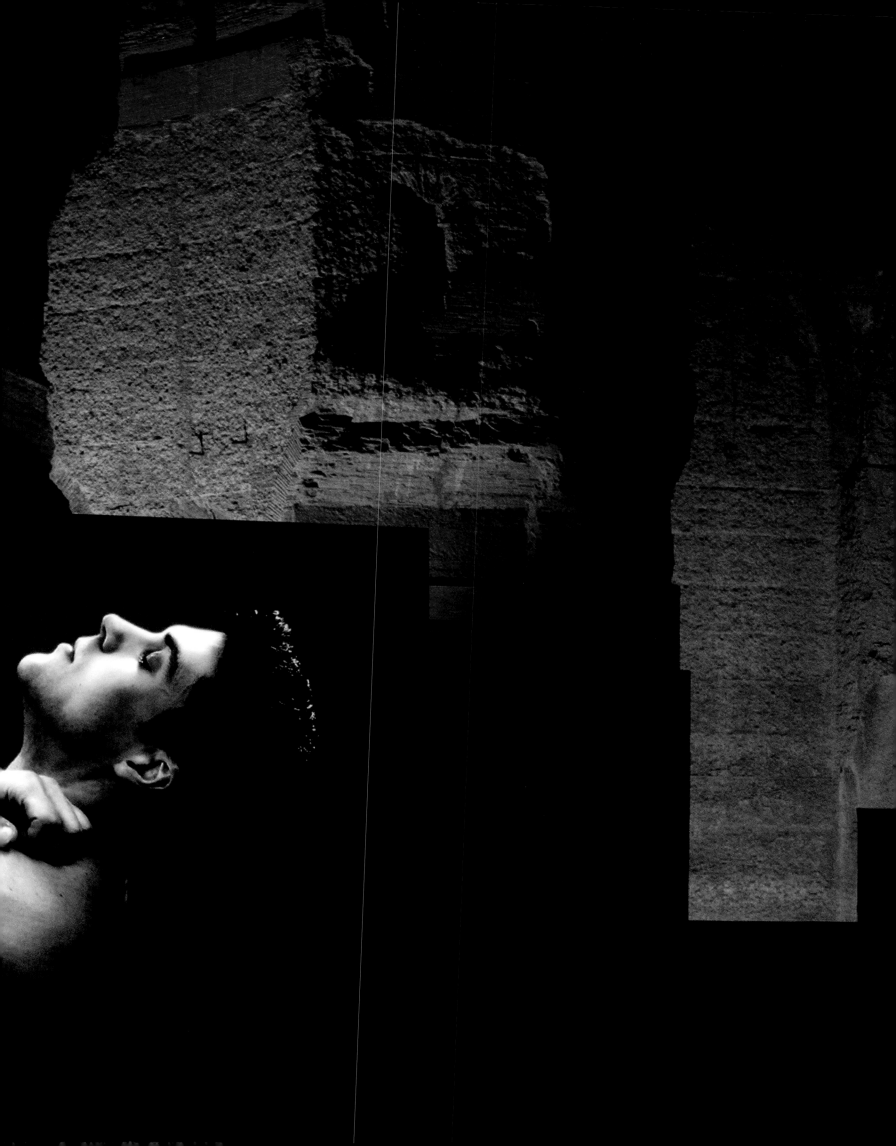

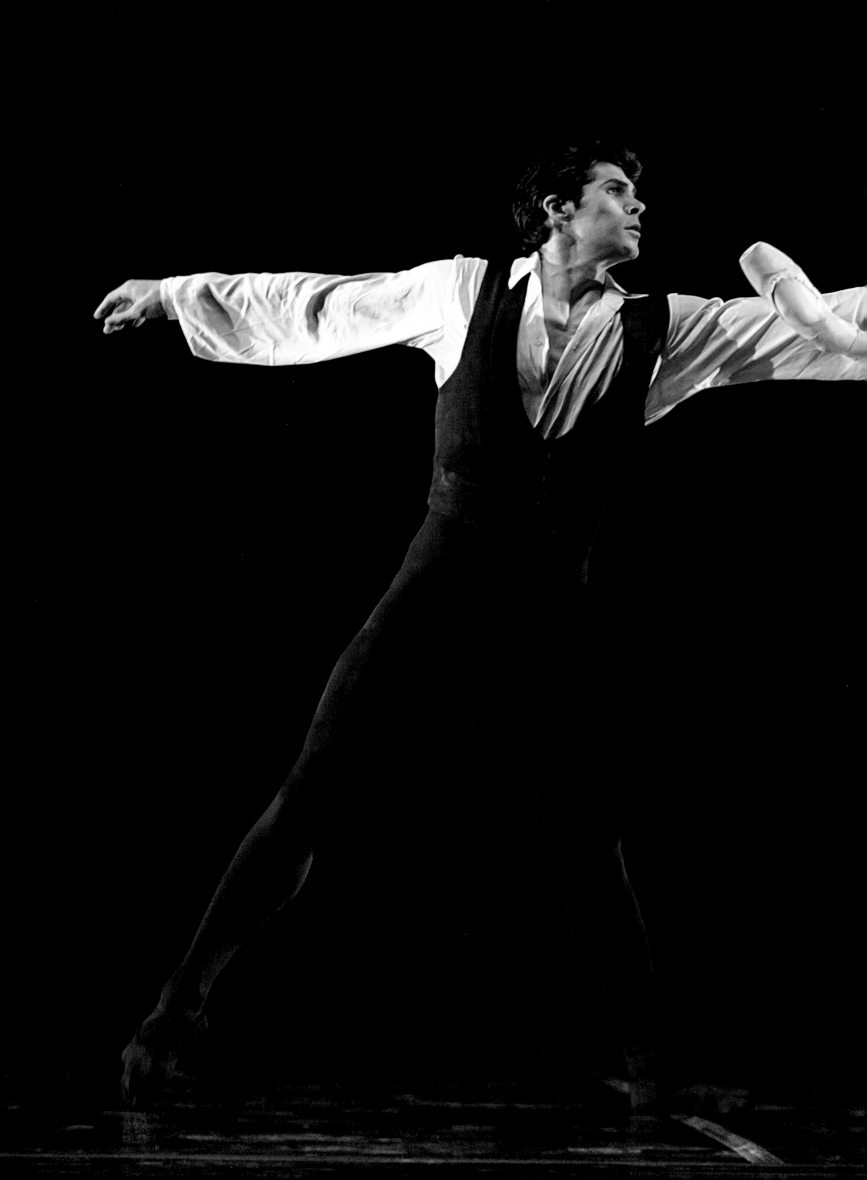

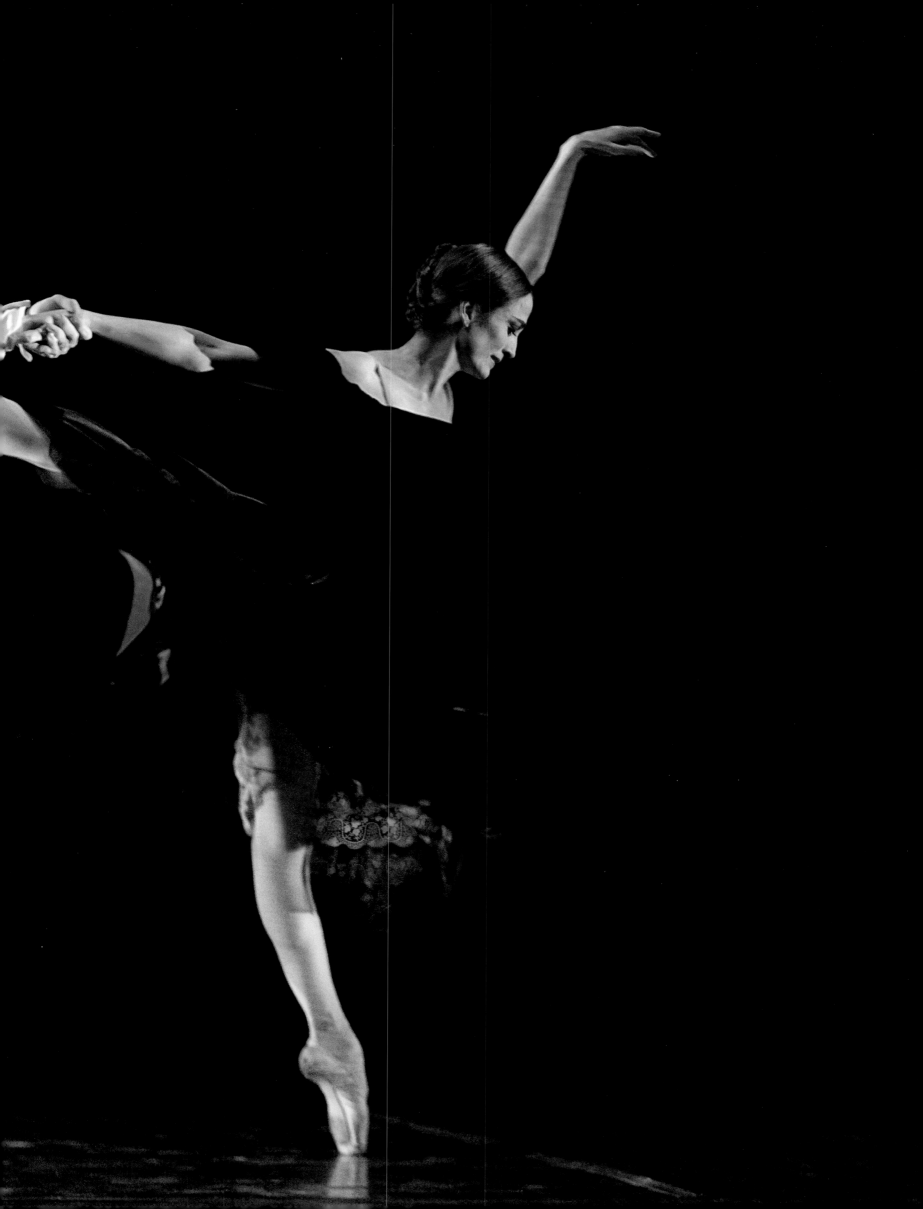

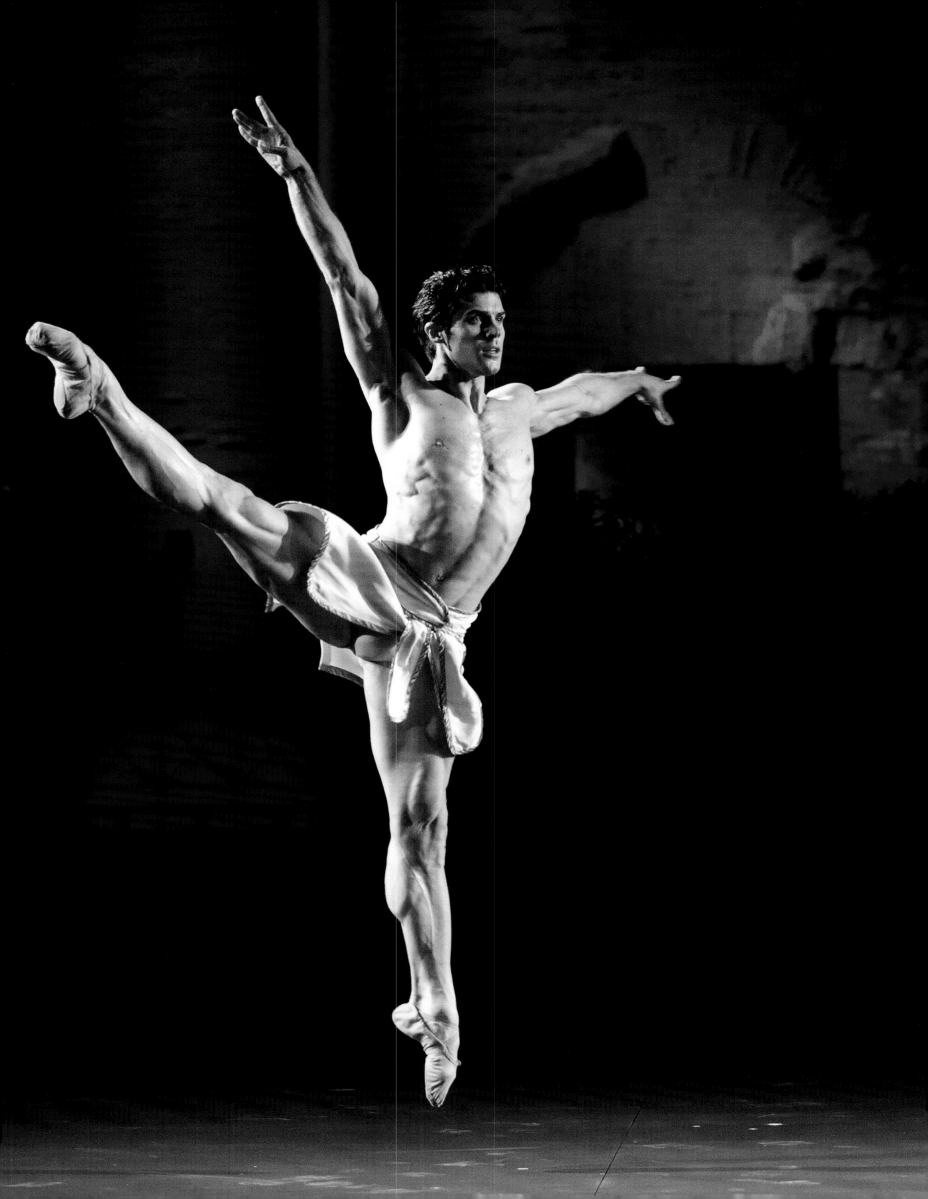

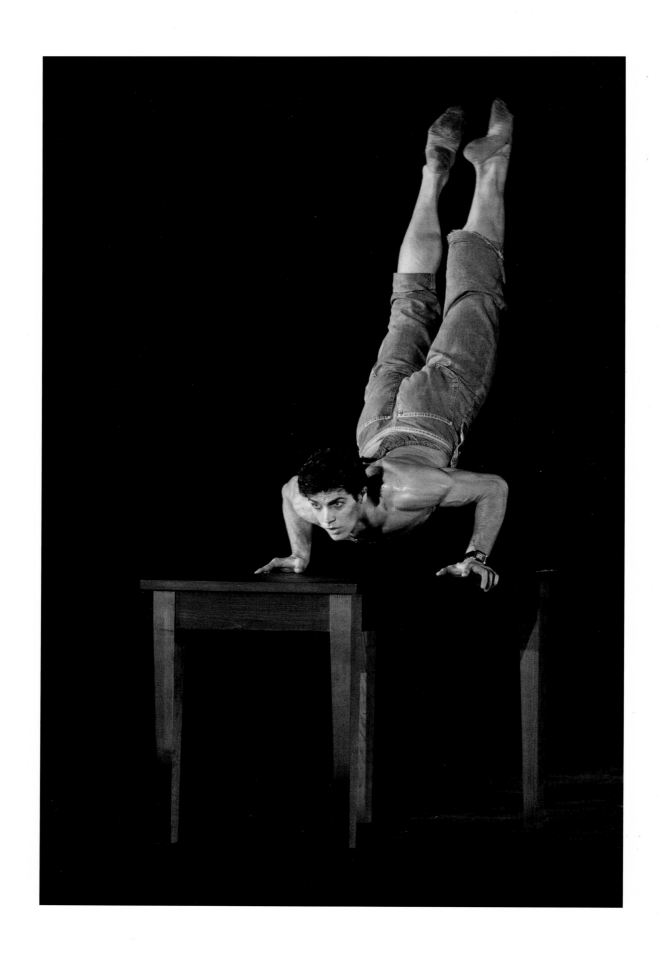

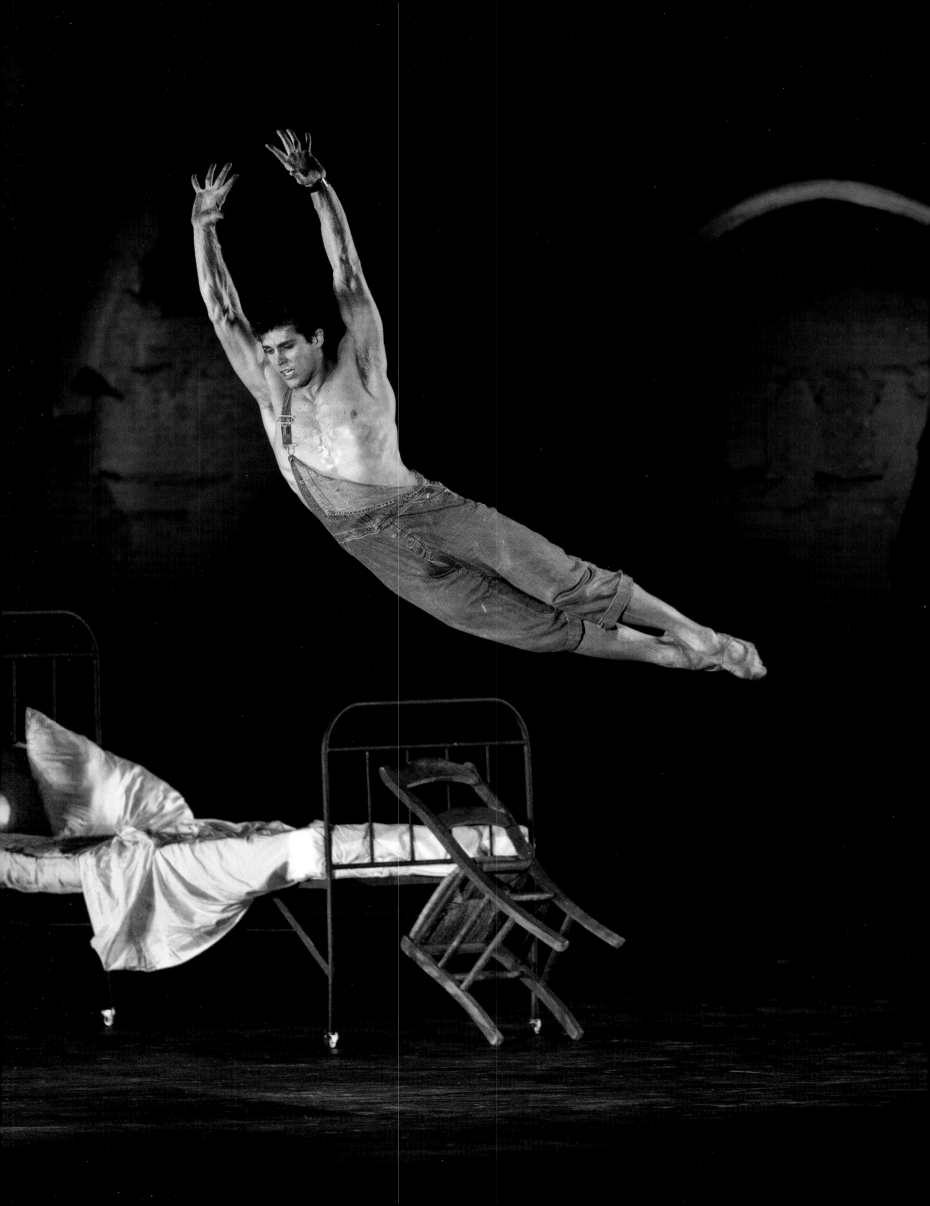

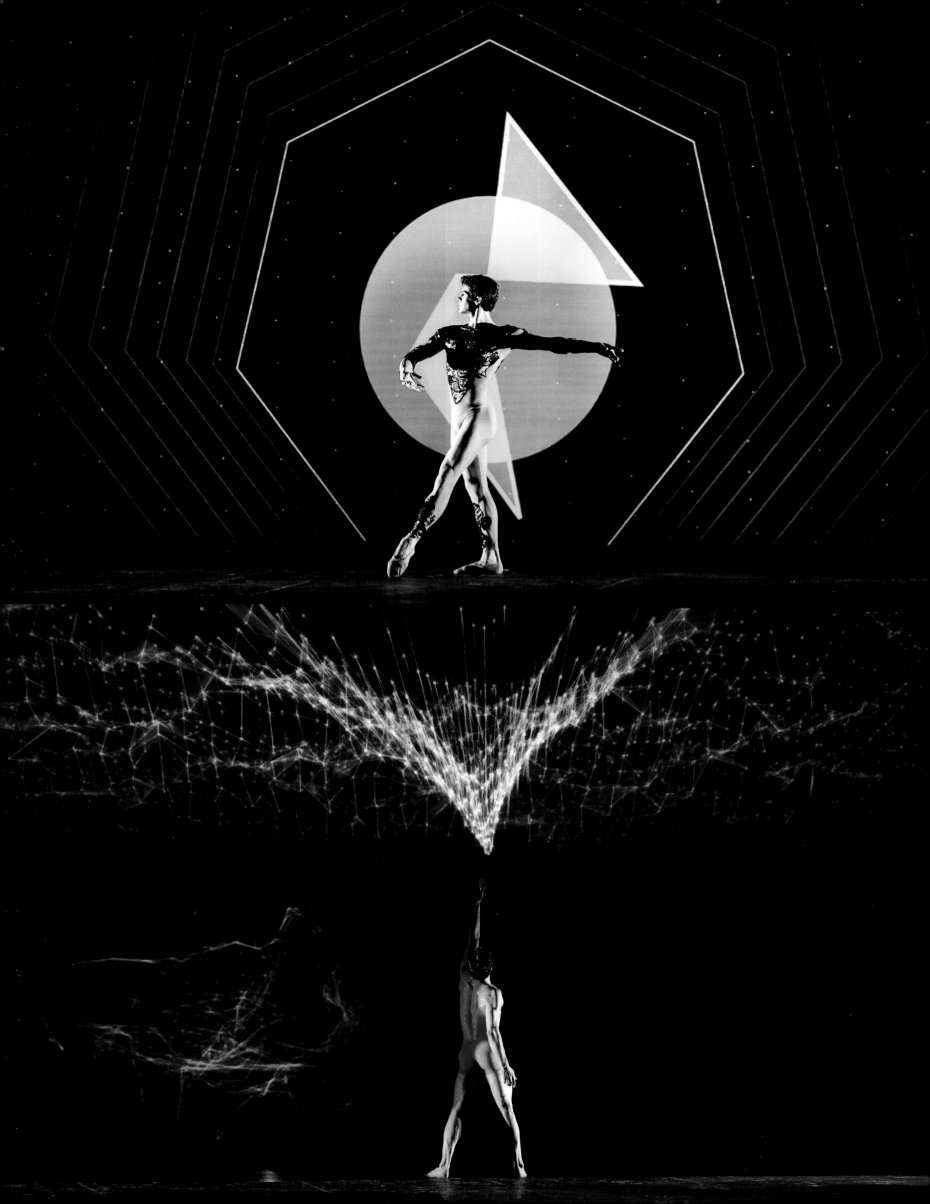

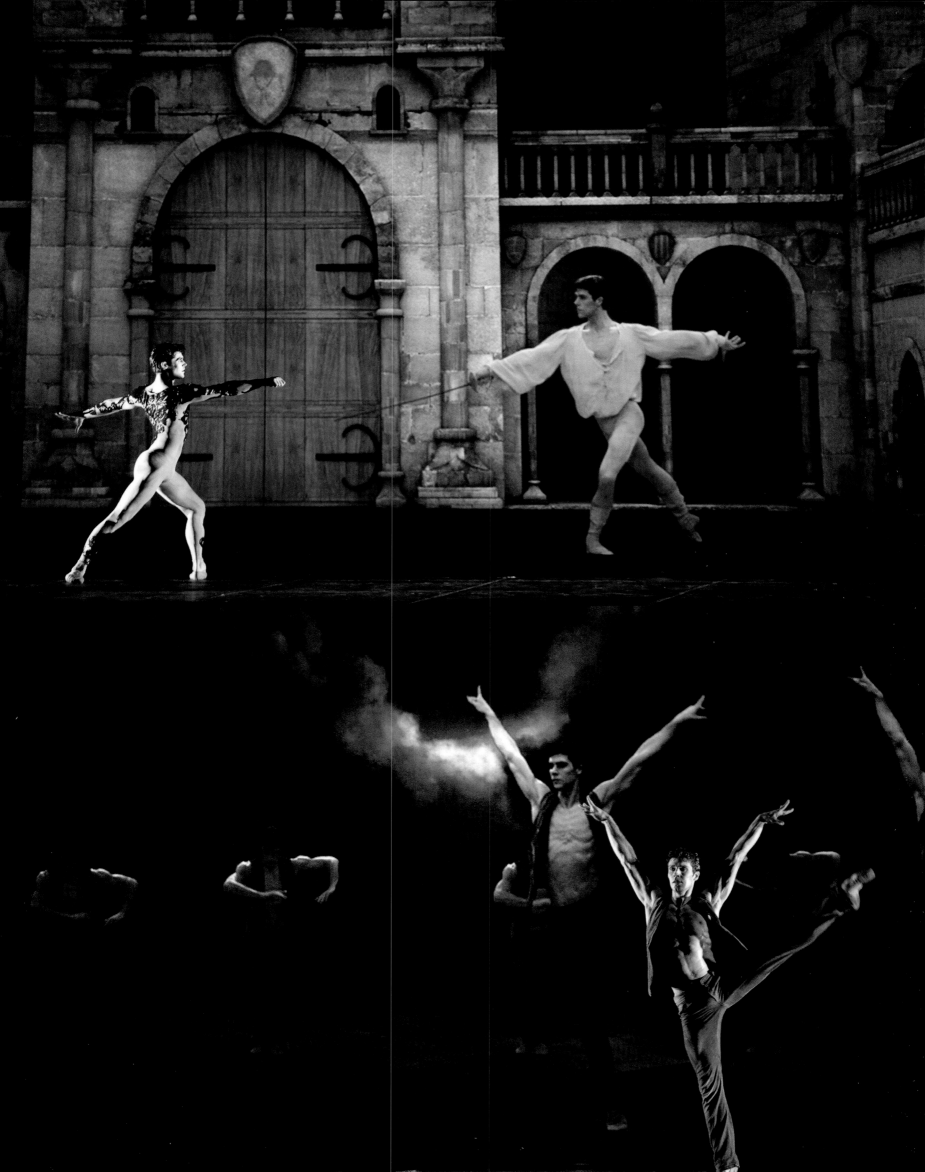

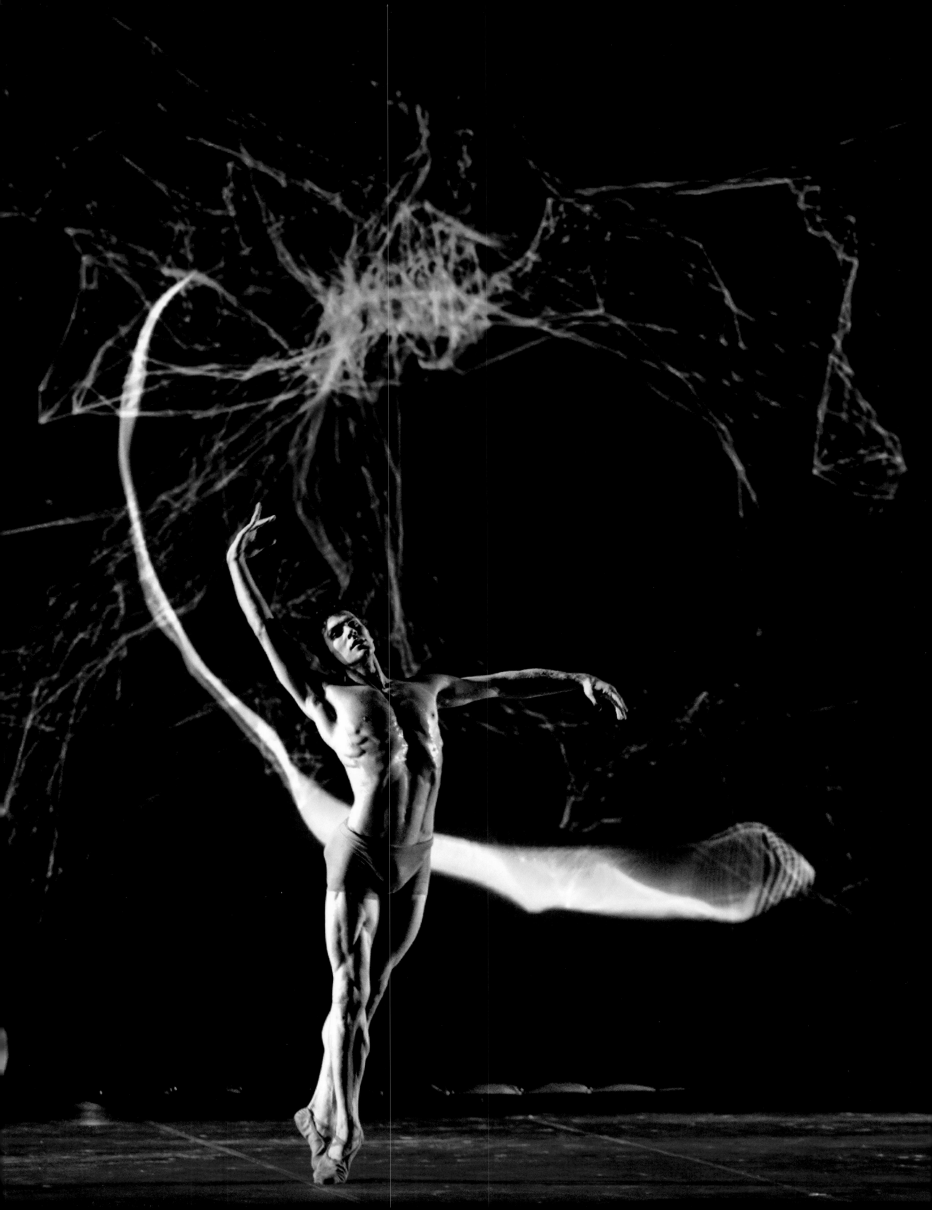

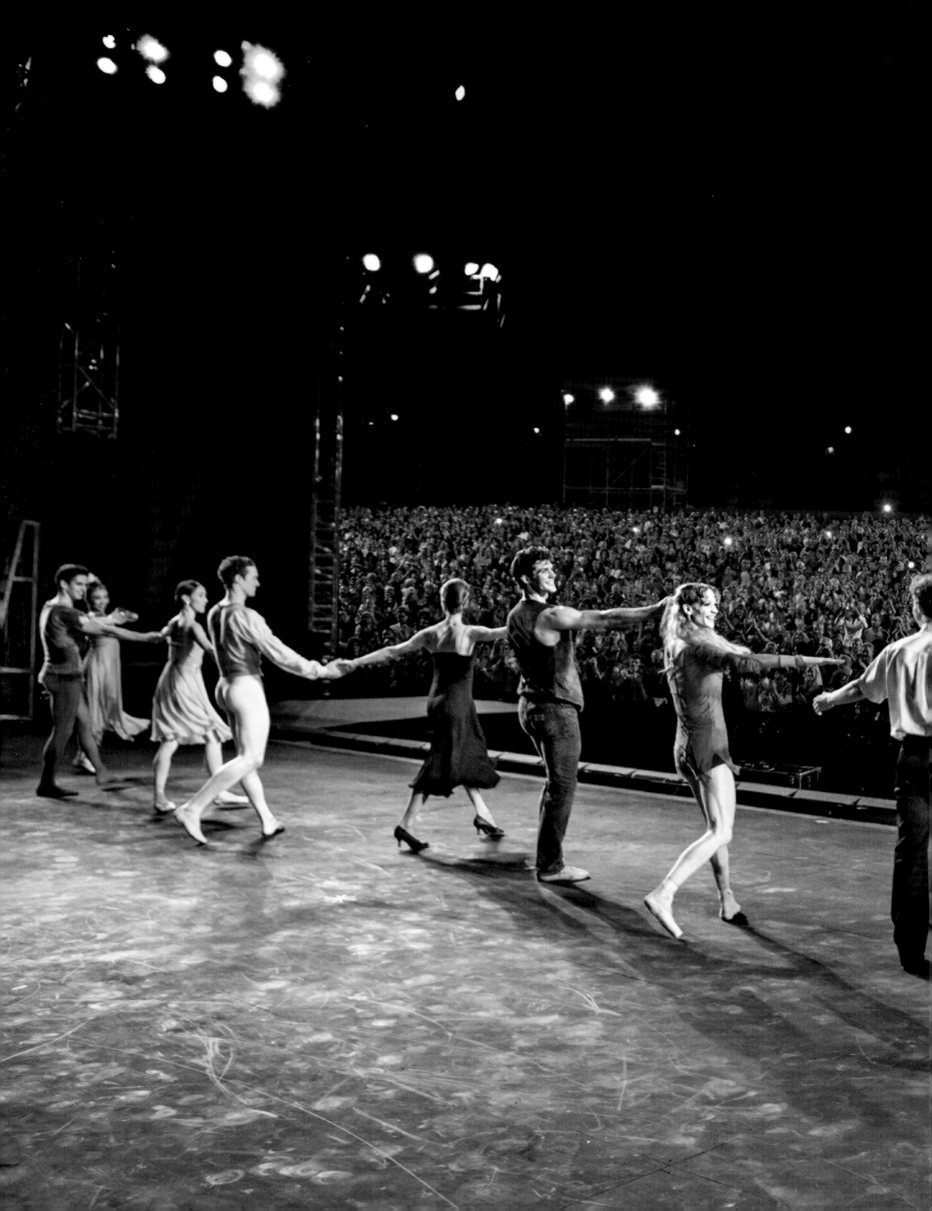

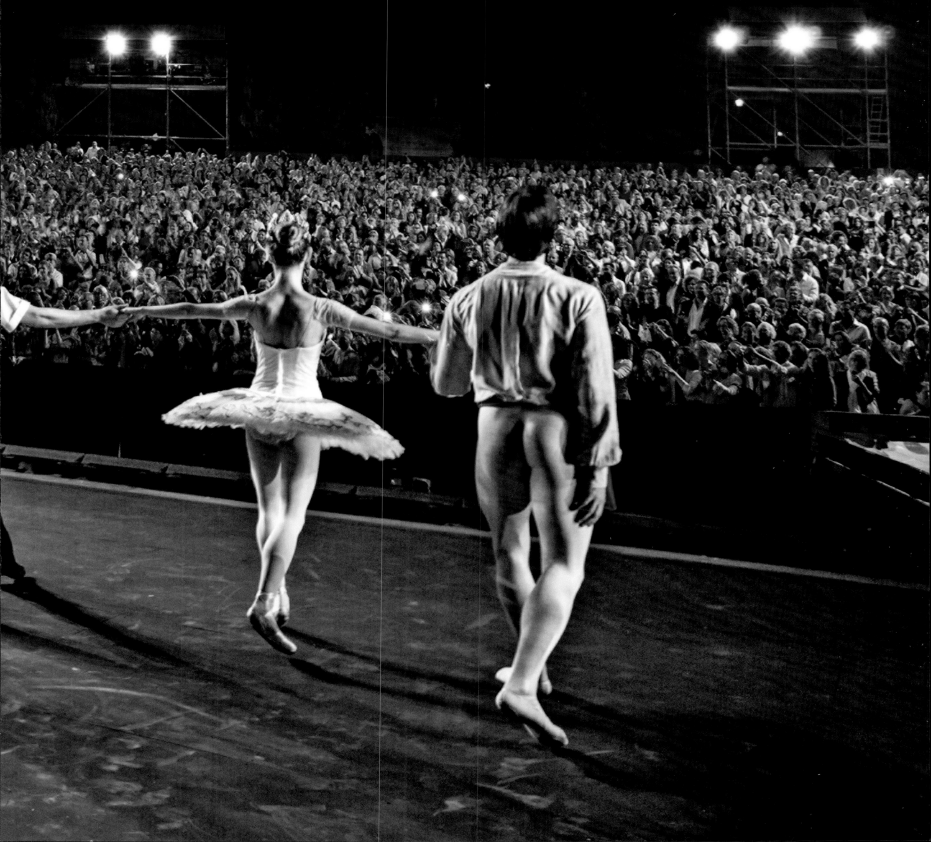

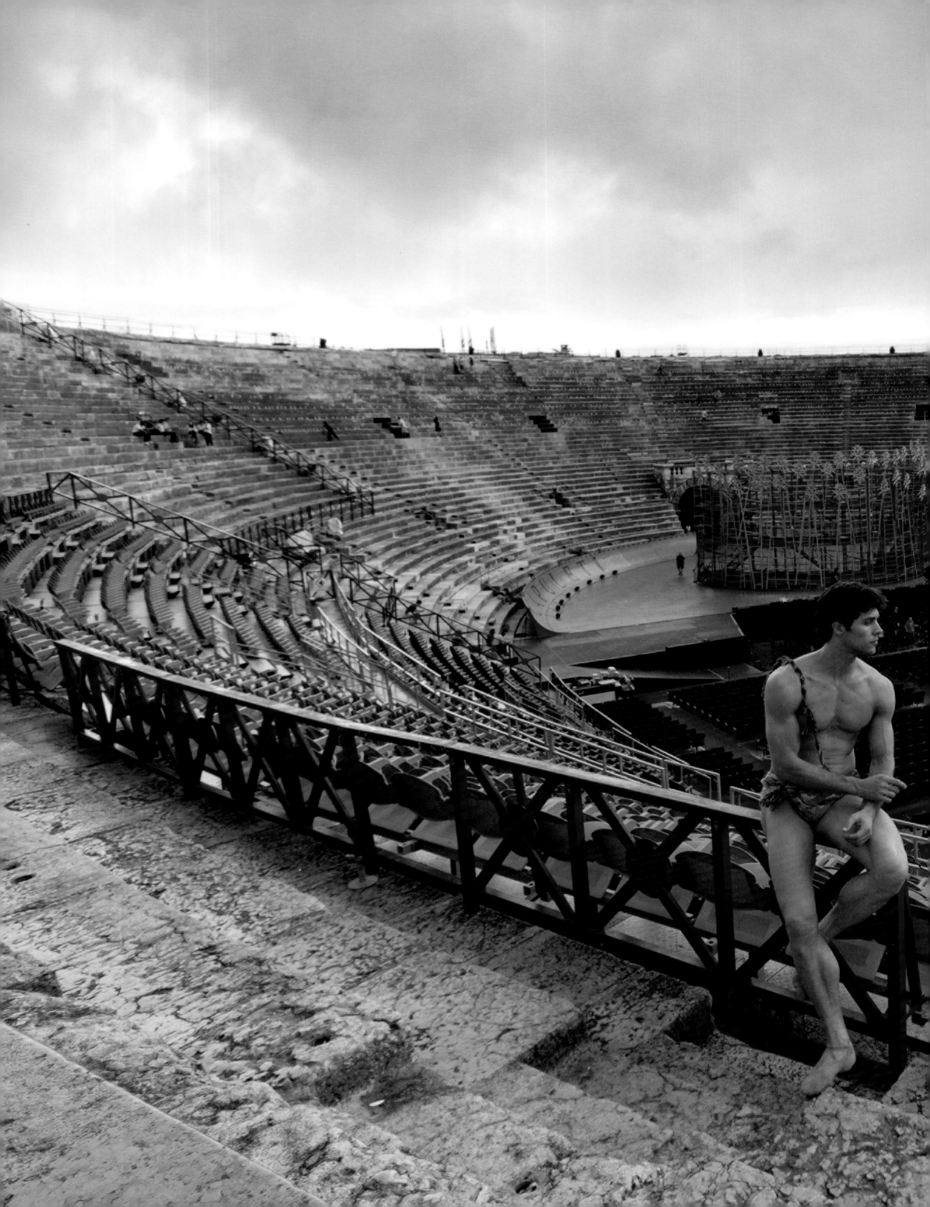

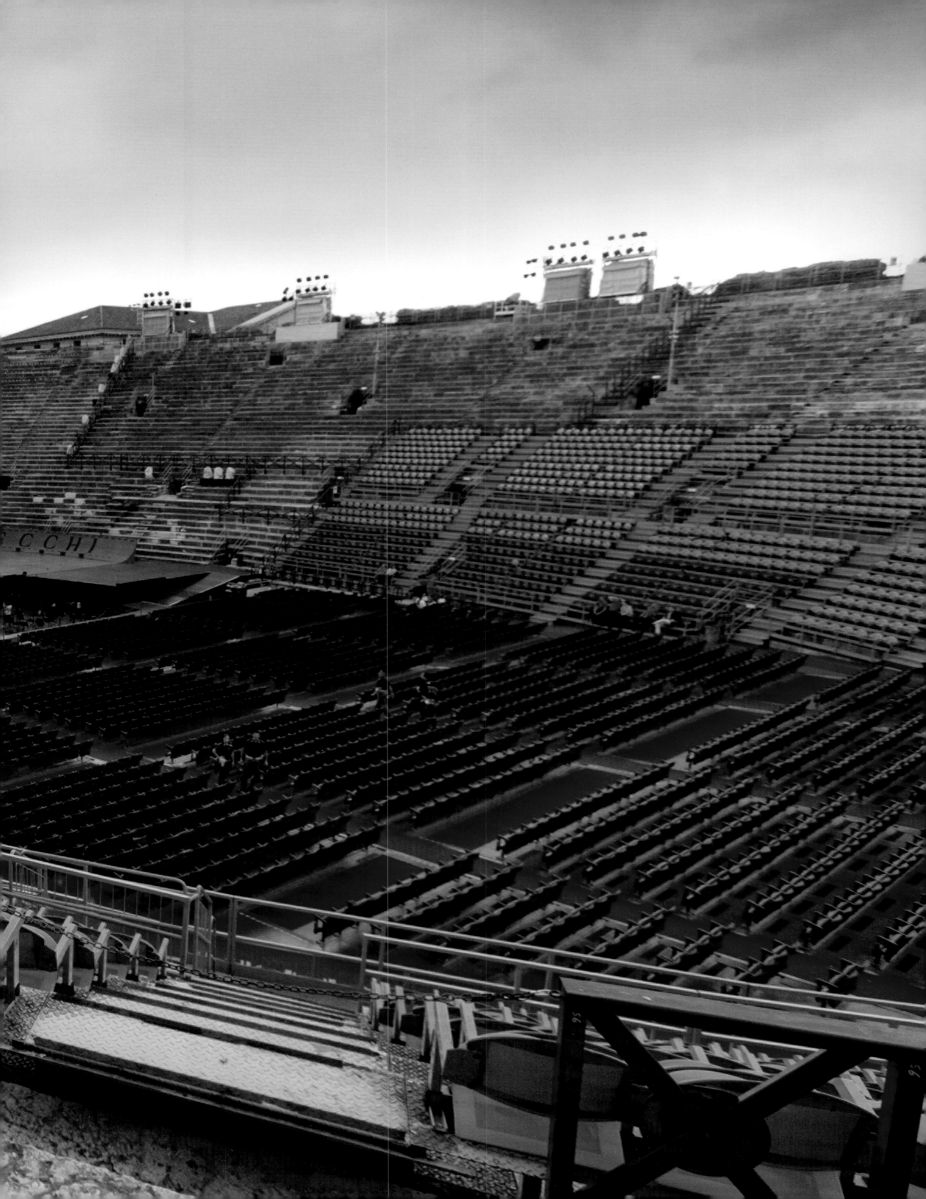

In the immense embrace of the Roman amphitheater,
dance loses its elitist dimension and becomes the most modern
heir to the spectacular events of antiquity.

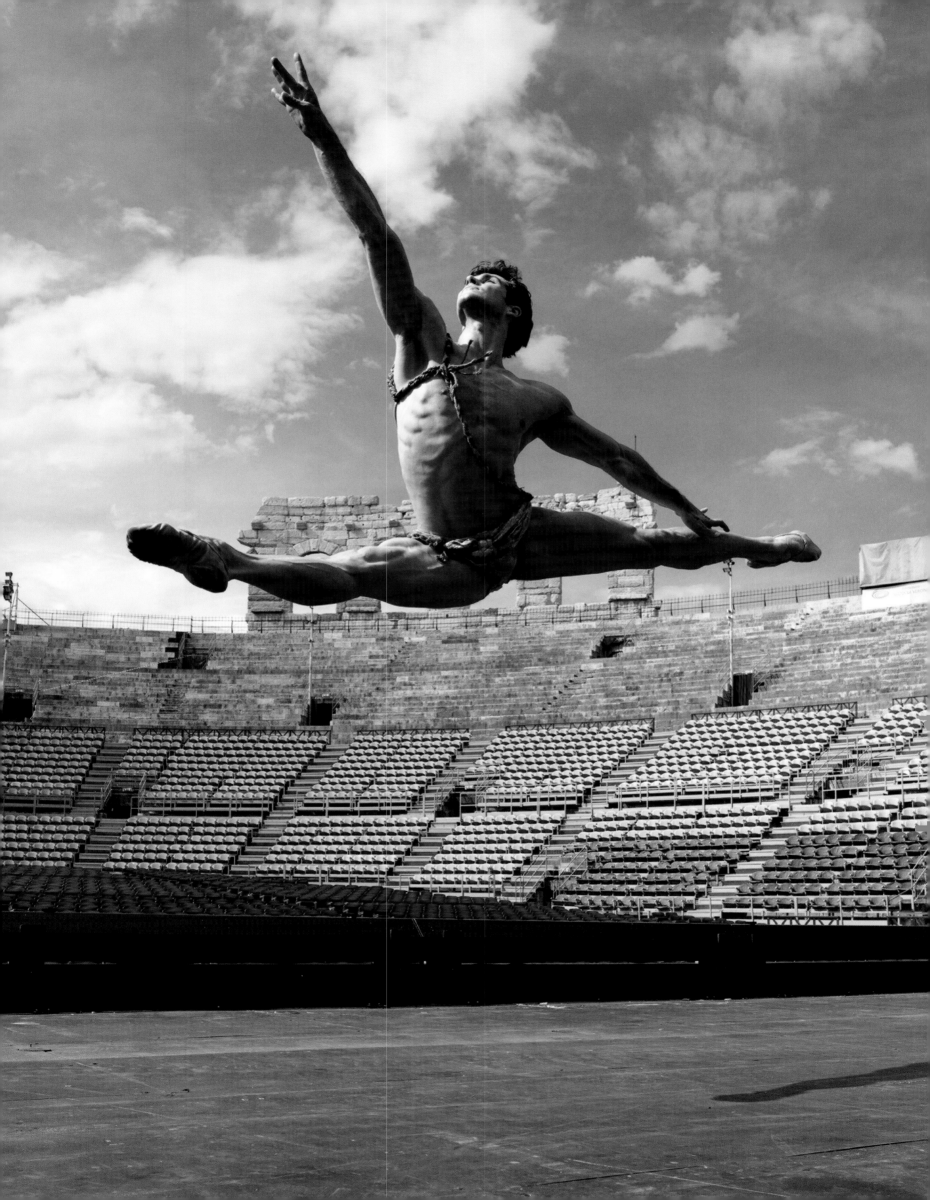

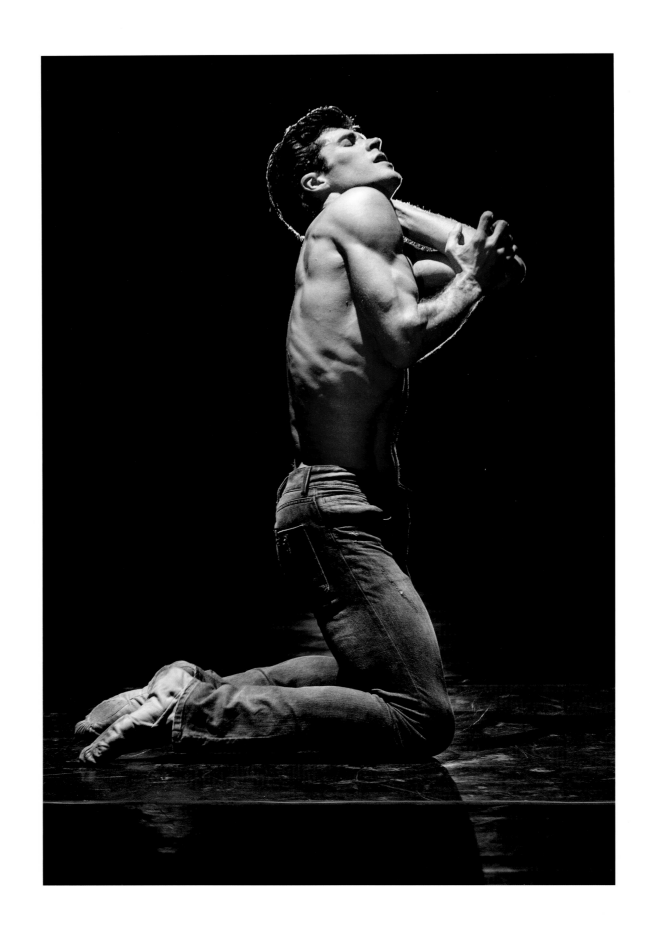

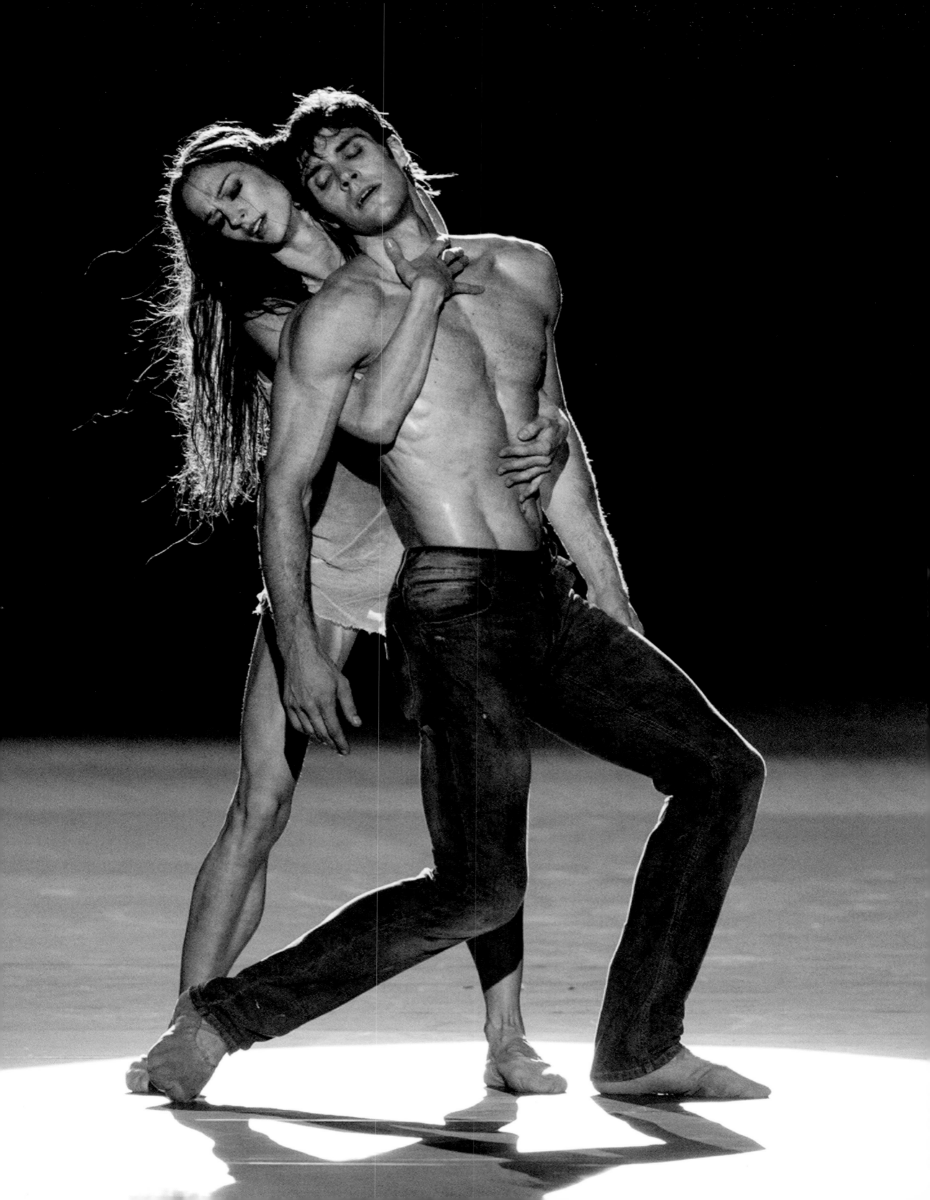

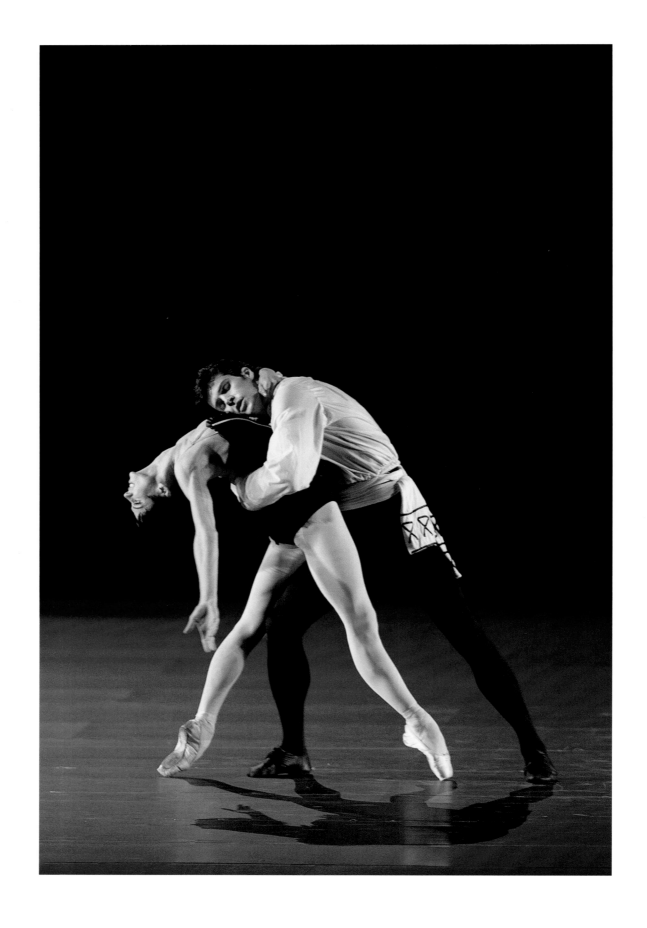

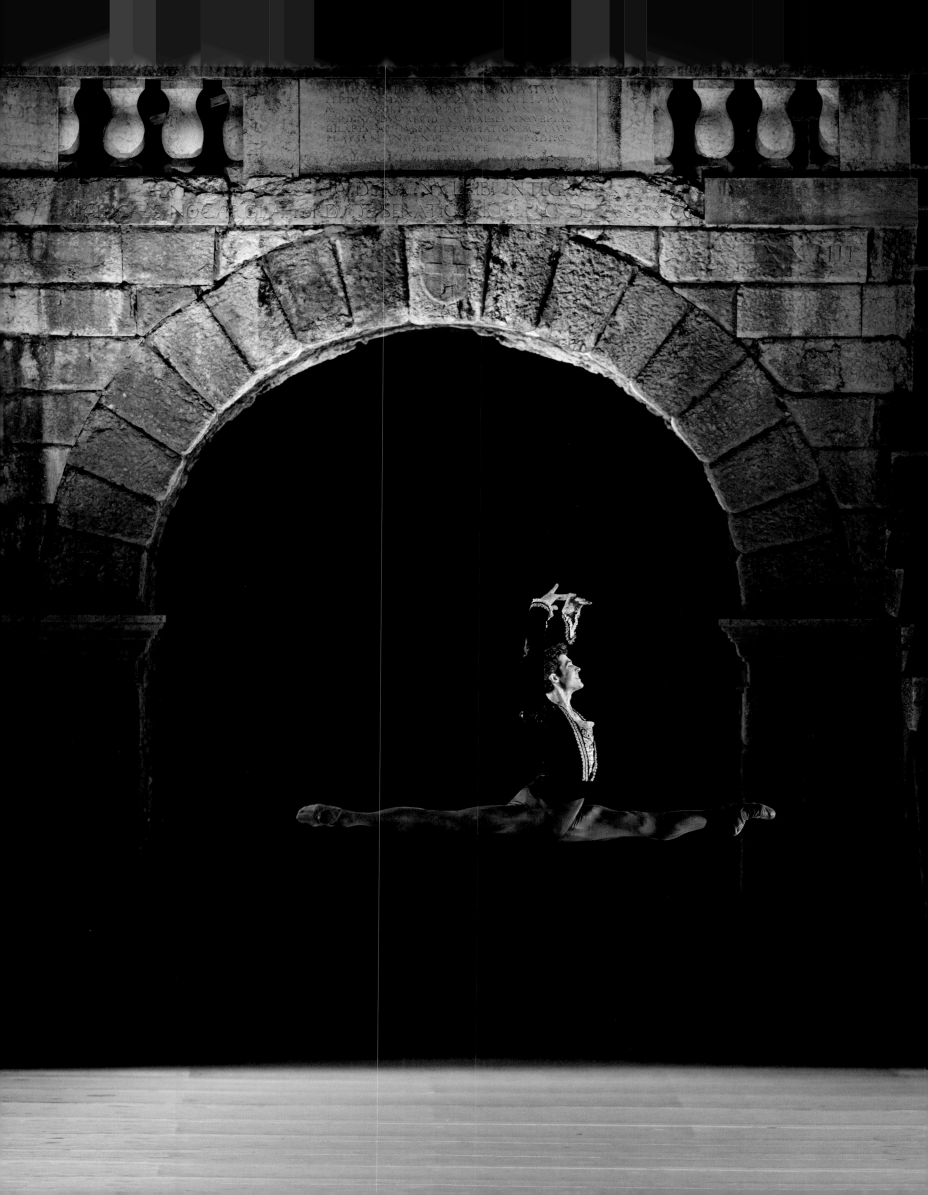

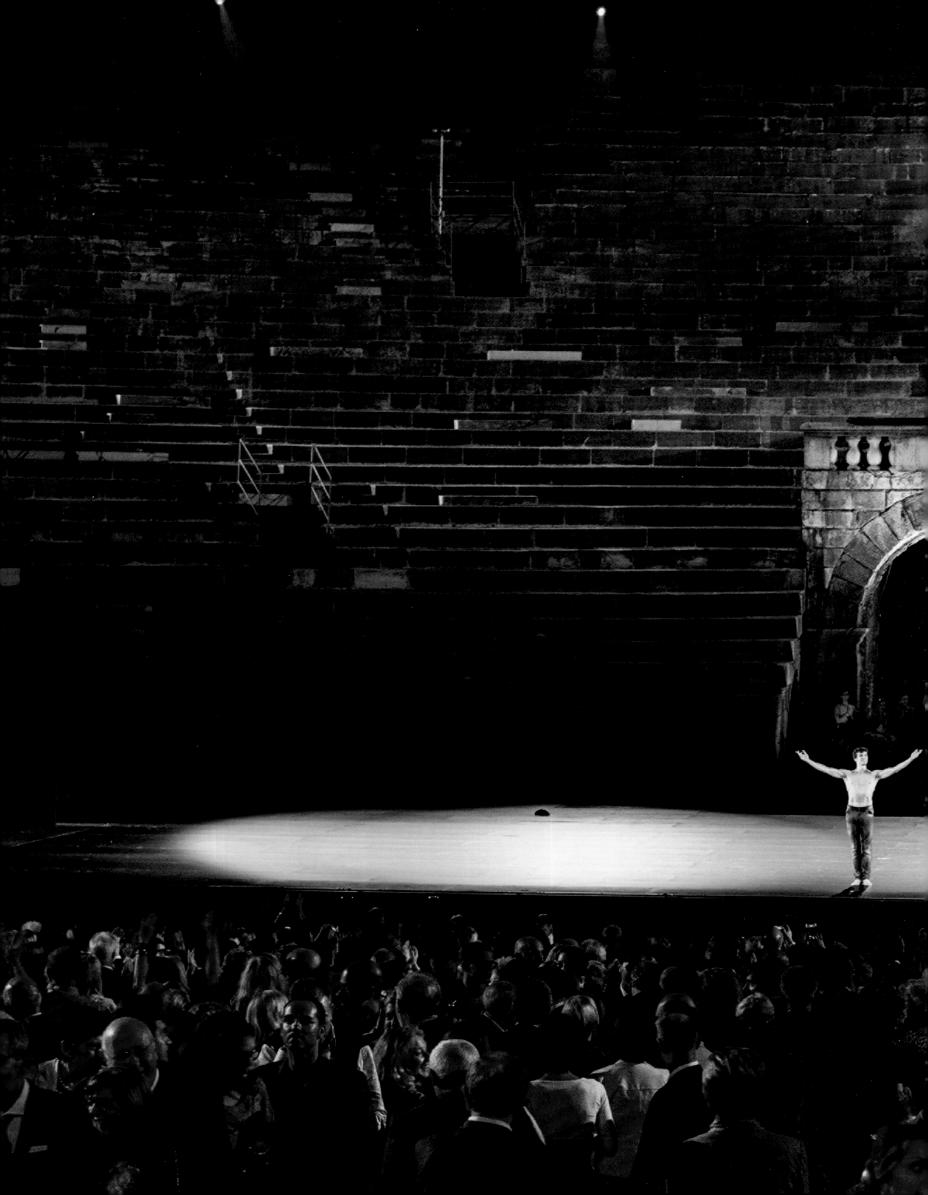

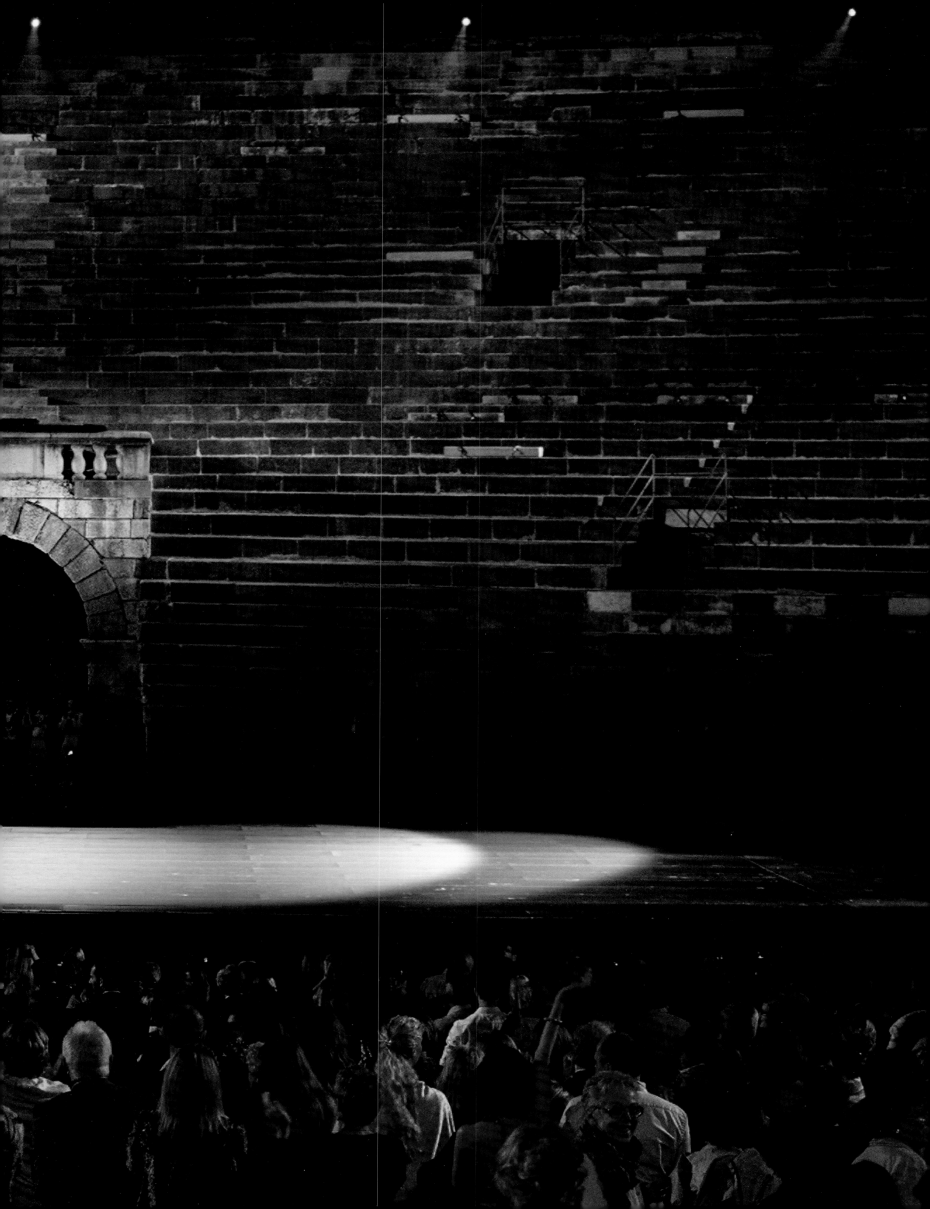

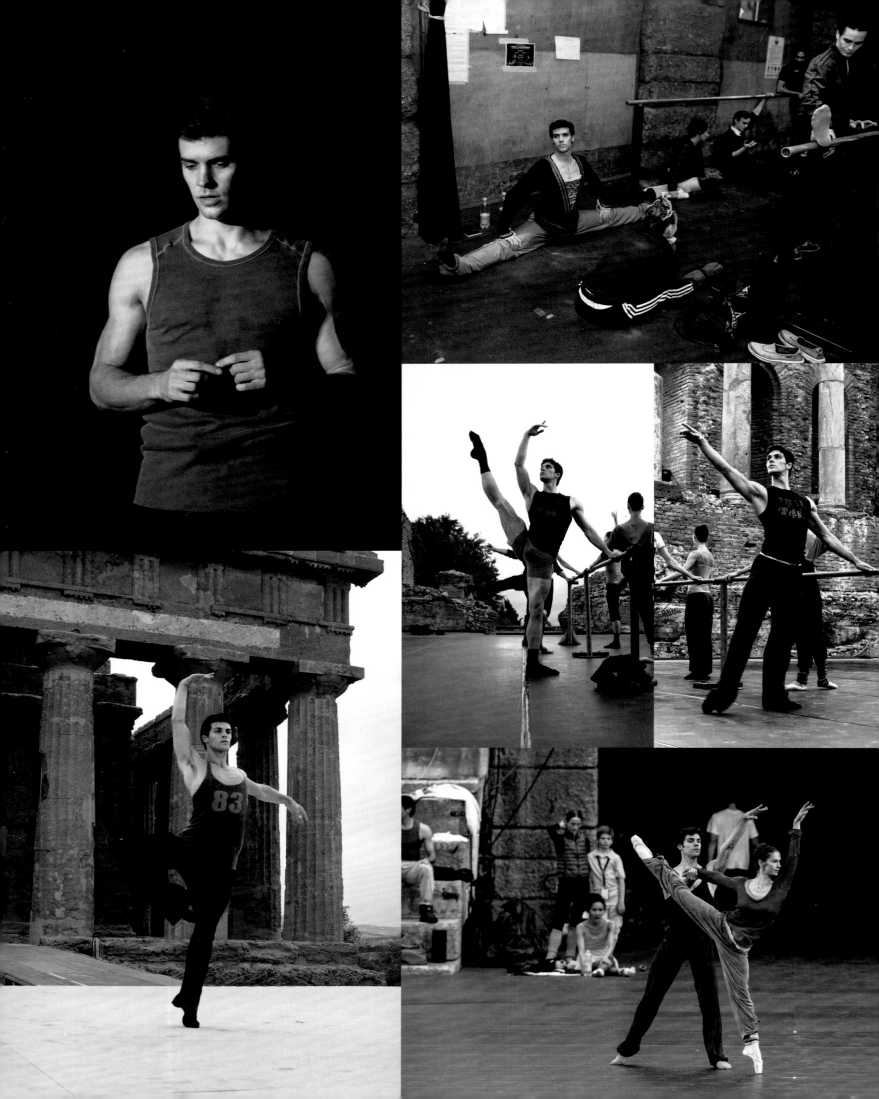

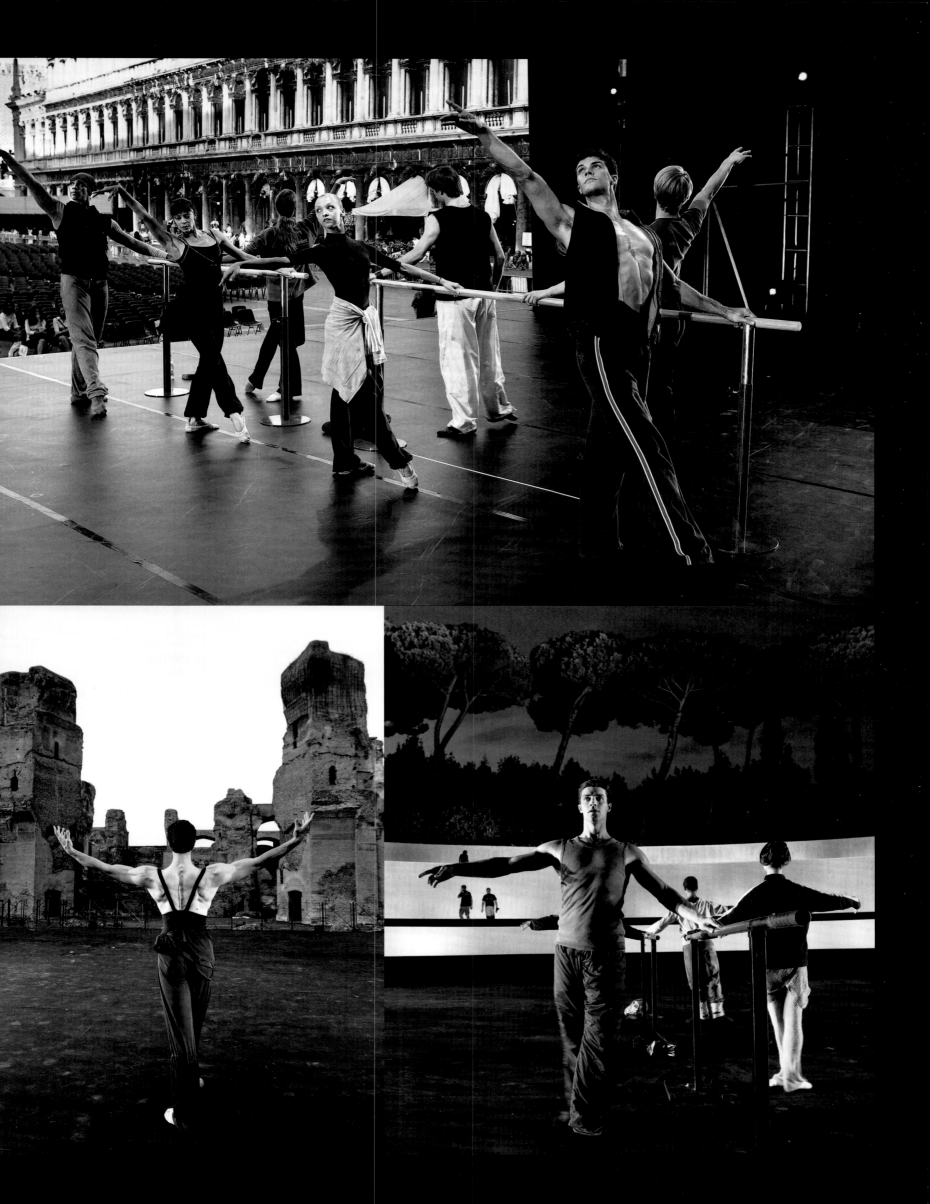

GALA
ROBERTO BOLLE
AND FRIENDS

ROME, THE COLOSSEUM
June 16th, 2008

Roberto Bolle
Alicia Amatriain
Sabrina Brazzo pp. 62-63
Alessio Carbone
Dorothée Gilbert
Arman Grigoryan
Ivan Kozlov
Ul'jana Lopatkina
Vahe Martirosyan
Natasha Novotná
Jon Vallejo

———

NAPLES, PIAZZA DEL PLEBISCITO
July 5th, 2008

Roberto Bolle
Sabrina Brazzo
Arman Grigoryan
Ivan Kozlov
Beatrice Knop
Václav Kuneš
Ul'jana Lopatkina
Vahe Martirosyan
Natasha Novotná p. 75, pp. 76-77
Dmitrij Semionov

———

MILAN, THE CATHEDRAL
July 13rd, 2008

Roberto Bolle
Alicia Amatriain p. 68
Sabrina Brazzo
Arman Grigoryan
Ivan Kozlov
Václav Kuneš
Ul'jana Lopatkina
Vahe Martirosyan
Natasha Novotná
Jason Reilly

———

CAPRI, LA CERTOSA
July 18th, 2008

Roberto Bolle
Alicia Amatriain
Silvia Azzoni
Sabrina Brazzo
Otto Bubeníček
Shirley Esseboom pp. 86-87
Ivan Urban
Oleksandr Ryabko
Alexander Zaytsev
Stefan Żeromski

———

AGRIGENTO, TEMPLE OF CONCORDIA
September 13rd, 2008

Roberto Bolle
Alicia Amatriain pp. 98-99
Otto Bubeníček
Isabelle Ciaravola
Shirley Esseboom
Nuñez Marianela
Francesco Nappa
Railly Jason
Thiago Soares
Ivan Urban
Katja Wünsche

———

TAORMINA, TEATRO ANTICO
July 23rd, 2009

Roberto Bolle
Sabrina Brazzo
Arman Grigoryan
Beatrice Knop p. 104
Vahe Martirosyan
Shoko Nakamura
Francesco Nappa
Nataša Novotná pp. 108-109
Dmitry Semionov

Special guests:
Simona Atzori
Mariacristina Paolini

———

FLORENCE, BOBOLI GARDEN
July 29th and 30th, 2009

Roberto Bolle
Alicia Amatriain
Sabrina Brazzo
Jiří Bubeníček
Otto Bubeníček
Julien Favreau
Arman Grigoryan
Yen Han
Vahe Martirosyan
Shoko Nakamura
Jason Reilly
Kateryna Shalkina

————

VENICE, SAINT MARK'S SQUARE
July 27th, 2010

Roberto Bolle
Alicia Amatriain
Filip Barankiewicz p. 155
Sabrina Brazzo p. 155
Václav Kuneš
Elizabeth Mason p. 155
Nataša Novotná p. 155
Marijn Rademaker p. 155
Jason Reilly p. 155

————

VERONA, ARENA
July 23rd, 2012

Roberto Bolle
Alicia Amatriain
Jiří Bubeníček
Otto Bubeníček
Alina Cojocaru
Alexander Jones
Johan Kobborg
Maria Kochetkova
Dinu Tamazlâcaru
Jia Zhang

————

VERONA, ARENA
July 22nd, 2014

Roberto Bolle
Alicia Amatriain
Skylar Brandt

Julie Kent
Eris Nezha
Jason Reilly
Polina Semionova p. 149, p. 150, p. 154
Daniil Simkin
Cory Stearns

————

ROME, BATHS OF CARACALLA
July 20th and 21st, 2012

Roberto Bolle
Alicia Amatriain
Juliana Bastos
Magali Guerri
Maria Gutierrez
Václav Kuneš
Alexander Jones
Nataša Novotná
Jia Zhang

————

ROME, BATHS OF CARACALLA
July 22nd, 2013

Roberto Bolle
Isabella Boylston
Misty Copeland
Marcelo Gomes
Yuriko Kajiya
Julie Kent pp. 132-133
Jared Matthews
Hee Seo
Daniil Simkin
James Whiteside

————

ROME, BATHS OF CARACALLA
July 25th, 2014

Roberto Bolle
Alicia Amatriain pp. 142-143
Federico Bonelli pp. 142-143
Skylar Brandt pp. 142-143
Julie Kent pp. 142-143
Hikaru Kobayashi pp. 142-143
Eris Nezha pp. 142-143
Hee Seo pp. 142-143
Daniil Simkin pp. 142-143, p. 154
Cory Stearns pp. 142-143

————

CREDITS

© Fabrizio Ferri: 2, 13-51
© Luciano Romano: 4, 52-155

Page 6: Peter Greenaway "Italy of The Cities," Shanghai World Expo 2010,
photo by Luciano Romano / Change Performing Arts

Page 10: Robert Wilson "Perchance to dream," New York 2010,
photo by Luciano Romano / Change Performing Arts

The author would like to thank Robert Wilson.
With gratitude to Cristiano De Lorenzo, Pamela Maffioli and Massimiliano Neri

Photographs of "Pompeii": by kind concession of the Ministry of Cultural Heritage and Activities and Tourism –
Soprintendenza Speciale for Pompeii, Herculaneum and Stabiae.
Photographs of "Capri": by kind concession of the Fototeca
della Soprintendenza Speciale for the P.S.A.E. and the Polo Museale of the City of Naples.
Photographs of "Agrigento": by kind concession of the Parco Archeologico e Paesaggistico of the Valley of the
Temples, Agrigento.
Photographs of "Taormina": by kind concession of the Regione Sicilia – Assessor for Sicilian Cultural Heritage and
Identity – Parco Archeologico in Naxos.
Photographs of "Verona": by kind concession of the Fondazione Arena di Verona.

For their kind collaboration we wish to express our gratitude to: Soprintendenza Speciale for the Colosseum,
the Museo Nazionale Romano and the Area Archeologica of Rome; Soprintendenza per i Beni Architettonici,
Paesaggistici, Storici, Artistici ed Etnoantropologici for Naples and the Province; Prefettura of Naples; Direzione
Regionale Campania; Soprintendenza per i Beni Architettonici e Paesaggistici of Venezia and the surrounding area.

UNESCO
Organizzazione
delle Nazioni Unite
per l'Educazione,
la Scienza e la Cultura

Commissione Nazionale
Italiana per l'UNESCO

ASSOCIAZIONE PER LA COMMISSIONE
NAZIONALE UNESCO - ITALIA ONLUS

CONCEPT & ARTISTIC COORDINATION Artedanza S.r.l
ART DIRECTION Sergio Pappalettera
GRAPHIC DESIGN & LAYOUT Gaia Daverio
TRANSLATION Sylvia Adrian Notini
EDITORIAL CONSULTANT Valeria Crippa
EDITORIAL COORDINATION Giulia Dadà
PRODUCTION Sergio Daniotti

First published in the United States of America in 2015 by
Rizzoli International Publications, Inc.
300 Park Avenue South
New York, NY 10010
www.rizzoliusa.com

Originally published in Italy in 2015 by
RCS Libri S.p.A.
© 2015 RCS Libri S.p.A, Milan

2015 2016 2017 2018 / 10 9 8 7 6 5 4 3 2 1

ISBN: 978-0-8478-4674-0

Library of Congress Control Number: 2015933392

Printed in Italy

Printed in March 2015
by EBS- Verona, Italy